THE ART OF THE
PHOTOGRAPH

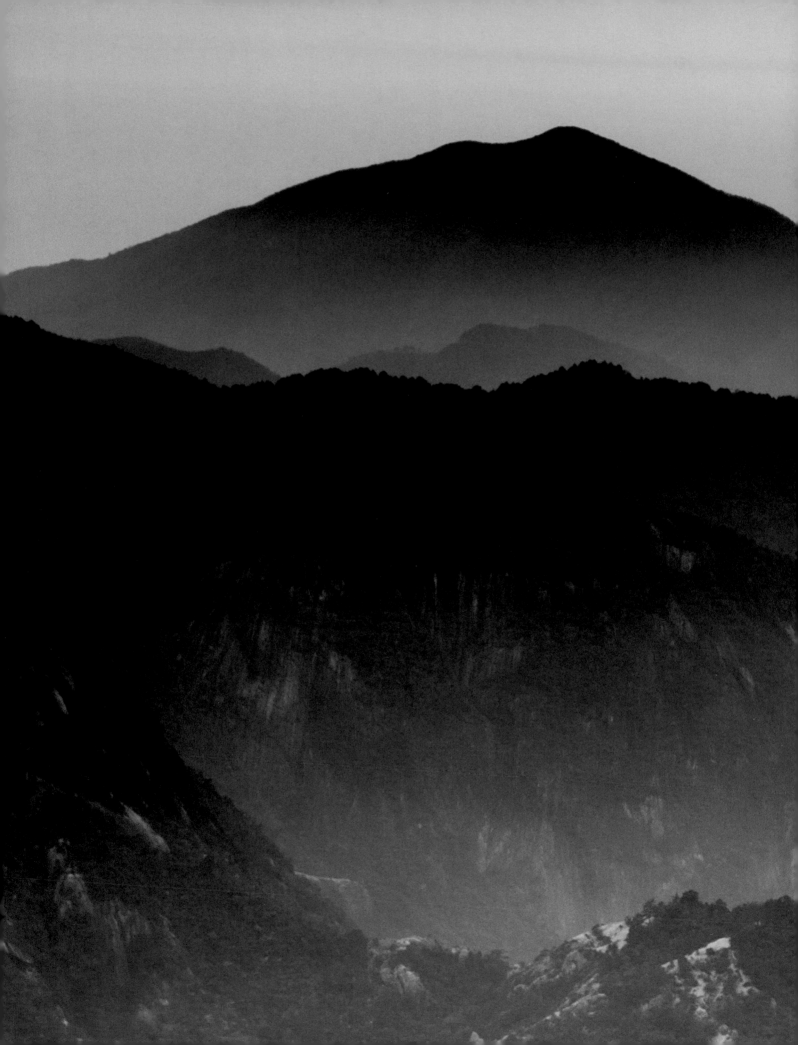

THE ART OF THE
PHOTOGRAPH

Essential Habits for Stronger Compositions

ART WOLFE AND ROB SHEPPARD

PHOTOGRAPHS BY ART WOLFE

AMPHOTO BOOKS

AN IMPRINT OF THE CROWN PUBLISHING GROUP / NEW YORK

Copyright © 2013 by Art Wolfe, Inc.
Foreword copyright © 2013 by Dewitt Jones

All rights reserved.
Published in the United States by Amphoto Books, an
imprint of the Crown Publishing Group, a division of
Random House, Inc., New York.
www.crownpublishing.com
www.amphotobooks.com

AMPHOTO BOOKS and the Amphoto Books logo are
registered trademarks of Random House, Inc.

Library of Congress Cataloging-in-Publication Data
Wolfe, Art.
 The art of the photograph / Art Wolfe and Rob
Sheppard ; photographs by Art Wolfe.—First edition.
 Includes bibliographical references and index.
 1. Composition (Photography) I. Sheppard,
Rob. II. Title.
 TR179.W645 2013
 770.1—dc23 2013004632

ISBN 978-0-7704-3316-1
eISBN 978-0-7704-3376-5

Printed in China

Text and cover design by La Tricia Watford
Photographs by Art Wolfe
Cover photographs by Art Wolfe

10 9 8 7 6 5 4 3 2 1

First Edition

For my two superb art professors at the University
of Washington, Ramona Solberg and Hazel Koenig

—*Art Wolfe*

CONTENTS

FOREWORD BY DEWITT JONES 8

INTRODUCTION 10

one FINDING INSPIRATION 13

two DISCOVERING THE SUBJECT 35

three CONSTRUCTING THE IMAGE 55

four CAMERA AND LENS 83

five THE ELEMENTS OF DESIGN 123

six COLOR AND BLACK-AND-WHITE 139

seven LIGHT AND COMPOSITION 171

eight CREATIVE SOLUTIONS 205

nine THE 10 DEADLY SINS OF COMPOSITION 227

ten EQUIPMENT AND WORKFLOW 249

ACKNOWLEDGMENTS 254

INDEX 255

FOREWORD by Dewitt Jones

"How do I become a great photographer?" I have been asked that question hundreds of times over the course of my career as a photographer for *National Geographic* magazine and with various advertising clients. There's no easy answer. Faced with such a diversity of books, classes, and workshops, it can be overwhelming and confusing.

There is no question that becoming a better photographer takes practice. Every professional photographer I have met has shot for many years to get to where they are. But how, exactly, should you practice? It's best to have some guidelines to make that practice valuable and effective. Otherwise, you may take a lot of photos but without gaining the right experience to get better. The book you now have in your hands gives you those guidelines.

There are three critical elements in this book: the images, Rob's text, and Art's stories. Each teaches an essential part of becoming a master photographer. Start by going though the entire book and just looking at the photographs. Don't read the text, don't read the stories, just stay with the photos. Don't analyze them; just experience them. You are in the presence of one of the finest photographers of our time; let his images instruct you. Let your eyes understand the lessons that the text will eventually teach your brain.

Now start again and read Rob's wonderful text, which was based on his collaboration with Art about how photographers and artists work with composition. This time, let your brain break apart the photos to see their underlying composition. Learn the "rules" that will eventually become second nature to you. Go slowly, and try to learn each lesson before moving on to the next. At the end of each chapter, read Art's story.

When you finish the book this time, go back to the begin-ning and read all of Art's stories again. Now that you have studied the photos and absorbed Rob's text, these stories will gain a whole new meaning. Stand with Art as a bright orange wall turns his head in a Japanese Shinto Shrine. Experience his frustration and joy as he searches for caribou in the Arctic. See how he moves from what he thought was the photograph to something entirely different. That is what good photography is all about. Whenever I have gone on assignment, I have always brought all of my knowledge about what makes a good photo-graph with me. Then I leave myself open to the conditions, to the subject, to the scene—just as you see Art doing.

Both Art and Rob are not only masters of their craft, but masters of their lives as well. It may be their technique and gear that turns a moment or idea into a photographic reality, but it's their deep engagement with life that allows them to have that idea, or see that moment, in the first place.

The Art of the Photograph takes photography apart and then puts it back together again. Amateur photographers often struggle with the beautiful imagery in publications like *National Geographic*, assuming that it is beyond what the average photographer can do. This book breaks it down, con-necting beautiful pictures with easy-to-understand ideas about how to master your own photography, to create images that celebrate your experience with the world. A lot of my work in recent years has been to help people celebrate what is right with the world. This book will help you better see that world and find the joy and wonder all around you. Gear, composi-tion, and workflow, yes, but also self-discovery and inspira-tion. Study it, enjoy it, experience it. It will go a long way toward helping you become a better photographer!

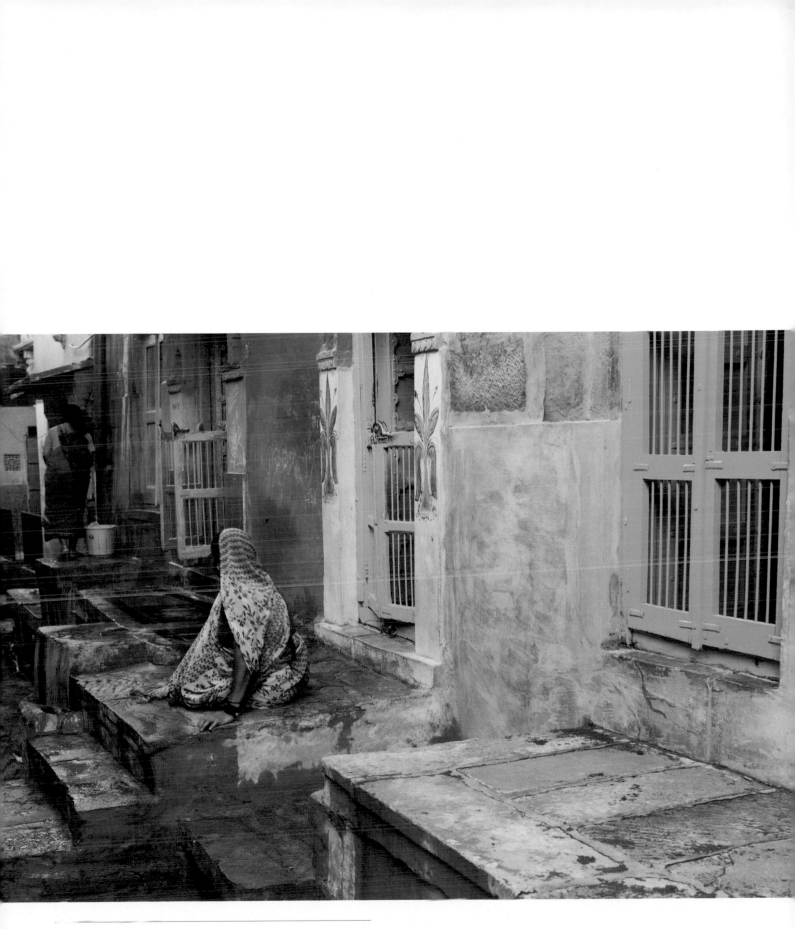

Alleyway, Jaipur, India
24–70mm lens, f/6.3 for 1/15 sec., ISO 200

INTRODUCTION

Photography has become such an important part of our world. From the time we wake up until the time we go to bed, we are immersed in images, from the news on TV to the designs on our milk carton, the photos in our newspapers, and the images online. The web has opened up a whole new way for photographers to express themselves and show off their images, from Facebook to Flickr, Tumblr, and so many other places.

Simply posting casual snapshots certainly does connect people through the Internet, but we believe photography has the potential to do so much more. By understanding how to control your photography to better communicate to others, your photography will not only improve but our whole world of imagery will get better as well.

The Art of the Photograph is a complete course in seeing and making better images. This has been an exciting project for us. We recognized a need for information that went beyond the common guides to gear and top tips. Those guides are certainly important and have helped many photographers, but we found a real lack of information about how to truly construct better photographs using solid principles of design and composition. Neither of us wanted to keep this "pro information" secret, just for our own use. We know that it has the potential to truly change the way people think about their photography, to expand their approach in such a way that we all benefit from better photography today.

Photography has long had a history of affecting others. More than 150 years ago, photographs of the Civil War gave people images of battlefields that they had never seen before, and images of the area around what is now Yellowstone National Park influenced Congress to preserve the land as the first national park. More than 100 years ago, Lewis Hine's photography of American industry was instrumental in reforming child labor laws. Today, images from around the world connect us with events and people in places we never would have thought about in the past.

But good photography is not about always changing the world, though it can have that effect. Good photography is about creating images that do more than simply record a subject and little more. Good photography is about showing others what it is that you find remarkable in the world, and doing so in such a way that your images connect with viewers, making them feel something about the subject. In this book, we give you tools to do exactly that.

Sometimes people see stunning photos from pros like Art and think that they could not possibly take pictures like that. And in fact, if you try to take Art Wolfe photos, you will likely be disappointed. The only person who can take great Art Wolfe photos is Art Wolfe. You have the opportunity to take great pictures, too, but photos that are yours rather than those that imitate other photographers' images.

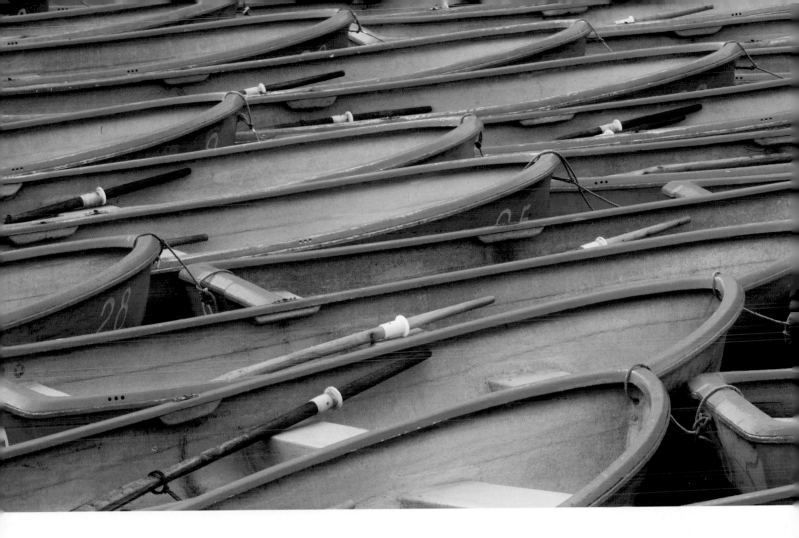

Use the photographs and ideas presented in this book to inspire your own approaches to the subjects you care about. You will learn to photograph without prejudice, meaning that you can find good images from any subject, in any location. All it takes is an open attitude that this is possible, rather than a prejudice that only certain locations or subjects make good images.

All of us photographers are on a journey to find better ways to connect with others through our images. That journey is personal and each of us has our own photographs to make. Our goal in this book is to offer ideas and approaches that will keep you centered on your own path.

Whatever your passion, believe in it and strive to be better at expressing it with your photos. Whatever your level of photography, look for ways to make it better through reading

books like this—and having lots of practice. Most of all, enjoy your photography, your connection to the beautiful world around us. Photography can be your own personal meditation on what is important and a vehicle to share that with others. Enjoy the journey.

—Rob Sheppard

Rowboats, Honshu, Japan
70–200mm lens, f/20 for 1/10 sec., ISO 400

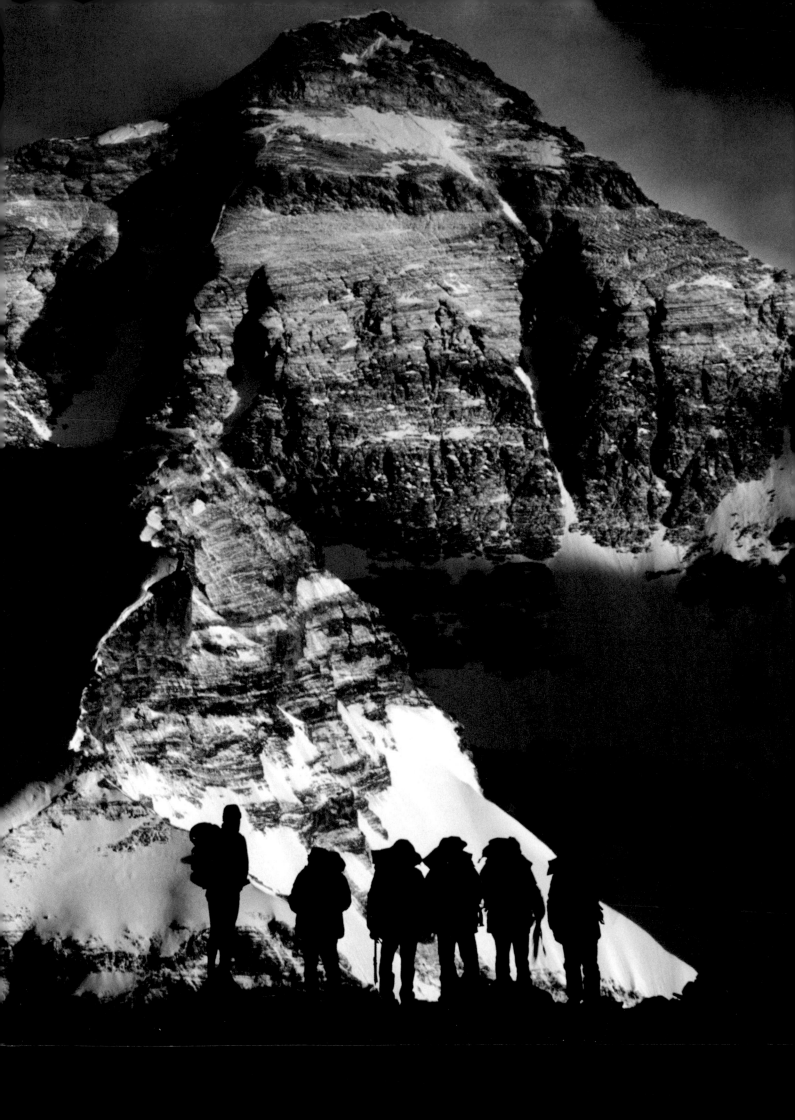

1

FINDING INSPIRATION

Where do you go to find inspiration? A book like this is a great place to start, but inspiration can be much more than a book, a class, or even a photographer. Inspiration for your photography can come from your life. Art's creative life and inspiration started when he was a kid and continues today. While you can't control your past, you *can* control your environment to ensure you'll find inspiration there. What you surround yourself with does make a difference.

In this chapter, Art will share some of the early life experiences that influenced him as an artist and later a photographer. You'll also learn how he became a photographer and what some of his inspirations were. In the process, you'll discover possibilities for finding your own inspiration and how elements like your home and garden can affect you. Here is Art's story.

"You can find pictures anywhere. You just have to care about what's around you and have a concern with humanity."
—Elliot Erwitt

GROWING UP AS AN ARTIST AND NATURALIST

My father, Richard Arthur Wolfe, familiarly known as Dick, was a photographer during World War II, working on an aircraft carrier in the South Pacific. This was way before even 35mm cameras were popular. At the time, everyone shot 4x5, and Dick was no exception. While still in the service, my father was stationed for a time in Bremerton, Washington, not far from where he grew up in Seattle. While there, he met and fell in love with Canadian Ellinor Smith.

Richard and Ellinor got married right after the war. They needed something to support themselves and their future family, so Richard trained Ellinor to take pictures, too, and together they started a wedding photography business in Seattle, using 4x5 Speed Graphics. If you have never seen such cameras and only know digital, it can be hard to believe what you had to go through to take a picture. These cameras took film holders that held sheets of film that measured 4 × 5 inches in size. Each holder held two sheets of film. To take a picture, you had to put the holder into the camera, activate the shutter, pull a dark slide out of the holder to allow the film to be exposed, press the shutter to expose the film, put the dark slide back into the holder to protect the film, take the holder out and flip it over, then start over again for the second sheet of film. Phew! This had to be done for every two exposures, so you can imagine the effort required to take a lot of pictures.

I was born in 1951, the youngest of three, including a brother, Chuck, and a sister, Grace. I learned how to cook and do house chores at an early age because my parents were always at work. Perhaps that exposure to hardworking photographers started me on a course toward photography, though truthfully, wedding photography never really caught on for me.

In spite of having two professional photographers as parents, as a family we had few photographs actually taken of us. Perhaps it had something to do with the effort and equipment required to take photographs, or the fact that many photographers get so focused on their work, they forget to take photos of their families, a bit like the old adage of a cobbler's children having no shoes. Whatever the reason, the image you see opposite is the only one we have. I am on the left, and my brother, sister, and cousin are to my right. Old family photos can be interesting to interpret. What am I thinking in this photo? I know exactly what I was thinking: "How do I get rid of my sister and brother, so I can go into the woods and play?"

From a very early age, I loved spending time in the woods near my home. Wooded ravines nearby were places for play and exploration. But I didn't just want to play. I wanted to know everything in those woods. I got a little bird book, a little mammal book, and a little tree book, and was determined to figure out all of my natural neighbors. This time spent connecting with nature has had a strong influence on me throughout my entire life. I have long been as much a naturalist as a photographer, as shown in my book *The Living Wild* (published in 2000).

At this point of my youth I was not yet a photographer. I liked drawing and started to draw what I saw in the woods. And my mother, through a correspondence class, learned to become a commercial artist to help with the photography business. This further encouraged me to develop my skills as an artist.

My first sale of an image came when I was 13, while in junior high school. Two of my teachers, who had migrated to the West Coast from the Midwest, had black-and-white photos of the farmhouses where they had grown up. These caught my interest, and using the photos as references, I rendered them into watercolor paintings. I added an old truck in front of one of the farmhouses, matted and framed the painting, and sold it to the teachers for $30. Now that was a deal! Back in the mid-1960s, that was a lot of money, especially for a boy my age. At that time, my siblings and I would pick apples and berries,

collect beer bottles from gutters, do whatever it took to earn money for the family to survive. More importantly, though, this sale showed me that I might actually make money from my art.

Money started to come in a little more as I got older, and I bought an old Chevy and started heading off into the Cascade Mountains. Just as I had loved playing in the wooded ravines near my home, I found that I loved to fish and walk up mountain streams. So far, I still hadn't taken a single photo.

My father was a lot like other fathers of the war generation. He was always busy working and could not easily take the time to play or show me how to use a camera. He was always taking wedding photos. One thing I learned was that I never wanted to be a wedding photographer because it seemed that such photographers always came home at the end of a long day and needed a stiff drink.

During my teens, I began to paint more regularly. I would stretch watercolor canvases and take them out to the Pacific Coast in Northern Washington, where I sat in the sand and made paintings of the wonderful scenes. At this point, I believed that I was going to be a painter. I dreamed of hanging watercolors of the Washington landscape in galleries.

When it came time to go to college, I became an art major at the University of Washington. I enjoyed the classes but faced a challenge. All of my teachers would tell me, "You're not going to make a living with your painting. We can't, so you won't be able to, either." Given this, the most viable career path seemed to be teaching art in a local school district.

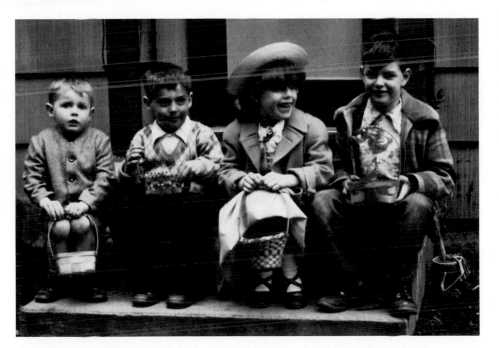

LEFT: *Art (at far left) with his siblings, Chuck and Grace, and their cousin*

PAGE 12 *Ultima Thule expedition members in front of Everest's North Face, Tibet*

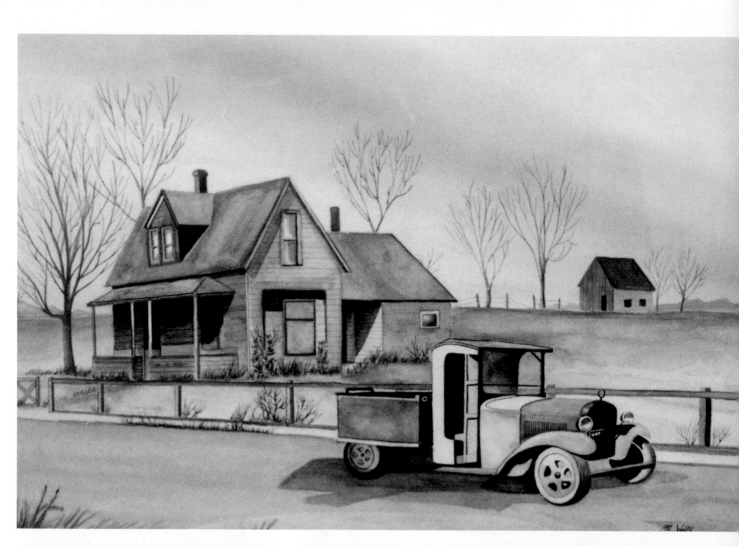

TOP: *Art's first sale: a watercolor made when he was 13 years old*

ABOVE LEFT: *As a young teenager, Art loved to hike in the Cascade Mountains with his dog, Wolfy.*

RIGHT: *One of Art's watercolor paintings of the Washington coast*

BECOMING A PHOTOGRAPHER

It was around this time that something happened to change the course of my life. As I was getting in to painting, I started to venture onto the higher meadows and glaciers of the Cascade Mountains. A friend's father got me into a climbing club, and I started to become part of a bigger community of climbers. I was climbing mountains on weekends, and I loved it!

While I was going out into the mountains and climbing, my parents gave me an old Konica camera they were not using. It had no instructions, though at the time, cameras were pretty simple compared to today—there were no extensive electronics, and no batteries were needed to power the camera. I started taking the camera along on my hikes and climbs. By 1976, I was taking many photographs on the weekends and on my climbs. I would go to art school during the week, and apply what I learned to my photography on the weekends.

My climbs in the mountains were not only a time for exploring photography but also for learning to understand and respect the natural conditions of the locations I visited. One Easter weekend on Mount Hood, I got a severe third-degree sunburn and missed a week and a half of college. So I learned to study the weather. For example, when lenticular clouds build up over Mount Hood, Mount Rainier, or any of the big volcanic peaks, you know to climb down. Every year people die on Mount Hood and Mount Rainier because they don't know how to read the weather. The mountains are so close to the coast that the storms come streaming in, leaving little time to react. I learned to read weather, predicting what was going to happen. This began a long tradition of staying connected to my surroundings. Inspiration does not come simply from seeing potential in a subject, but from connecting to the subject and setting in such a way that your photograph offers the viewer a richer, deeper experience. This point of view began in these mountain adventures.

TOP: *Mountaineering in the Cascade Range*

ABOVE: *Base camp on Mount Rainier, Washington*

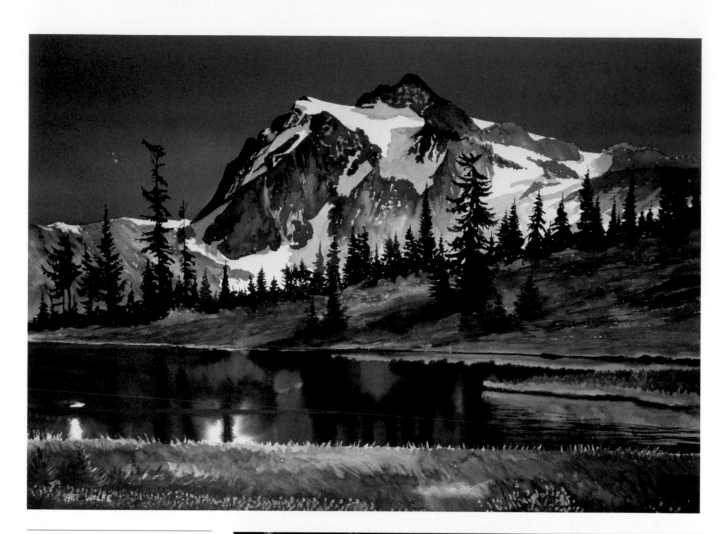

ABOVE: *Watercolor of Mount Shuksan*

RIGHT: *Mount Shuksan, Washington*

OPPOSITE: *Huang Shan, China*

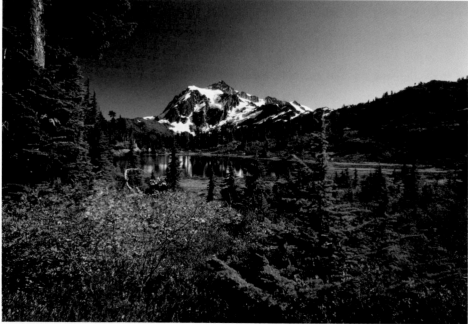

GREAT INSPIRATION

While in my late twenties, I became a program chairman for a climbing club. Part of the job entailed contacting famous climbers—people such as Jim Whittaker, Willie Unsold, and Tom Hornbein—to get them to come to the club and give talks. I became inspired by their adventures and learned much by watching how they spoke.

This led to an invitation to participate on the first-ever Western climbing team allowed into Tibet through China since the Cultural Revolution, the Ultima Thule expedition to Everest in 1983. This was an exciting prospect. China and Tibet were exotic locations with what seemed like amazing, compelling mountains.

I also had a dream to see what Lhasa was like, and dreams can inspire us to do many things. Lhasa sits in a river valley surrounded by the Himalaya mountains. Located at 11,830 feet (3,606 meters), Lhasa is one of the highest cities in the world. More importantly, it is at the heart of the Tibetan Buddhist culture and includes amazing architecture, such as the famous Potala Palace. During the 1950s, like so many young people at that time, I was surrounded by talk about the threat of Chinese communism. Tibet was part of this conversation and was a big unknown. I did not want to go to Tibet simply to stand on the summit of the highest mountain in the world. I had a dream to see what its culture was like—and if I had to spend time on that mountain just to see the people of Tibet, that's exactly what I would do. Lhasa was the place to do this.

The expedition to the top of the mountain was not successful, even though we spent three months at 16,000 feet and higher. The group reached 800 feet below the summit on the northeast ridge, but no higher. Part of the problem was there was no living person we could talk to who had climbed that high on that ridge. The twenty-two of us struggled up the mountain and collectively lost 378 pounds. The expedition returned to the United States without achieving its goal, but this was not a problem for me. I had had a grand experience that had tested my mettle. And, of course, I got to visit Lhasa and experience Tibetan Buddhist culture.

On the way back to the United States, some of the group stopped in Huang Shan, China. I had loved studying the Japanese and Chinese master artists in college, but their work showed such unusual landscapes that I was sure the Chinese *sumi* brush painters were either very imaginative or high on opium. The landscapes they painted were so fanciful, so magical, but also so fake looking! They seemed to be having a great time. And that certainly was an inspiration, even though it could not possibly be real, I thought.

Then I arrived in Huang Shan. I quickly discovered that these paintings were quite literal. Huang Shan was just like the painters had painted: vertical columns of rock surrounded by mist, with trees that were naturally bonsai-shaped by frequent winds. Huang Shan captured and captivated me. I had the feeling I was walking into a giant painting. Just to see this art transformed into a real world was astounding. Huang Shan so inspired me that it changed my life.

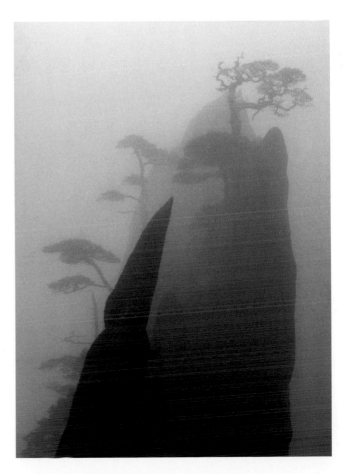

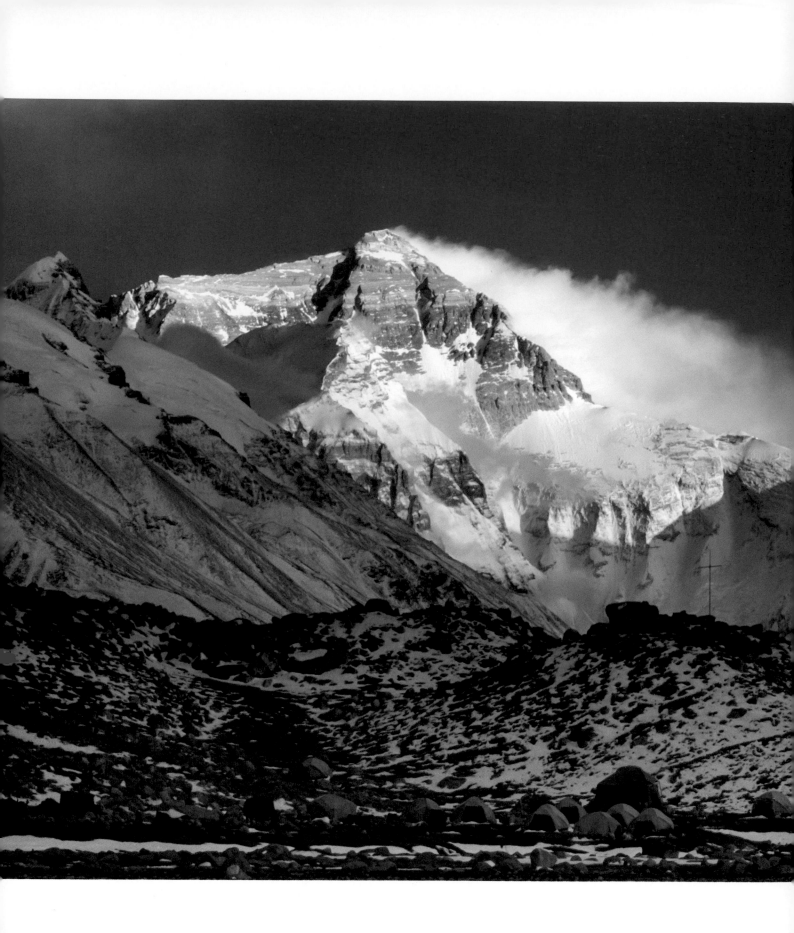

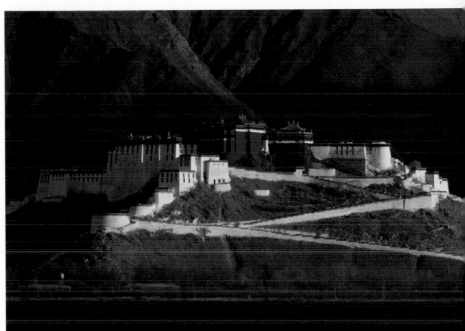

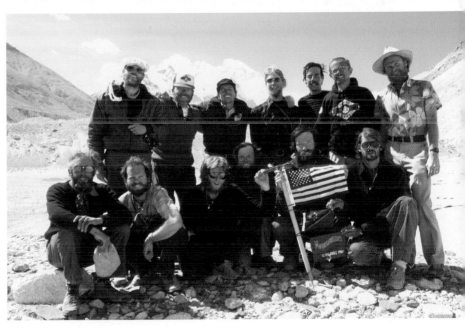

LEFT: *Base camp below Everest, Tibet*

TOP: *Potala Palace, Lhasa, Tibet*

ABOVE: *Ultima Thule expedition members, Tibet*

CULTIVATING INSPIRATION AT HOME

A few years after my adventures in China and Tibet, I bought an old house in West Seattle that no one wanted. It was covered in English ivy and had a very average grass yard.

But I saw its potential, and my time in China got me thinking. I started to bring pieces of granite into the yard as I could afford them. Transforming the yard became compulsive. Eventually, I brought in more than 100 tons of granite. At one point, I hired the largest mobile crane I could find in Seattle, which reached 200 feet into the air, and placed 12-ton boulders in my yard. My neighbors thought I was nuts! I also planted more than 300 trees and put in pools and streams. As a result, the garden has become a magnet for wildlife.

I am a nature photographer, and nature photographers are not known for their cash flow. What I put into this place was a lot of effort, time, and love for the beauty that is possible when you work to find it. The most expensive things that I bought were the bonsai trees. Every year I have to prune them, and get lost in the process. Of course, when you prune a bonsai tree, it attacks back, so afterward I am always decorated with pitch for two weeks.

Even though the English ivy is long gone, I am still thankful for it because it hid the house from all other prospective buyers. It took me two years to eradicate the ivy, but the work is never done. Now I'm working on the wild clematis, which threatens to become even worse than the ivy if it is not constantly cut back.

Many nature photographers eventually leave the city to live in the country. But after transforming my small city lot into these amazing gardens, I have decided to stay in the city. The trees I planted are now more than 60 feet tall.

As for the house, which was built in 1910, I have worked to turn its original Tudor design into more of a Craftsman style, though I kept the original lines. Over the years, I have continued to refinance and upgrade. You as a visual person don't have to be this compulsive, but try to live in a space that uplifts your spirit.

When I come home from a trip, after being strapped to a plane seat for 48 hours, I am bone tired and grumpy. But as soon as I arrive home, I am instantly transported to the nature and art that fills the space where I live.

Everything in the house is fairly inexpensive: baskets from around the world, antlers found in the Olympics, knick-knacks collected over the years, and my photos. They are all remembrances. As much as I can, I work to surround myself with the aesthetic that inspires me and nurtures my soul.

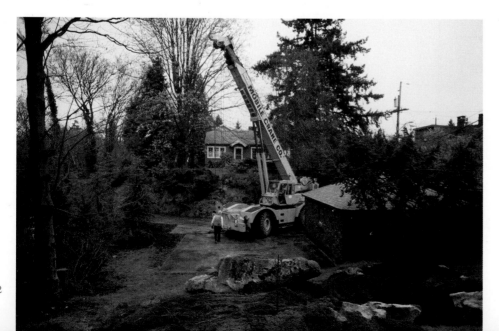

LEFT: *Landscaping Art's yard, Seattle, Washington*

OPPOSITE: *Resident sharp-shinned hawk*

OPPOSITE, BELOW LEFT: *Art's yard today*

OPPOSITE, BELOW RIGHT: *Resident great blue heron*

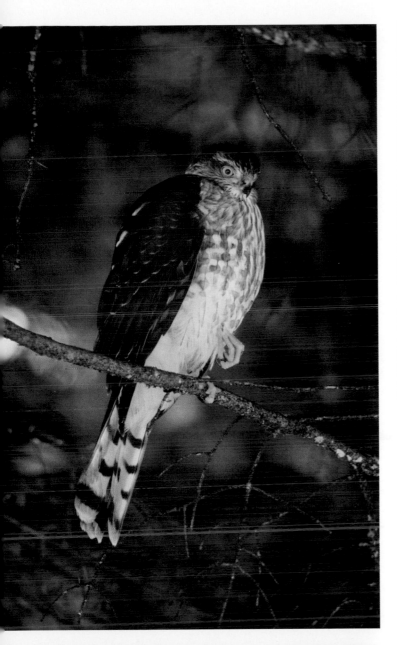

The Native Garden

Not all nature photographers live in the wilds. In fact, both of us live in urban areas but enjoy creating inspiring gardens. Our yards provide us with connections to the natural world as well as places to play and experiment with photography close to home.

Much of both of our gardens is based on native plants. Native plants connect you with the wilds of the area you live in and have a lot to offer, including beautiful flowers throughout the growing season. Natives also attract a variety of birds and insects, even mammals. Exotic plants can create sterile environments for interesting bugs, or be too attractive to insects and demand toxic sprays. Natives attract a balanced variety of insects, from pollinators to predators, bees to butterflies, so are less likely to attract problem insects that can take over your garden.

Once you have a garden or natural outdoor space at your home, it's easy to set up a camera and go outside! Gardens can also be useful stress-relievers. Going out and concentrating on the amazing insects that visit the flowers in the garden can put you in a better mood, lifting your outlook on life and nature. Focusing through the camera on a composition of native flowers, or trying to follow a native bee, might just keep you grounded and thankful for the beauty of life all around us.

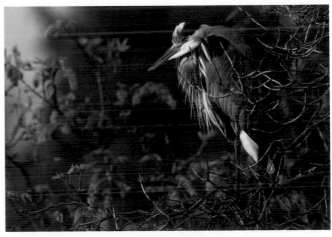

OVERLEAF: *Bonsai on Art's deck*

INTEGRATING YOUR LIFE

All of these experiences—my childhood days playing in wooded ravines, experiencing Huang Shan, and building a beautiful, wildlife-filled garden in the city—are connected. They are important parts of my life that inform and inspire my photography today. They are also integrated into many aspects of my life. I strongly believe in striving for an integrated life. Everywhere I go on my property or in my house reminds me of what I am all about, from the environmental groups that I support with my photography to the places that I go when I am *not* working. It's an old climber's ethic: I am constantly drawn to the outdoors, to the mountains, to the wild places.

What about you? Is your life integrated with the things you love and care about? Does your home show off who you are? This does not mean that you have to become a full-time, professional photographer, but it does mean that if you care about photography, it is important to consider how your environment affects you.

If you live for photography but have none of your work hanging on the walls, or if you live for nature but have noth-ing that reminds you of nature in your home, then there is a disconnect. We all live with stress; the economy, world affairs, the environment—all of these things stress us out. I seek comfort in taking pictures and I have comfort in how I live. Everything in my house, every view from my home, reminds me of what I am about. You can do the same.

This does not have to be an expensive endeavor. I collect rocks from riverbeds that have patterns and lines, and put them in my garden. Looking at them uplifts me. The water that flows down through the garden is very comforting, just the sound of it. Remember, this is a city-lot garden, so it is not a huge place. It's a small property that is on a bluff and has a view out to the water. Yet this house sat on the market for more than a year. People would drive up and they couldn't see the house—every inch had succumbed to ivy. Now, raccoons, fox, and coyotes come to visit. The window in my den looks out over the garden. I can sit there, drink a glass of wine while reading a book, then look up to see the sharp-shinned hawk that comes every day to drink water from one of the pools.

THE INFLUENCE OF ART

In art history class during college, I studied pieces from 3,000-year-old Venus figures to modern abstract expressionists, and everything in between. This included the French painter Georges Seurat, famous for his painting *A Sunday Afternoon on the Island of La Grande Jatte.* Seurat built up his canvases with little points of color. If you explore his work, you'll see that blacks are not simply black but are made up of blue and orange. He has incorporated complementary colors into his world.

Why is that important? How is that relevant to a photographer's inspiration? As a photographer, you will go out with these collections of ideas, visual content that's locked up in your brain. These ideas influence how you see the world around you, and ultimately, how you photograph.

When I am out and about, thanks to my exposure to Seurat, I may see a pointillism "painting" ready to be photographed. Imagine a photograph with many points of color, a flat tapestry of color and no leading lines or horizon. It is a very distinct style of photography. I may never have noticed this potential for a photograph without having been exposed to and inspired by Seurat and pointillism.

On the other hand, I wasn't all that intrigued at the time by Picasso, Braque, and cubism, thinking that cubism was a big goof. Remember, I was a literal painter. I painted what I saw, perhaps one reason why I made the transition to photography so easily. Over the years, however, I have evolved to being much more impressionistic and abstract. Eventually, my awareness of cubism led me to see a composition in a group of overturned boats along Lake Baikal in Siberia. And being familiar with Salvador Dali's surreal landscapes enabled me to find surreal landscapes in the Namibian desert, as shown on page 29. You will find inspiration in art if you just look, if you open yourself up to possibilities.

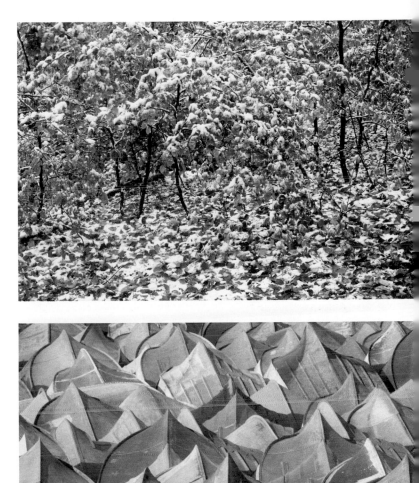

TOP: *Newly fallen snow breaks up the color of fall leaves in a scene reminiscent of pointillism, Sweden.*

ABOVE: *Boats in winter storage, Lake Baikal, Russia*

OPPOSITE: *View from Art's den*

You probably know Grant Wood's iconic painting, *American Gothic,* which portrays a couple in front of a house, the man holding a pitchfork. I didn't think much about this picture over the years, but while traveling through the mountains of Turkey, I saw an elderly couple collecting wildflowers from vast fields there, intended as feed for their cattle. Through an interpreter, I asked them to pose, stylizing the composition to reference *American Gothic* (see page 30).

Another artist who has inspired me a great deal is the Dutch artist M.C. Escher. Escher is known for unique patterns that play with our perceptions, often showing something that looks real yet is impossible, such as a waterfall that flows down and then seems to wend its way back up, or a pattern of ducks that changes into a pattern of fish. (To see examples of Escher's work, visit mcescher.com.) In Escher's compositions, positive space becomes negative and then positive again. There is a sense of playfulness to his work, an originality that has always appealed to me. I tried to pay homage to him through the photographic medium. In 1994, I published a book called *Migrations*, which features images showing the patterns of life, which became a lightning rod on the world stage.

By this time, my nature photography was being published in *National Geographic* and *Audubon*. But I also had a deep-rooted interest in art history. Along came digital technology. In *Migrations,* I decided to alter the content in about 30 of the book's 100 images to reflect this art-based approach.

For example, in one image of a zebra herd, my technical crew and I filled in gaps by adding new animals from behind. That particular image became the cover of the book. Most of the book's photos were unaltered, and when photos were changed, the adjustments were usually minor in order to complete a pattern. In a photo with 100 flamingos, for example, we may have added four to fill a dark space.

This was at the time when Photoshop was just starting to be understood by photographers. The technology scared a lot of traditional photographers, especially nature photographers. They thought it would create something removed from real nature, and my work in *Migrations* was seen as blasphemy. I had hate letters coming in, and some prominent nature photographers attacked me personally without understanding what the work was about. I was condemned by colleagues yet also praised by art designers, and the book won several awards.

I knew the book was going to be controversial, so in the introduction, I stated quite openly that it contained digital illustrations. However, I quickly discovered that no one reads introductions. Truthfully, the book was an art book strongly inspired by M.C. Escher.

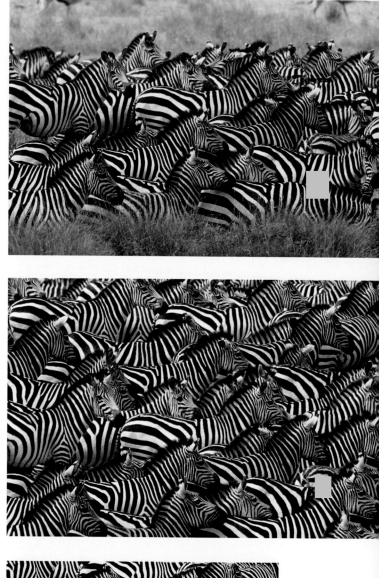

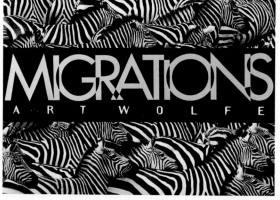

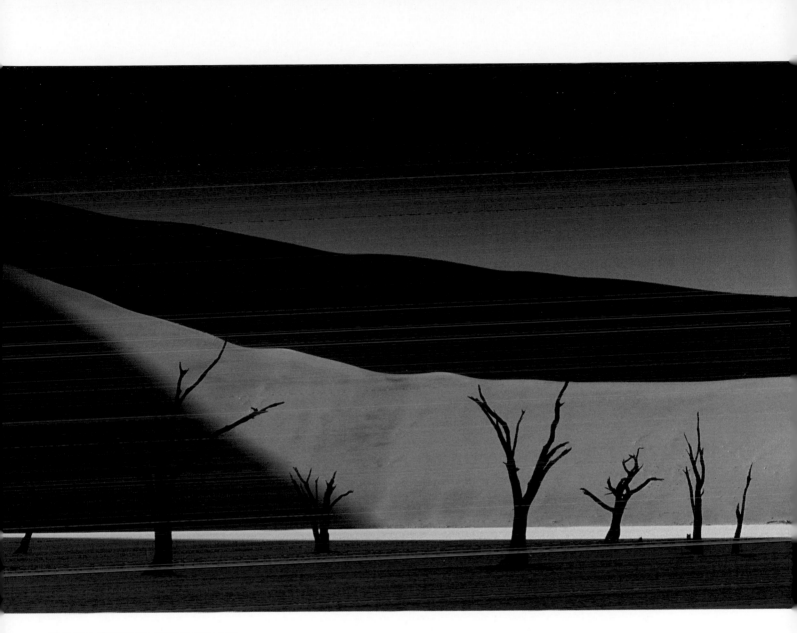

ABOVE *Deadvlei, Namib-Naukluft Park, Namibia*

OPPOSITE, TOP: *Zebra migration, original*

OPPOSITE, CENTER: Zebra Migration, *fine art photographic print*

OPPOSITE, BOTTOM: *The cover of my book* Migrations

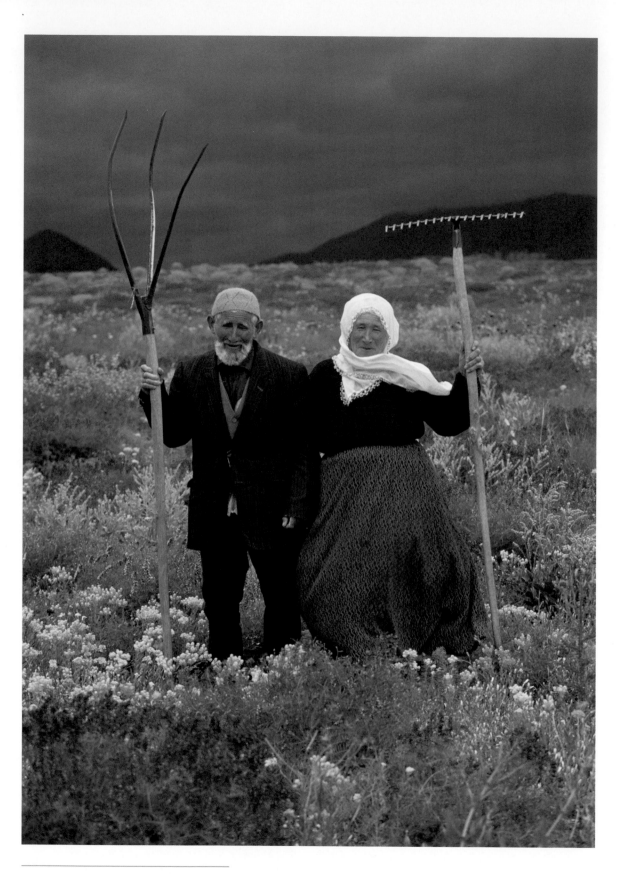

Farmers, Cappadocia, Turkey

| the art of the photograph

ADDING YOUR OWN SLANT

We all have unique experiences and points of view, yet none of us creates anything entirely original. Like all artists, we are inspired by other people's work, whether that of historical artists or the people around us today. The trick is to take what you can from the source and put your own slant on it.

I once led a raft trip through Northern Canada with Robert Bateman, a Canadian wildlife painter. Up until that point I had photographed many animals as trophies. I would get as close as possible to the bear, eagle, or elk, for example, and take a classic portrait. I was like a hunter but with a camera instead of a rifle.

As we traveled down the Taku River, I asked Bateman why he was photographing everything on the sand dunes along the riverbank. Bateman said that if he was going to go home and paint a picture of a coyote in sagebrush country, he wanted to get the details right. He was painting pictures of animals within the context of their environment.

This lead to a series and book called *The Living Wild*, where I started shooting broader perspectives, giving context to the animals by showing their environments. Thanks to Bateman's inspiration, I became a better photographer.

As with all things, learning about and exposing yourself to art, people, and experience can help you connect ideas in your brain to what is in front of you.

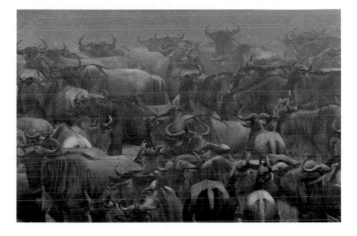

Wildebeest migration, Kenya

What Is Your Inspiration?

1. Do you have a place in your home to display things that inspire you from nature and other cultures?

2. Do you have a garden or other place that offers inspiration and respite, a place where you can go to relax and photograph?

3. When was the last time you went to an art museum? What inspiration can you find there? How can you take what you see and put your own spin on it?

4. How did growing up affect what you photograph today, and how can that knowledge take your photography in new directions?

5. Do you admire certain photographers? How can you use that admiration to inspire your own work—not copying it, but finding your own way to use what you like about the photographer's work?

6. What do you seek out for your photography? Is it the subject matter, or do you find photos that transcend the subject and create something special for you and the viewer?

ORANGE WALL AND SNOW:
Being Alert to the Special Moment

I am a romantic at heart. I love to photograph traditions; I love to photograph nature. I love to photograph things that nurture the soul. A lot of this chapter has been about what nourishes my soul and inspires me.

This is a photo that I would never have taken four years ago, because I simply would not have seen it. The orange would have been too garish for my color palette. But I am still maturing, still finding inspiration from the world around us, and seeing things that I may not have seen a year or two ago.

I was on my way to interview a monk during the filming of *Travels to the Edge,* my television series, when I walked by this Shinto shrine that was bright orange, a color revered by the Shinto religion. The snow had just stopped falling, and the color was so intriguing. It had some of the Asian influences that I have been inspired by, but with the color, there was more.

The monk was waiting, standing in the snow in his wooden slippers, so I started to walk away, but then thought better of it and said to myself, "No, I had better get it now."

I took one click with the camera, went and interviewed the monk, came back to shoot this subject exhaustively, and then it was all gone. The wind picked up, the snow dropped off, and it was over. The black branches on their own against the orange wall would not have done it; it was the combination with the white that made it happen.

—Art Wolfe

Koyasan Winter, *fine art photographic print*
EF70–200mm F4L IS lens, f/16 for 1/10 sec., ISO 125

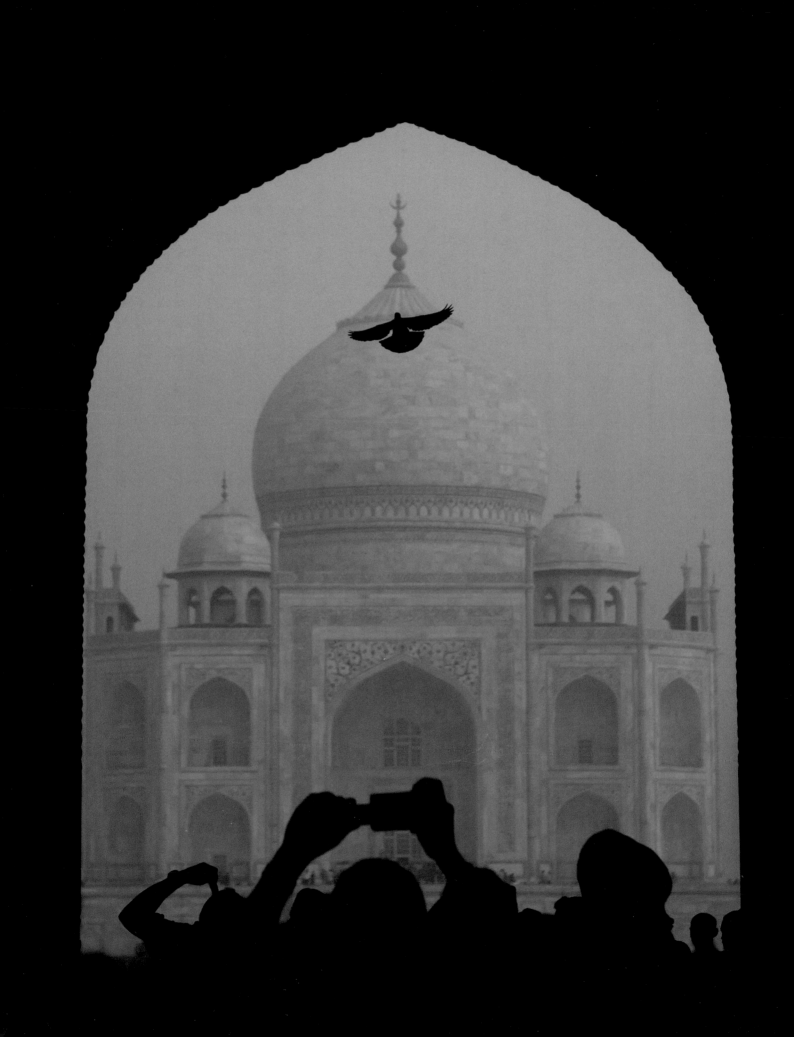

DISCOVERING THE SUBJECT

Edward Steichen was one of the great photographers of the early twentieth century. His quote below has a little bit of that Yogi Berra quality to it, but there is also great truth here. Once you make the decision to really look at the world through your photography, the world opens up to show you even more things that are possible.

Every photographer faces the challenge of discovering the subject. When you go out looking for photographs, the world can seem like a chaotic place. There is so much going on that you might wonder how you can make anything out of it. You have probably had this challenge. You've done Yellowstone, the Grand Canyon; you've spent a lot of time photographing whatever natural area is close to you; but you are losing inspiration. This book is about opening up your imagination. There is a huge world out there to find and photograph. Discovering a photograph that works starts with how you think about that world around you.

"Once you really commence to see things,
then you really commence to feel things."
—Edward Steichen

PHOTOGRAPH WITHOUT PREJUDICE

What are you seeing as you photograph? How do you perceive the world and what's important to you? This is something that goes much deeper than thinking about getting the latest camera with the most megapixels. Good shots come from cultivating the eye. Scrutinize every subject without prejudice. A good photo can be found in rusting debris lying in an alley of a big city or out in a pristine environment. Finding images everywhere is how you practice, how you improve your work. It's about the subject only in how you frame it, and in the message you send with the photo.

Do you shoot any possible subject, whether a rusting can in a gutter, a grand ceremony in a foreign land, or birds on a beach? Or do you define yourself as a "bird photographer" or a "landscape photographer"? Try not to limit your subjects or how you define yourself as a photographer. Photographing without prejudice opens up the world! You can't even walk into a grocery store without finding a viable subject. And along the way, you gain practice that cultivates your eye.

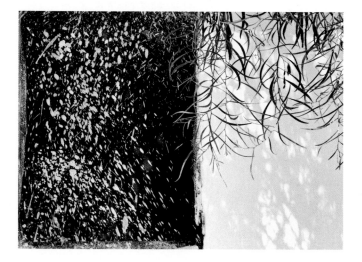

PRACTICE MATTERS

You might think that composition comes naturally for professionals like us. Naturally, perhaps, after many years of doing it! There is no question that if you are to succeed as a photographer, you have to take a lot of pictures. This is sometimes frustrating for people who have invested a lot of money in the latest gear and want instant results since you have to take a lot of both good and bad photographs to get better.

There is an old joke about a visitor to New York City trying to get to a concert at Carnegie Hall. After getting a little lost, he saw a man walking down the street with a large cello case. He stopped the musician and asked, "How do you get to Carnegie Hall?"

The musician looked sternly at the visitor and said, "Practice, practice, practice."

A concert pianist rarely gets up on stage and gives a bad performance, but only because he or she has had years of practice. That isn't to say that you can't get good pictures at whatever stage you are in, but it does point out how important it is to get out and take lots of pictures. Practice does matter.

LEFT: *Paint-splashed house, Morocco*
70–200mm lens, f/18 for 1/4 sec., ISO 125, converted to black-and-white

PAGE 34 *Taj Mahal, India*
24–70mm F2.8 lens, f/4.5 for 1/1000 sec., ISO 800

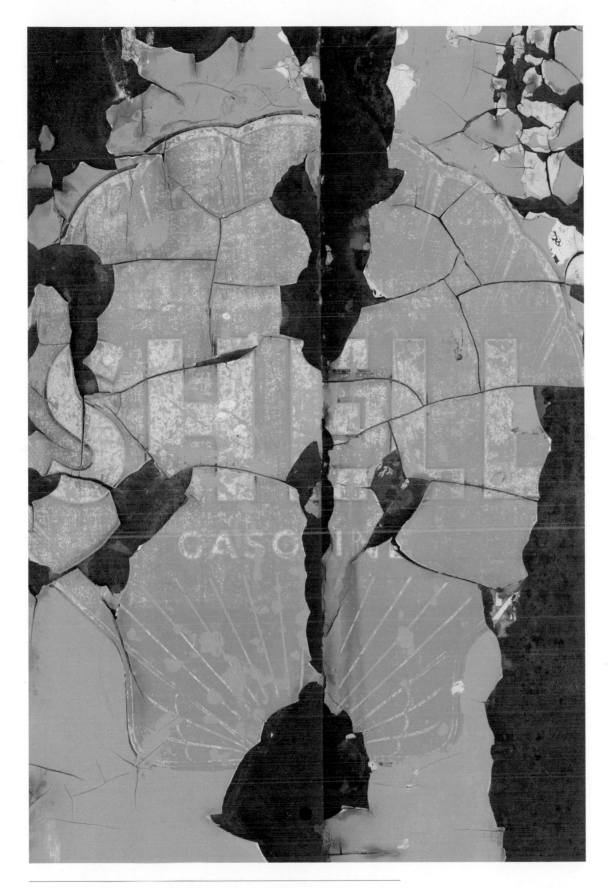

Abandoned gas pump, Bodie State Historical Park, California
70–200mm lens, f/20 for 1/6 sec., ISO 100

THE SUBJECT OR THE PHOTOGRAPH?

One thing that can hold photographers back from finding great images is that they focus too hard on finding the "perfect" subject. Whenever possible, try to avoid "trophy hunting" for subjects. That means going out and trying to find the same subjects that photographers like Art Wolfe shot, or going to major locations and photographing only the big, iconic subjects. Think about that. You can buy postcards of those big, iconic subjects that were shot under ideal conditions. When you start looking for subjects simply as trophies to be captured, you stop looking for the photograph.

If you simply look for subject matter, you'll often be disappointed because the camera is not looking for subject matter. The camera doesn't care what your subject is! The camera is simply looking at light and shadow and how to translate that into pixels. It is your job as a photographer to work with your camera to find interesting photographs, not simply to capture a subject.

As noted in the previous chapter, looking at the art world outside of photography can be instructive. Painters have to figure out what the *whole* image is going to be, not simply the subject. They have to interpret a scene in a certain way on their canvas, rather than simply pointing a camera at a subject and pressing a button. Seeing through that "lens" can help you navigate the challenge of finding original compositions in the world you walk through every day.

Notice that in this book there are very few photographs of the big, iconic subjects that so many others shoot. Art looks for and finds subject matter that is going to translate into interesting photographs that appeal to him. He responds to the world around him as a place filled with photographic possibilities because he is not simply looking for an interesting subject. He is always looking for interesting photographs.

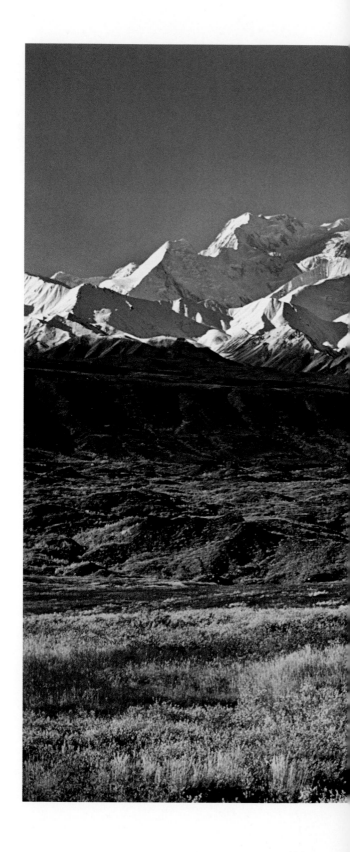

Moose, Denali National Park, Alaska
70–200mm lens, f/16 for 1/8 sec., Fujichrome Velvia

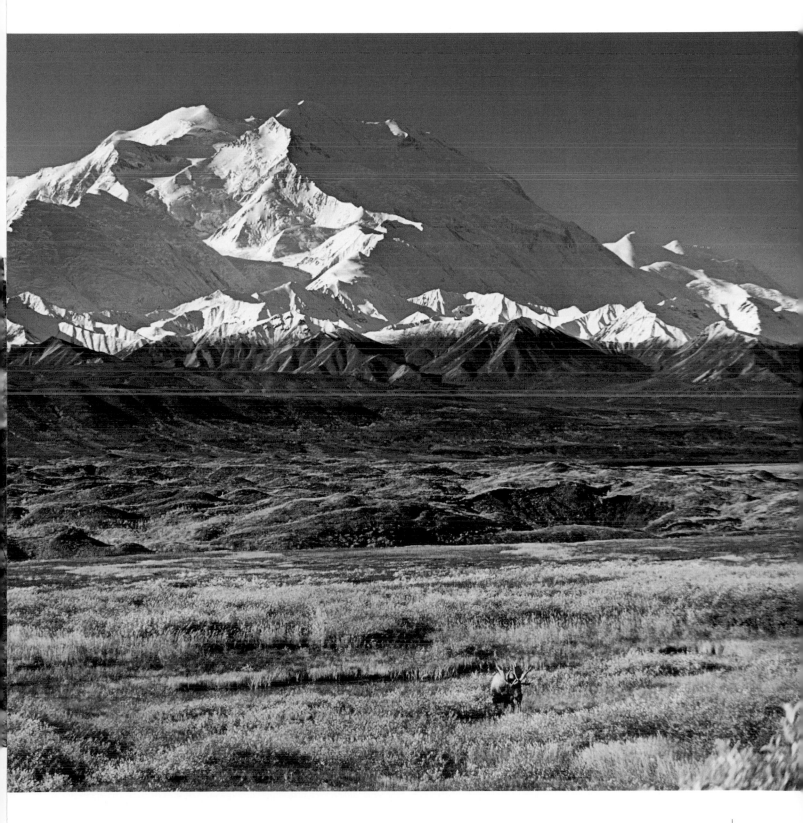

VISUALIZATION

The term *previsualization* is usually associated with Ansel Adams, though later he revised this to simply *visualization*. Adams defined visualization as "a conscious process of projecting the final photographic image in the mind before taking the first steps in actually photographing the subject" (*The Negative,* 1981). Basically, this means having an idea of what your photograph will look like as you look at the world around you. You start to visualize an image from all of the visual choices that appear in the world.

Digital photography has been a great boon to photographers learning to visualize how a scene translates into a photograph. You can look at that scene in your LCD while you still have the subject in front of you. You can compare what you see with what the camera is actually able to capture.

We often become aware of the subject first. This is completely natural, even though, as discussed earlier, you are after the photograph, not simply the subject. At this point, many photographers will start thinking about what exposure to use, what focal length to use, and so forth—the technical aspects of the picture. It is very easy to get caught up in technical things like megapixels and to forget that the ultimate goal is to create an interesting and dynamic picture that satisfies you and your viewers. We debated including technical information about the photos in this book because that can be a distraction from what is really important about them. What difference does it make if a photo is shot at f/8 or f/16 if it has no effect on you?

Until you have an idea of what you want from a subject, technical decisions are rather arbitrary and less than helpful. This comes from your heart, from what you are passionate about. Finding the best subjects and creating your best photographs starts when you look for photographs that connect with your heart.

Both of us critique a lot of photographs, and there are some universal themes. A very common problem we both see is that there's a subject, such as a bear, a flower in a field, or a boat in a harbor, and people tend to zoom in and think only about that subject. But the subject is just the starting point. You have to think about the framing of that subject, visualizing it as a photograph. This process is at least as important as the subject itself.

Of course, the technical aspects of photography are important because they affect how you actually take the picture. That's the craft of photography. But it's important to keep the craft in a supporting role, rather than as the goal unto itself.

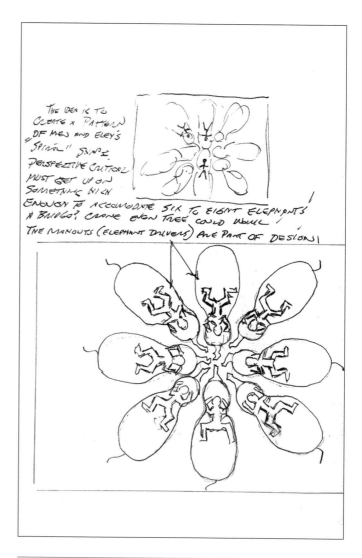

Art's sketch of mahouts, showing his visualization of an image

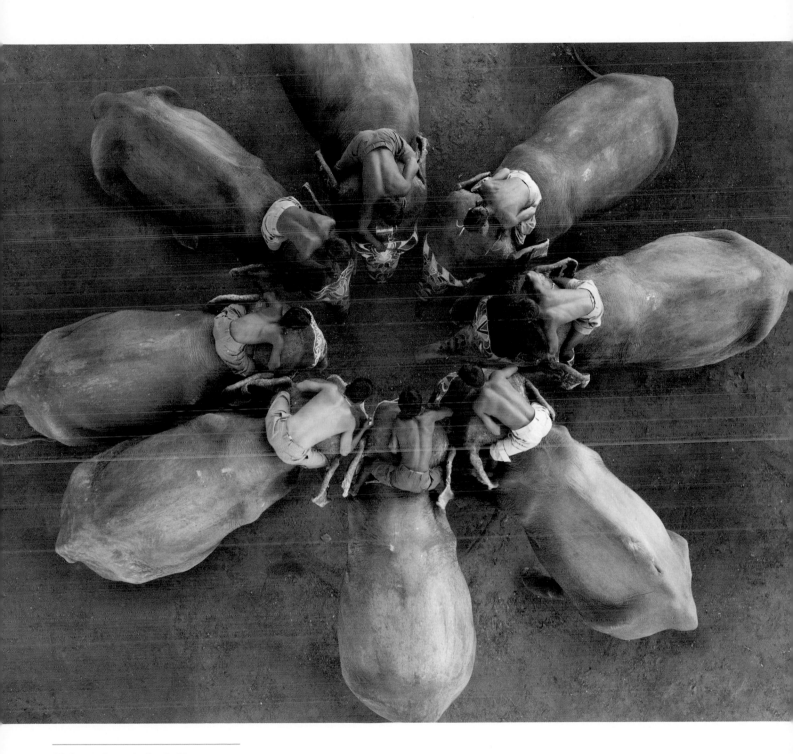

Mahouts in a circle, India
16–35mm lens, f/4.5 for 1/100 sec.,
ISO 400

HOW WE SEE

Notice the first image shown opposite, of two white triangles in the center. With those subjects in the middle, the eye rotates around them without anchor. That's not a good thing! For the record, you do not want that.

Think about the framing. That box, that square or rectangle that holds the image, is as important as those white triangles inside. When you're framing a shot, you need to be very aware of that entire rectangle.

Right now these white triangles, the "subjects," are positive space, while all the black is negative space. Generally, positive space is the space occupied by the subject and negative space is the neutral space of the background and surroundings that help define it. Positive space and negative space often have a very strong influence on how people see photographs. In the framed image, opposite, top right, the negative space is not working at all with the subject.

Now let's zoom in and anchor the subject, so the dark area, that triangle of black that you didn't see before, is every bit as visible as the white triangles were before. There is now a balance to the image. Do you see an inverted triangle? There is no triangle there. You see an inverted triangle because your mind is filling in the gap. That is a powerful tool to use— playing with perceptions in the space of an image.

Have you ever seen the arrow shown opposite, bottom left? You may have seen it before but not recognized it. FedEx designed its logo to create a subtle, unconscious feeling of movement. Most people never see it until it is pointed out to them, even though it is a key element of the logo and affects our feelings about FedEx.

Finding that arrow is a great metaphor for finding the subject. It's the point where your mind and subject connect. Most of the time, it is easy to walk right past the best shot because you are not connecting with it. We see the obvious stuff—we see Mount Hood at sunset—but miss all of the other shots that can be so valuable to you as a photographer. For us, the most rewarding shots are the ones that most people would not see.

TURNING NEGATIVES INTO POSITIVES

What do you see in the black-and-white abstract image here? It appears to be an abstraction of what might be some strange buttes in a foreign land. Or perhaps it looks like a cartoon drawing of something. It is the Great Mosque in Mali. Art turned a straight shot upside down and removed the color. But notice that in the inverted image, the white comes forward. It is the positive in the image, but in fact, was the negative space for the real scene!

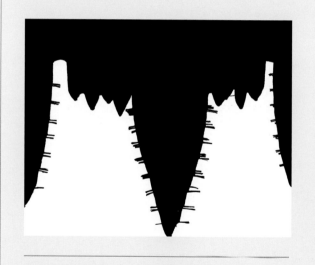

Detail of the Great Mosque, Djenné, Mali, inverted and converted to black and white
70–200mm lens, f/16 for 1/320 sec., ISO 400

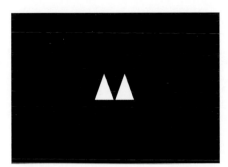

Subject in the middle

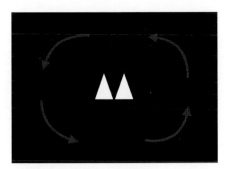

Our eye rotates around an unanchored subject.

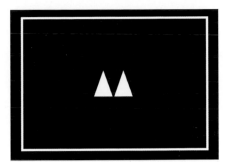

Framed subject

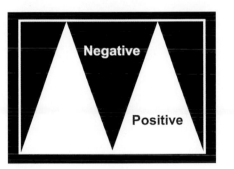

Positive and negative spaces

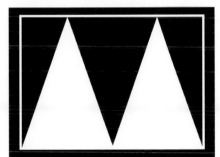

Anchored subject

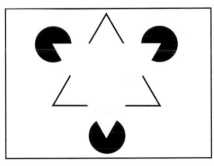

Optical illusion of inverted triangle

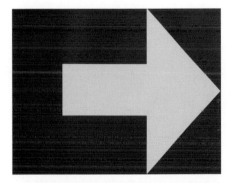

Arrow in Federal Express logo, New York City
70–200mm F4L IS USM lens, f/4.5 for 1/50 sec., ISO 400

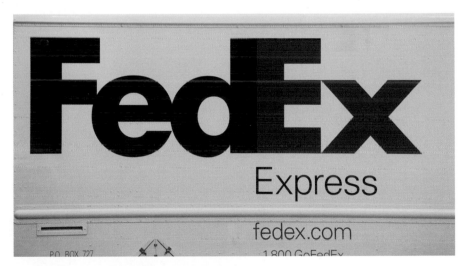

Federal Express truck, New York City
70–200mm F4L IS USM lens, f/6.3 for 1/160 sec., ISO 200

WORK THE SUBJECT
TO FIND BETTER IMAGES

You might think that the only time pros photograph is when they are in some exotic location on a quest for new images from the area. Truthfully, most pros are always going out and challenging themselves to see things differently. We often set up little self-assigned challenges to do this, and you can, too.

Here's an example of such a challenge, when Art had to make a photograph illustrating positive and negative space. The subject, shown below, is a pile of rocks along the Strait of Juan de Fuca, not far from Art's home in Seattle. It shows that he has some talent for balancing rocks should the photography thing quit working for him.

Art moved to the opposite side of the piles and shot into the late-afternoon light, later converting the image to black and white (shown opposite, below). This image is very analogous to the two white triangles on page 45. The subject is in the middle of the frame and your eye rotates around it. There's no connection between all of the white space and the rocks.

Now what happens if Art zooms the lens and tightens up the image? As shown opposite, above, the white area is now balanced with the black. There is a balance between the posi-tive and the negative. When you look at really great photos, ones that have become famous, there is always a beautiful balance between the elements. They are not loosely composed; they are very carefully composed. One difference between an average shot and a great shot is that the great shot has been photographed with intention and carefully composed.

These rocks have become something more than simply rocks along the ocean. The image has turned into a modern-day abstract. This could be printed big in black and white, framed, and hung in a New York City gallery. It's become a modern abstract expression.

Work the subject. Find new approaches to it rather than thinking you have it all from your first view. Visualize different possibilities. Zoom in and out, move left and right. Discovering that if you take a step back, all of the elements have different relationships can be amazing. Don't be afraid to take lots and lots of photos. Once you own that camera and memory card, it costs you nothing to take pictures. And if you get some photos you don't like, there is always the delete button.

Rock piles, Olympic Peninsula
70–200mm F4L IS USM lens + 1.4x,
f/14 for 1/160 sec., ISO 500

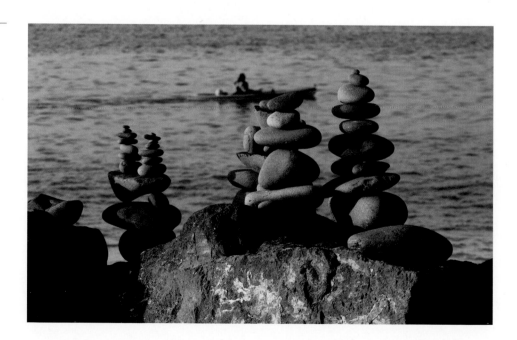

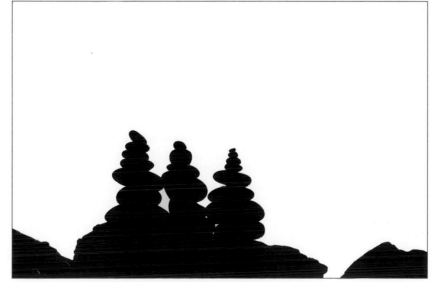

ABOVE: *Final composition of rock piles*
70–200mm F4L IS USM lens, f/22 for 1/100 sec., ISO 100

LEFT: *Rock piles, converted to black and white*
70–200mm F4L IS USM lens, f/22 for 1/125 sec., ISO 100

STAY WITH THE SUBJECT

We have both had the experience of asking students in a workshop to find a subject to shoot and giving them time to find something. It is surprising to us how many students simply walk to the closest tree and use that as their subject. They shouldn't even have taken their camera out for the first 15 minutes, instead using the time to walk around and find a subject that matters. Sometimes they complain about being bored after a short time. Yet they have barely begun to explore the area.

There is a famous story about the naturalist/scientist Louis Agassiz, a professor at Harvard in the late 1800s. He gave students a fish to study and left. After 30 minutes, he came back and asked what they had learned. The students were mostly bored, but offered some ideas. Agassiz told them to keep looking and this time left for a couple of hours. The students started discovering new things and were excited to share what they had learned. Agassiz came back, the students talked about their fish, and Agassiz told them to put the fish away for tomorrow.

The next day, the students again worked on the fish. One student wrote about this whole exercise (you can find it on the Internet) and told how amazed he was at how many new things he saw in this fish. Yet the first day, he had been bored and thought he had seen it all after working with the fish for 30 minutes.

You don't have to go to the extreme that Agassiz and his students did, but the lesson is clear. Spend time with your subject to really see it. If you start shooting just what you first saw, how do you know you did not miss something important?

Neither of us will come to an area and just start shooting. We always walk around, and don't even bring our camera out of its pack until we have found something that is worth the time. No matter how experienced you are, you can't make magic happen automatically. You have to work it. Walk around the subject, look at the light, the texture, how it all works together. And if it's not worth the effort, keep walking until you find something that is.

As an example, notice the image of willow limbs shown opposite, below. There is a beautiful gracefulness to the limbs, which are poking through a lake in the Cascades. First, you see one way of shooting it, but this is just the beginning. For one thing, there is nothing anchoring the image to hold and direct the viewer's eye. In the second image, shown above, Art came in closer, connecting and anchoring lines to keep the eye from rotating around the subject in the center.

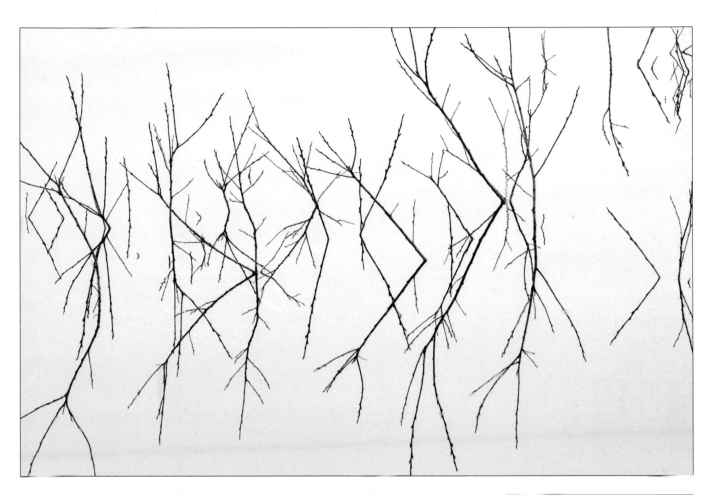

ABOVE: *Willow twigs, final composition*
500mm lens, f/12 for 1/25 sec.,
ISO 400

LEFT: *Willow twigs, original composition*
500mm lens, f/14 for 1/13 sec.,
ISO 100

MOVING BEYOND THE VISIBLE

As a final thought about discovering subjects, why limit yourself to what you can see? If everything you photograph is identical to what we see around us all the time, it can be deadly dull. Why not bring an element of surprise to the image? Try playing with long exposures, for example, to create something beyond what the human eye can see. Blurs from long exposures of moving objects, whether water, running animals, blowing grass, or moving people, can be fascinating ways of capturing unique images.

The image shown here is a long exposure of waves coming into the Monterey coast. It is not as you would see it; this is a five-minute exposure using a neutral density filter, transforming the landscape with waves. Notice the balance that exists between the light and dark areas.

Once you start experimenting beyond the visible, it's like Christmas all over again! Sometimes there will be really bad presents in the box, but sometimes there will be great surprises. Just keep shooting, knowing that there will be both but also expecting some of the surprises to be terrific.

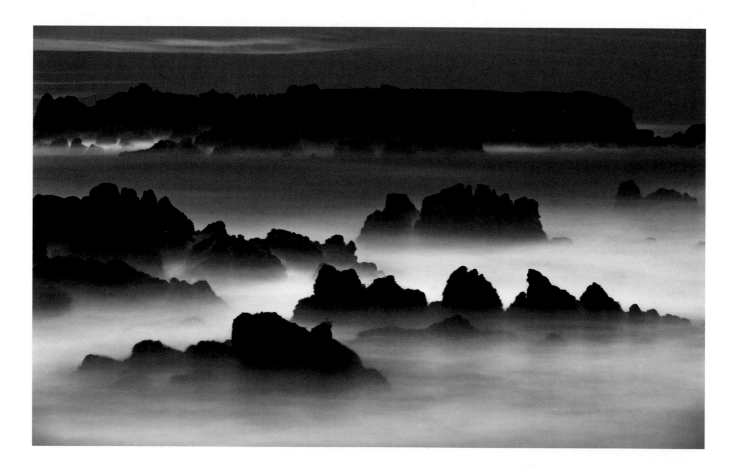

Coastline, Monterey, California
70–200mm F4L IS USM, f/8 for 195 seconds, ISO 100, converted to black and white

NEUTRAL DENSITY FILTERS

Neutral density filters are dark gray filters that fit over the front of your lens and cut down the amount of light entering the lens. They are not the same as graduated filters or split ND filters, which are dark in only half of the filter. It is impossible to get long exposures during the day without them. There is simply too much light, even when you use a low ISO setting.

Neutral density filters come in different strengths, and you can buy them in specific densities. A good one for photographers interested in capturing blur is a 3-stop ND filter, which cuts your light by 1/8th. So, for example, if you had a base exposure of 1/30 sec. at f/16, you would need an exposure of 1/4 sec. at f/16 with the filter. The 1/30 sec. shutter speed will not give you much of a blur unless your subject is moving very fast, but the 1/4 sec. speed would capture interesting blurs with many subjects.

You can also get a variable neutral density filter. These filters allow you to change the amount of density by rotating one filter over another. These can cut the light so much that you can have minutes-long exposures, even during the day.

Are You Discovering Unique Subjects?

If all you are doing is shooting photos that your photographic heroes shot 50 years ago, you are not advancing the field of photography. Be curious and try new things. Use your awareness of line and light, of positive and negative spaces, to enhance whatever subject you choose. It opens up the world. It keeps your visual sense alive, your eye and mind fresh. Ask yourself these questions to help you discover subjects:

1. Are you photographing without prejudice? Are you looking for a narrow range of subjects, or a diverse range of photographs?

2. Are you looking beyond the subject to find the photograph?

3. How do you define yourself as a photographer? Are you limiting yourself by a narrow definition, or are you open to possibilities because you are willing to go beyond a certain subject matter?

4. What is your unique point of view? How do you see the world differently from anyone else? How is that affecting how you discover subjects?

5. Which do you think of first: the photograph or the technology, such as how you make your exposure? Beware of arbitrarily imposing technology on a subject.

6. Do you stay with the subject? Do you let it speak to you about what it is and how you can best photograph it?

7. Do you work the subject, moving around, trying different focal lengths, angles, and so forth? Or do you find a subject, take a picture, and move on?

ALASKA'S AUFEIS: Finding Pictures When the Subject Changes

A challenge that nature photographers always face is the possibility of the subject not showing up! Then what? Do you just give up and try again another day? And what if there is no other day?

I am always looking for opportunities, always alert to discover new subjects beyond whatever I originally came to shoot. Anything can be a good subject with the right frame of mind. In one such situation, my crew and I were way up the Arctic looking to photograph caribou for my show, *Art Wolfe's Travels to the Edge.* It was spring, time for the caribou to be migrating. But there were no caribou.

Our group stood on frozen ice, *aufeis*, a German word that means "ice on top" and describes a layered mass of ice that builds up over winter. It is common in Arctic river valleys and has a unique texture and look.

Because it was spring, the ice and snow had begun to thaw, but the wind was blowing sand across the ice, making conditions dirty, cold, and miserable. And of course, there were no caribou, even though this was the landscape where the most caribou live.

I looked for a place to take off my pack so I could grab a sandwich while we waited for the uncooperative caribou. As I scanned the surface for that elusive clean spot to put down my bag, I started to notice something: a line. I started to think, "Is there something here?"

So I started to walk around with my camera and a macro lens. I started to see things not as dirty splotches on wet ice, but what they *could* be. I was abstracting what I saw into photographs that went beyond the subject. My mind shifted over to seeing and looking for calligraphy. There I was, standing right on it, and more and more it started to reveal itself. I became fully engaged in the patterns on the ice, realizing that I was, in fact, sur-

rounded by subjects that could take hours to photograph. They were everywhere: floral patterns, Japanese woodblock prints, ghosts and goblins, strange creatures—all right there.

At that moment, somebody yelled, "There's a caribou!" And I said, "*Forget* the caribou!" My mind had switched over to the strange, weird, and wonderful shapes—salmon skulls, even caribous, were on the ice. It can be a great feeling, when your mind switches over and allows you to discover new subjects.

—Art Wolfe

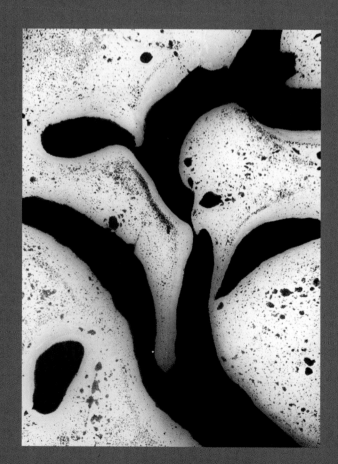

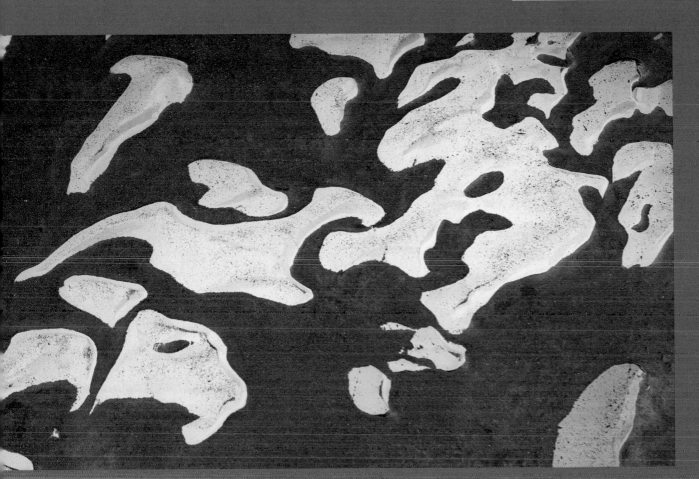

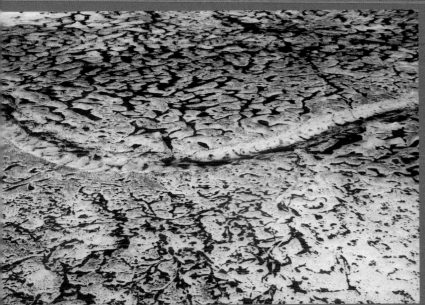

Aufeis, Arctic National Wildlife Refuge, Alaska

TOP: 24–70mm F2.8L USM lens, f/5.6 for 1/15 sec., ISO 50

LEFT: 24–70mm F2.8L USM lens, f/13 for 1/5 sec., ISO 50

ABOVE: 70–200mm lens, f/13 for 1/13 sec., ISO 50

OPPOSITE: 24–70mm F2.8L USM lens, f/5.6 for 1/40 sec., ISO 50

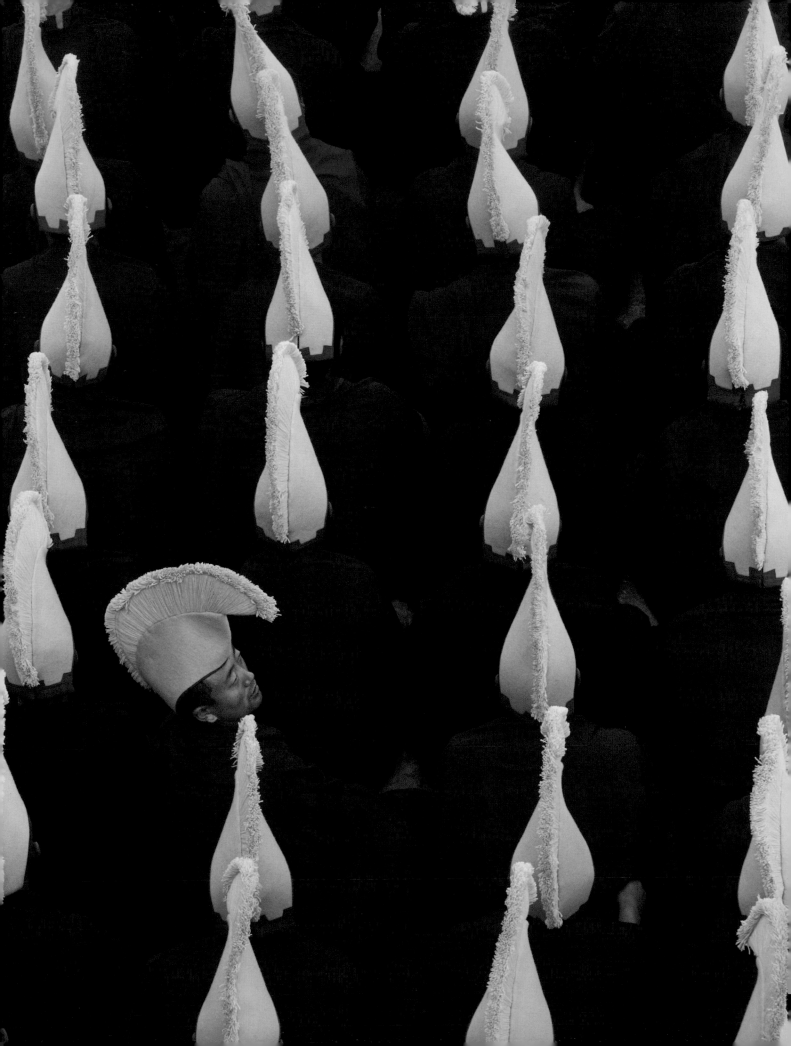

3

CONSTRUCTING THE IMAGE

With the high level of camera technology available today, many amateur photographers start out making better images than even pros might have struggled to create twenty years ago. That's the good news. The bad news is that this technology can lull you into thinking that if you have a decent camera and some basic instruction, all you have to do is find a good subject, point the camera at it, and you are done.

If you want better photographs, better compositions, you have to leave that attitude behind. Good photography does not come from simply capturing an image. It comes from constructing a photo, building it up visually in your mind. How you build anything depends on its structure, and the structure of your photo has great influence on your composition. Sometimes amateurs hear that and think that only pros can "structure" a photo, or that it will take way too much time. Neither is true. Any photographer can learn to build a better photo, and with just a little practice, you can work quickly and confidently.

"You've got to start looking for pictures nobody else could take. You've got to take the tools you have and probe deeper."
—William Albert Allard

POINT OF VIEW

It is simple for all of us to focus on gear and techniques—these things are easy to talk about. What's not as easy to discuss—but ever so important—is your unique point of view. This can be scary because it is personal. It means you have to put a little of yourself on the line with your photographs.

Point of view is important because it will help you get better pictures. As soon as you recognize that you are always creating something unique, you will start looking at each scene differently. You will look for the special elements of a subject that truly connect with you. As you capture these things in your photographs, you will also feel more connected to your images and the location.

One question all photographers should ask themselves is, "What is my photograph about?" This is not meant as a challenge, like, "What are you thinking?!" It's meant to reflect something all of us, as photographers, need to ask of ourselves. What, indeed, is our picture really about? The answer is not the subject. It goes beyond that. The point of view with which you capture an image can profoundly affect how the viewer emotionally attaches to the image.

Perhaps you don't think you *have* a unique point of view. You might think, "Oh, but I am just an ordinary photographer. I don't have any unique way of seeing the subject. I just want a good picture." We believe everyone sees the world differently, and photography is a way of expressing how you see the world. Being able to photograph subjects in different ways is an outstanding part of photography. You *do* have a unique point of view, and it starts with every subject you choose to photograph. It is then refined by the choices you make in composition, what you choose to emphasize, and truly what your picture is about.

So how do you find a distinct point of view for an image? Photographers often see a subject, set up the camera, then zoom in and out until they have framed up the scene. That's a pretty direct and straightforward way of taking the picture, but it might mean you are missing some unique aspects of your subject.

Take time to scrutinize the subject, searching for the most important element. What is your photograph about? What is it about your subject that grabbed your attention? Too often photographers just start adding things up: the photo is about the waterfall . . . and the mountain . . . and the clouds . . . and the trees . . . oh, and those flowers . . . and so on. This creates a confusing mess. What is your photograph really, truly about? What is most important?

Once you identify the most important element of your subject, strive to compose the image to emphasize that element. Emphasis is so important for point of view. Often photographers will pick positions that simply have a clear *view* of the subject, but don't have a clear *point of view*. In other words, everything in front of them has more or less an equal emphasis, or the emphasis is random because of the arbitrary positioning of the camera.

Looking for emphasis translates into very real decisions you must make when you compose the shot. Consider the two images shown here, of young girls in a nunnery in Myanmar. Shot from above, the top photo emphasizes pattern and color. That's what the photo is about—as much as the nuns themselves.

As the camera is lowered, we see faces. The point of view changes so that personality becomes part of the story of the photo. The focal length, exposure, and light in both photos is all similar. What has changed is the point of view, which affects the emphasis of the photograph, and thus what the image is about.

Another example is a shot of a fast-moving fire in Northern Australia that had been caused by lightning. Such fires, actually commonplace in Australia, are important to the ecosystem there since they revitalize the grasses and take out an occasional tree to keep the terrain open.

What would your point of view of this fire be? Would you just frame up the fire so it was the main part of the scene? In the image shown on page 58, Art deliberately took the picture from high above the ground, rather than low. He did this

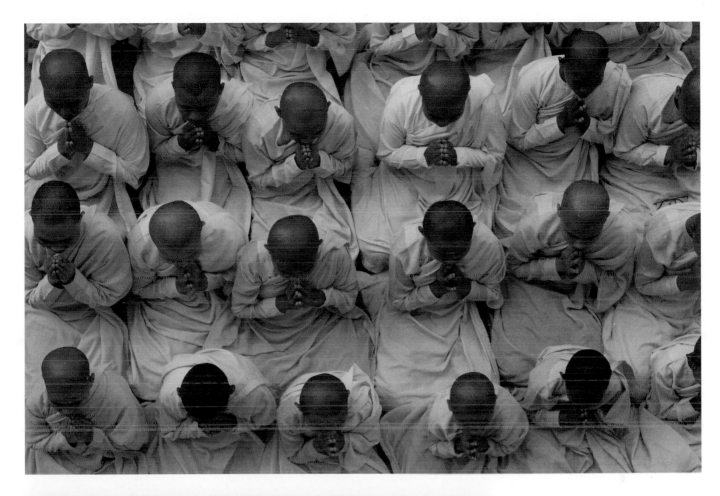

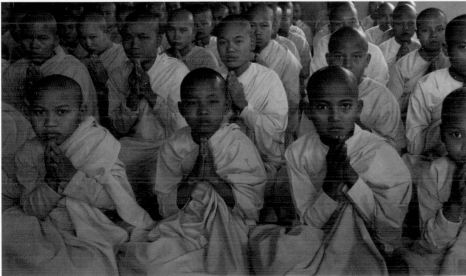

Buddhist nuns, Myanmar
ABOVE: 70–200mm F2.8L II USM lens,
f/16 for 1/25 sec., ISO 400

LEFT: 16–35mm F2.8L II USM lens,
f/14 for 1/5 sec., ISO 800

PAGE 54: *Buddhist monks,*
Kathmandu, Nepal
70–200mm lens, f/10 for 1/40 sec.,
ISO 200

so the fire would appear at the bottom of the composition, to emphasize all the light reflected on the trees. The source of the light—the fire—was also important, but not as the main emphasis of the composition.

Sometimes it is worth trying a unique angle of the subject simply to discover a unique point of view. Have you ever been to a location where many photographers were photographing a beautiful scene, all of their cameras lined up on tripods at eye level, more or less pointing in the same direction at the same thing? There aren't going to be many unique points of view from those photographers.

We believe in continually trying new and nontraditional points of view, often getting above and shooting directly down on subjects, or getting below and shooting up. Unusual angles create unusual compositions, which are also often the most memorable.

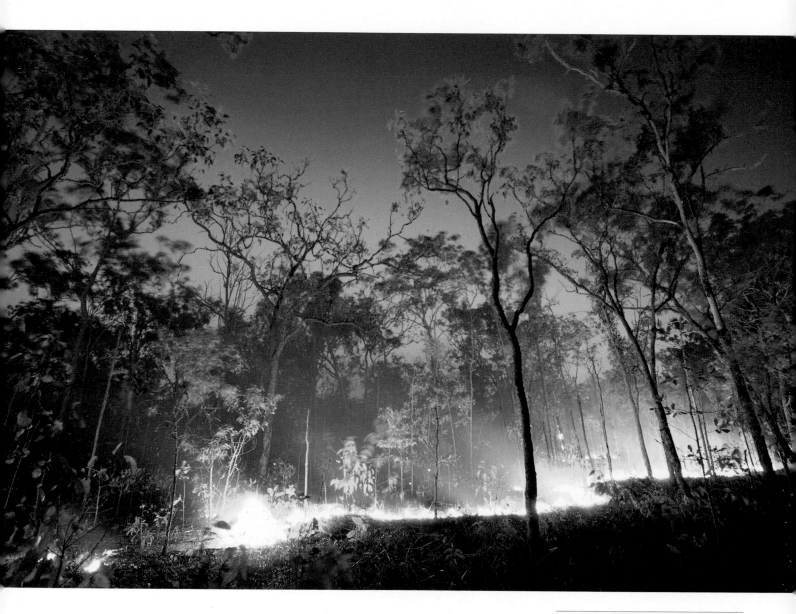

Bush fire, Arnhem Land, Australia
16–35mm lens, f/9 for 20 seconds, ISO 400

BACK TO PRACTICE

If you apply the ideas in this chapter while shooting a diverse range of subjects, and then study your photos afterward, you will see your regular subject matter in a different way and become a better photographer.

Practice can happen at any time. During one of Art's trips to New Delhi, he got up early to photograph people waking in the soft light of early morning. When the light became harsh, he headed back to his hotel in a rickshaw. That might have been the end of it, but as he rode back, he noticed an old wall that had been covered with layers upon layers of posters from years past.

Art saw something in that old wall. Details of the wall suddenly became abstract paintings full of lively color combinations. Was Art creating wonderful photographs that would instantly appear in books and magazines? Not at all. This is his practice. Images like these might serve no other function than providing interesting visuals for him to enjoy later, but shooting such photos constantly refines and enhances his eye.

Photography should be fun to practice, something you enjoy doing. As George Bernard Shaw said, "We don't stop playing because we grow old; we grow old because we stop playing." Play with photography, experiment with different subjects, and don't take it too seriously. There is a great feeling of accomplishment when you find photographs where others don't.

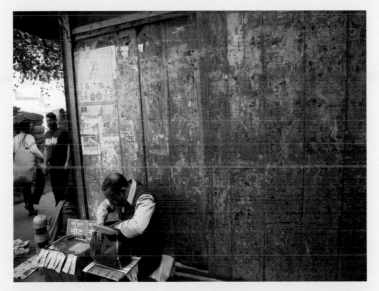

LEFT: *Street scene, New Delhi, India*
24–105mm F4L IS USM lens, f/4 for 1/80 sec., ISO 400

BELOW: *Close-up of wall, New Delhi, India*
24–105mm F4L IS USM lens, f/4 for 1/80 sec., ISO 400

ORIENTATION

Cameras are designed to be held and used horizontally. Unfortunately, horizontal and vertical compositions are not the same thing, so if you pay too much attention to how easily the camera works horizontally, you will miss vertical shots of the scene.

This is not simply a matter of changing your camera from horizontal to vertical. Nor is it a matter of cropping a vertical from a horizontal. Each camera orientation lends a different look at your subject, a different point of view, and a different emphasis, and deserves unique attention.

The basic way to use horizontal and vertical compositions is simply to look for them as you are photographing. Make the effort to turn your camera vertically and find a new composition after you have found your horizontal composition. Not all scenes will work both ways, but many do. Even if one orientation looks better than the other, you will discover all sorts of interesting things about your subject and your point of view simply by changing the orientation of your camera. You might discover, for example, as you change to a vertical picture, that parts of the scene you did not notice before gain emphasis. You might want to incorporate them into a horizontal picture as well. Regardless, the discipline of shooting both horizontal and vertical pictures will encourage you to seek out the best of your subject and not simply rely on the first way you see it.

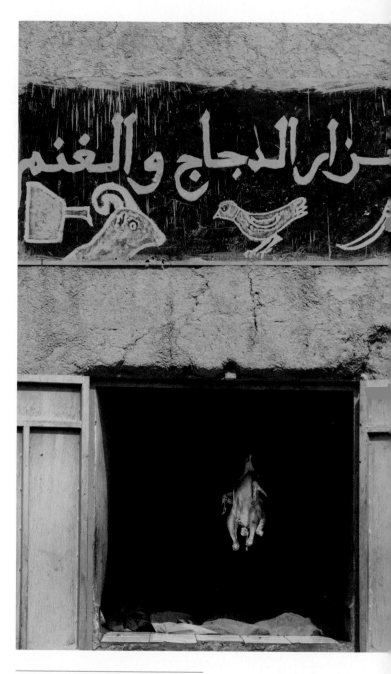

ABOVE: *Butcher shop, Morocco*
70–200mm lens, f/10 for 1/50 sec.,
ISO 50

OPPOSITE: *Butcher shop sign,*
Morocco
70–200mm lens, f/10 for 1/50 sec.,
ISO 50

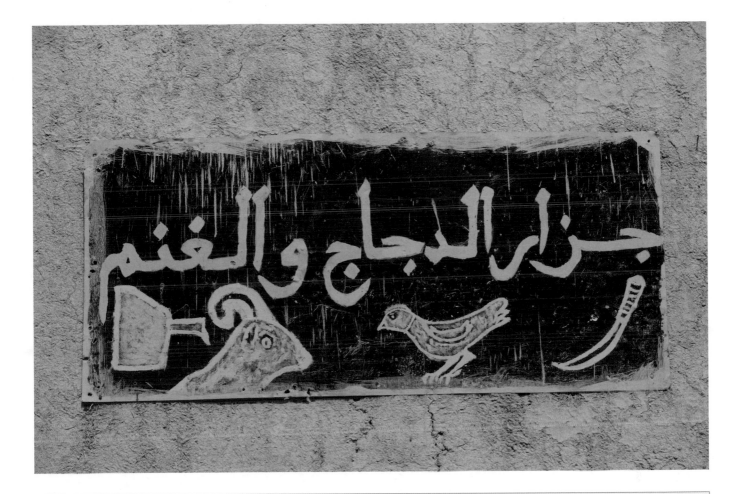

THE AUTO-ROTATION CHALLENGE

One thing that can keep you from getting your best vertical shots is the *auto-rotation* feature in your camera. Many photographers never change this from the default settings that come from the manufacturer. Frankly, the default settings are for snapshooters who don't care that much about their photography.

Auto-rotation takes your vertical picture and rotates it to display upright and vertical in the horizontal orientation of your LCD when the camera is held horizontally. A vertical picture doesn't fit very well in that horizontal frame. You are essentially losing nearly half of that already small LCD to blank space. This makes your vertical harder to see and evaluate, and makes it seem inferior to horizontal images because it is displayed so much smaller.

On most cameras today, you can change this feature so your pictures will not auto-rotate when displayed on your LCD (though it will continue to rotate vertically when displayed on your computer screen). You can usually find this setting in your camera's menu, but check your camera manual to be sure.

Once you do this, vertical pictures will display filling up the entire LCD. That does mean that they will be sideways when your camera is held horizontally, but if you're looking at a vertical picture, why not hold your camera vertically anyway? The point is that your vertical pictures will get the display they deserve and will appear equally important as your horizontal pictures.

SUBJECT PLACEMENT

In a lot of photographers' compositions, where is the subject? Often the subject is right in the center of the picture. But centered compositions are not necessarily the best: they tend to be dull and boring for most viewers.

Why is this? When the subject is in the center, a viewer's eye finds the subject and then just circles around it, getting tired of the picture. The emphasis of the picture is simply about the subject and nothing else; the viewer quickly gets it and wants to move on. The viewer does not spend much time looking at how the subject relates to the rest of the photograph. This means that he or she spends less time with your picture.

Other problems with a centered picture include a lack of emphasis and often a weak point of view. If your horizon is physically centered in a landscape, for example, the sky and ground get equal emphasis, and you are not sharing a distinct point of view about that landscape.

When you get your subject out of the center, viewers will look at it more strongly and start seeing how it relates to the rest of the picture. Their eyes will move all across the photograph. They will become more interested in the subject and its relationship to the setting. Thus, they will spend more time with your photograph—and isn't that a good thing?

Yet let's face it; the center is a very easy place for a subject to end up. Probably the main reason why so many subjects are in the middle of the picture is that photographers are so mentally focused on the subject, they don't pay as much attention to the photograph as a whole. The subject appears in the center because if that's all you're looking at, where else would it go? Another reason is that most of today's viewfinders display autofocus points, which tend to encourage a centered approach.

Remember that when you are taking pictures, you're not simply capturing a subject. You are creating a photograph, which means paying attention to the entire image area. Once you start becoming aware of this, you'll find yourself naturally moving the subject out of the center.

Digital cameras have a helpful feature for this: the LCD. Play back your images on your LCD once in a while. Some former film photographers like to make fun of people looking at the LCD; ignore them. You paid for that LCD, so don't be afraid to use it. It is like a Polaroid test print, but better because there is no waste and it is truly instant. Since LCDs are not big, it is very easy to see whether your subject is in the middle of the frame or not.

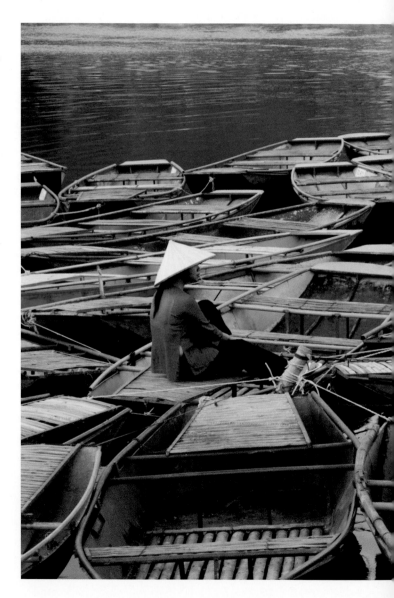

Pink-shirted woman in boats, Ninh Binh, Vietnam
70–200mm F4L IS USM lens, f/14 for 1/15 sec., ISO 500

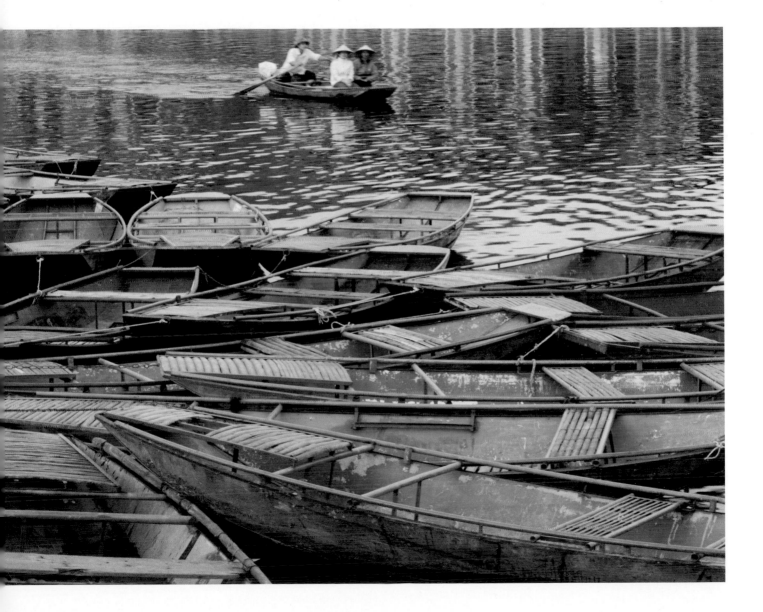

THE RULE OF THIRDS

Many photographers are familiar with the "rule of thirds" as a guide for getting your subject out of the center of the picture. The rule of thirds instructs to divide your image area into thirds both horizontally and vertically, creating a grid with two horizontal lines and two vertical lines. The rule of thirds says that, rather than placing your horizon line in the center of the frame, you should align it with the top third line or the bottom third line, each option lending a different emphasis to the composition. In the image of Redwoods State Park, shown right, the strong horizontal bands of sand, surf, and sky form a nearly perfect rule of thirds composition.

The rule of thirds also guides us in placing a composition's strong vertical objects and key visual elements. Vertical objects should align with one of the vertical thirds lines, while key visual elements should fall on the four spots where the horizontal and vertical lines cross. In the bamboo forest image, opposite, placing the figure in the left third emphasizes the vastness and relentless verticality of the bamboo.

The good news about the rule of thirds is that it helps you think about getting things out of the center. And given that it is based on a set of rules for artists that evolved over many years, you will usually end up with a reasonable composition if you follow it.

The bad news about the rule of thirds has two parts. First, it means that your compositions will look much like every other photographer's compositions because everyone is following the rule of thirds. When photography becomes based on a rule rather than what is actually in front of the camera, the photographer's unique point of view is lost.

Second, the world doesn't always read the rules. The rule of thirds was originally developed by painters and other artists who create works from scratch on a blank canvas or piece of paper. For them, it is very easy to arrange objects to follow the rule of thirds. For photographers, this isn't always so easy—in fact, sometimes the world can seem to be going deliberately against the rule of thirds. It becomes a problem when photographers start feeling that the rule of thirds is exactly that, a rule they must follow. And when it is imposed on a composition that doesn't want to cooperate, the composition rarely works.

TOP: *Surf on beach, Prairie Creek Redwoods State Park, California*
80–200mm lens, f/32 for 2 seconds, Fujichrome Velvia

ABOVE: *Doorknob on abandoned farmhouse, Oregon*
24–105mm F4L IS USM lens, f/14 for 1/20 sec., ISO 100

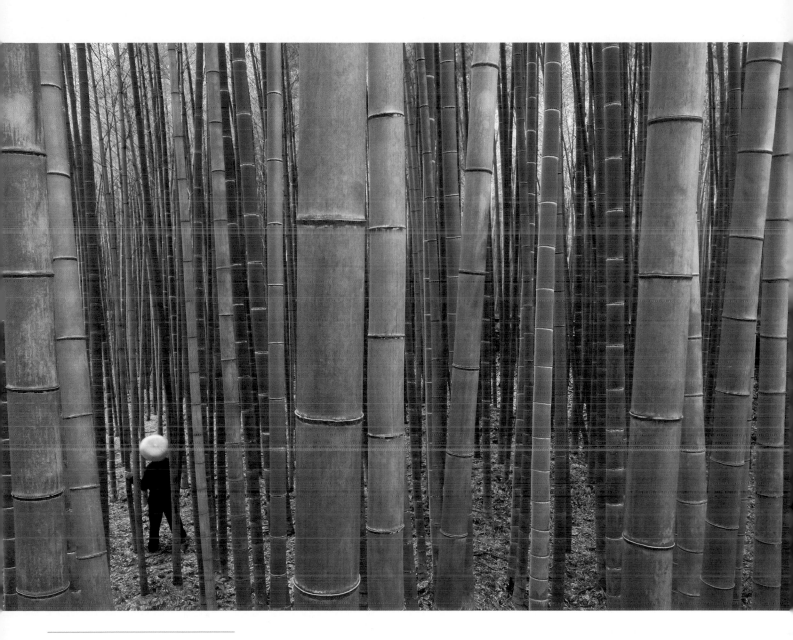

Bamboo forest, Kyoto, Japan
17–40mm lens, f/16 for 20 seconds,
ISO 400

WHAT DOES
THE SUBJECT NEED?

So if we don't want to center the subject, and the rule of thirds is a bit arbitrary, where does this leave us? Sometimes it is as simple as looking carefully at the scene in front of you, including on your LCD after you've taken a shot, and trying to understand what the scene needs. What is required for your picture to effectively communicate something special about the subject and setting?

Okay, so it might seem a little New Age-y to think about a scene sharing its needs. You might think that we have been spending a little too much time on the West Coast imbibing California wines or some of that medicinal green stuff. But the truth is, you really do have to pay attention to your scene and its needs. So many photographers try to *impose* a composition onto a scene rather than working with what is actually in front of them. Learning to find your connection with a subject is a part of composition that is not always taught in the depth that you are discovering in this book. It is a lot easier to talk about f-stops, shutter speeds, and RAW files than it is to discuss composition like this. Unfortunately, photography is not like a sporting event where there are specific rules to define what you can and cannot do. That's why photography is called a creative art.

The first thing to do is become aware of how the scene in front of you is being translated by your camera into a photograph. That is one advantage of the rule of thirds: it forces you to think about how the scene is being translated into an image. Think about what you see on your LCD, consider how that little image is interpreting what you see in front of you, and you will become more aware of subject placement within your image.

Think about what you want to emphasize in your photograph and what you want to communicate about your subject. Why do you want to get a good picture of this scene or subject? What do you want to emphasize and what do you really want to *say* about your subject? This is what it means to pay attention to what your subject needs.

Become aware of the space involved in your photograph, from top to bottom and left to right. Many photographers focus so much on the subject that they don't see what is happening in the space around it. A subject at the bottom of the frame is very different from a subject at the top. A subject on the left side of the frame is very different from a subject on the right. Start paying attention to this, and you will start placing your subject in different locales within the composition.

As you go through this book, notice where Art has placed the subjects in his images. Don't use it as some sort of rule; just try to figure out what he emphasized in each picture by his choice of subject placement. What does the photograph communicate?

CONVEYING SCALE

Looking for a sense of scale can be another way of defining a composition and influencing how you place your subject. Scale is simply a way to give the viewer perspective on how big the scene is within the photograph. Once you understand how to use scale, you can decide in each case whether or not to include it. Sometimes abstract photographs look their best when there is no sense of scale whatsoever, while big landscapes need it to reveal themselves to the fullest.

There are lots of things that can be used to convey scale within a photograph. Anything that is recognizable to viewers and will immediately convey an idea of its size will work. This is one reason why human figures are often used for a sense of scale in landscapes and street scenes. People can also personalize a place and help a viewer better connect with it.

Other useful elements are items that people use, from vehicles to houses; these have a human scale that people understand. Animals also provide a sense of scale, as shown in the image on pages 68–69, as do certain types of plants, such as a big pine tree, another evergreen, or a large cottonwood tree—iconic types of trees that people recognize and have an idea of the size of.

The trick to using any of these things for scale is that they must look like a natural part of the composition. A big mistake that people make when trying to convey scale is to simply add something to the picture without thinking about how it integrates into the overall scene. That always looks odd and gives the feeling that the object was simply added as an afterthought—which it probably was!

Never compose your picture around the object that is there for scale purposes. Compose your picture based on the various ideas discussed in this and other chapters, then look for a way to incorporate your object so that it contrasts with the rest of the picture but does not start to look like the subject. When you're using an object for scale, it needs to be a supporting character for the scene, never the star.

In general, things used for scale work best near the edges of a composition or along the bottom. Don't slam them against the edge of the picture; that looks awkward; put a little bit of space between them and the edge. By placing these objects well away from the center of the picture, you are telling the viewer that there is an important relationship between this object and the rest of the scene.

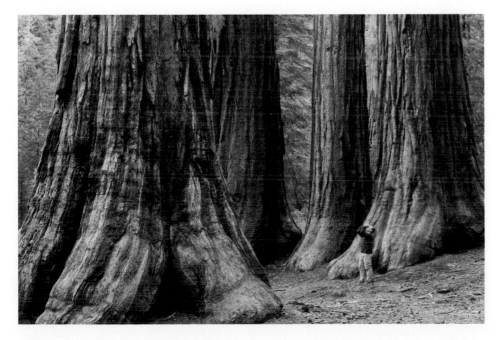

Park visitor with Sequoias, Yosemite National Park, California
70–200mm F4L IS USM, f/9 for 0.5sec., ISO 400

OVERLEAF: *Polar bear, Svalbard, Norway*
500mm lens + 2x extender, f/8 for 1/640 sec., ISO 100

MAKING ORDER
OUT OF CHAOS

One of the challenges all of us photographers face is that the world is ultimately rather chaotic visually (perhaps in other ways, too, but that is beyond the scope of this book!). A photograph is an arbitrary way of defining that chaos so it makes sense for the viewer.

In his book *Nature's Chaos,* the great color nature photographer Eliot Porter wrote, "When I photograph, I see the arrangement that looks orderly, but when you consider the subject as a whole or on a larger scale, it appears disorderly. Only in fragments of the whole is nature's order apparent." Porter has it exactly right, and this is one reason why many photographers struggle with finding subjects in nature. There is just too much to look at, and of course, that doesn't fit very well inside the camera.

A photograph needs to have some sort of order for a viewer to enjoy the experience of looking at it. If you simply point a camera at a chaotic scene and take the picture, the resulting image will not be something most people will want to look at. There needs to be some sort of defining order to that chaos.

Yet that's exactly where many photographers struggle. They zero in on a subject and don't necessarily see the chaos around it, chaos that keeps the picture from having order and structure. A chaotic image will still be chaotic, even if it is defined by the rule of thirds.

Ultimately, what every artist does is decide what to share and define it with the edges of the artwork, whether it is a painting or a photograph. Go to a museum and look at the paintings.

In every case, the painter has defined his or her work with the edges of a canvas. On one level, that's really a pretty simple thing. Composition is just a choice of cutting a slice of reality out of the chaos in front of you.

As an example, look at the pair of shots shown opposite, of a cypress tree in Carmel-by-the-Sea, California. The limbs of these trees have been contorted by years of storms coming in off the north Pacific—that is a story. That tree has character, naturally formed by the raw elements of nature. There were a number of ways that Art could have shot and framed this tree. Many photographers would just start shooting the whole tree and the landscape. The challenge is to bring photographic order to the trees and the branches. Art walked left and right, backward and forward, zooming in and out. Each time, he challenged himself to find a slice of the reality in front of him that created a composition with a certain order and balance. Every element mattered. For example, in the image shown opposite, top, the lowest, heaviest branch supports the image. Had that dark limb not been there, the image would have been out of balance. In the image shown on the bottom, a strip of sand and surf anchors the picture. For each, the weight of one picture element is balanced by the weight of another, all within a very specific framing of the scene that isolates and extracts an ordered composition.

Monterey cypress, Monterey, California
OPPOSITE, TOP: 75mm lens, f/22 for 1/10 sec., ISO 100

OPPOSITE, BOTTOM: 75mm lens, f/25 for 1/20 sec., ISO 100

ZOOM LENS CHALLENGE

Both of us learned photography before zoom lenses were a key part of anyone's gear. Early zoom lenses were expensive, and the results were not satisfactory. Nearly all pro photographers used single focal length or prime lenses.

This meant that to compose a scene in front of us, we had to replace a lens in order to change the focal length. And once that lens was replaced, the focal length change was dramatic because you could not tweak it by zooming. To refine your composition, you had to move closer or farther away from the subject. As photographers worked this way, they learned to look at a scene in front of them in terms of how a particular focal length would deal with it. They started picking out pieces of the scene before they even changed the lens.

Zoom lenses today are phenomenal. They offer outstanding image quality and are extremely convenient. But one thing has been lost for many photographers: the ability to look at a scene and start isolating pieces from the chaos in front of them. Short of buying a whole bunch of prime lenses, what can

you do? One thing that can help is to set up your camera on a tripod, then zoom your lens to a telephoto position and leave it there. Now move your camera to frame up different parts of the scene and see what you get. As soon as you start zooming your lens, you will start losing the feeling of taking a very specific slice of the reality in front of you.

There's no reason why you can't zoom your lens to refine your composition once you find something interesting. But a good way to start learning how to isolate slices of order is to lock down your view to a very specific slice, rather than zooming all the time. Try your lens at different focal lengths, but again, lock it into a specific focal length as you move your camera over the scene. Look for ways to define and structure a composition based on the framing of each specific focal length. Then adjust your zoom to refine your composition as needed.

If you start doing this regularly, you will train your eye to find details in the scene before you, details that out of the chaos of reality give order to a photograph.

TRAINING YOUR EYE

Here is an exercise that might help you learn to see slices of reality with a zoom lens.

1. Go to a location where you know that you can shoot for a period of time and find a variety of images.

2. Put a zoom lens on your camera, one with a moderate range. Extreme range zooms are difficult to use for this exercise, although some photographers like the challenge. You'll be using this lens for a while.

3. Zoom your lens out to its widest setting. Find a photograph that looks interesting by moving physically closer or farther away from the subject, not by zooming. Take a picture.

4. Zoom your lens in to its narrowest, or most telephoto, setting. Again, find a photograph that looks interesting by moving physically closer or farther away from the subject, not zooming your lens. Take a picture.

5. Zoom your lens out once again to its widest setting. Repeat step 3, finding another photograph that looks interesting by moving physically closer or farther away from the subject, not by zooming.

6. Continue to shoot at least 20 to 30 pictures, alternating your widest focal length with your most telephoto focal length. Once you get past the first 10 or so shots, you will start seeing what your focal lengths are doing before you even zoom the lens. With practice, this can become a habit, and you will start isolating pictures and creating order out of the chaos in front of you without even bringing a camera to your eye.

SIMPLICITY

One way of wrestling down chaos to get a better photograph is to look for simplicity in your compositions. Simplicity lends a sense of order to any photograph. It will grab viewers' attention and help them understand your image.

So many photographers try too hard to keep adding stuff into their photographs. They get to a beautiful location and see something in the foreground that they have to have in the picture, then they see something in the background, then something in the sky, and so on, as in the first image shown here. All of these start adding up to a picture that is not very easy to look at or understand. The picture loses its focus. Eventually, you are back to chaos.

A clear, simple composition makes it very easy for viewers to understand exactly what is going on in the image. And unless your viewer understands it, what's the point? Why make a picture other people won't understand? This does not mean you cannot challenge a viewer, but even complex images need to be understood visually. Sometimes photographers figure they can help viewers understand the photograph by explaining it, such as telling us how we should look at the photo or what we are not seeing in the image. If you have to explain an image, then more often than not, it is not very clear. Exceptions to this are very abstract images, which are often simple and clear as abstract compositions; they are not "about" the subject as much as they are about the abstraction. Of course, it is also possible to do more complex compositions, too, which we'll cover in the next section.

When we do classes and critique images, we hear lots of excuses as to why a particular composition is not clear and simple: the photographer could not get in the right spot, he or she didn't have the right lens, the light was wrong, and so on. Viewers of your photograph don't care what your excuses are. They want to be able to understand it and to see what you saw. If they can't do that, they zone out and you have lost the chance to communicate with your image.

How can you make your pictures clear? Keep it simple. The more you try to cram into your picture, the harder it is to keep it clear.

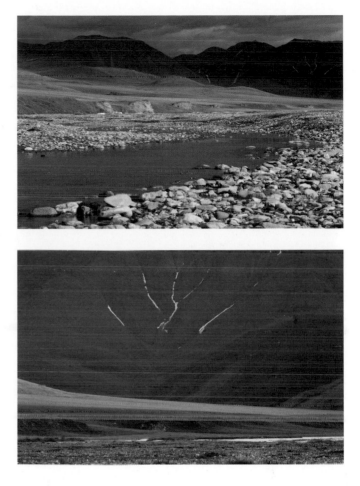

Kongakut River, Arctic National Wildlife Refuge, Alaska

TOP: *Too complex.*
70–200mm lens, f/22 for 0.4 sec., ISO 50

ABOVE: *Better, but still too complex.*
70–200mm lens + 2x extender, f/10 for 1/10 sec., ISO 50

PAGE 74: *Simple.*
500mm lens, f/4.0 for 1/60 sec., ISO 50

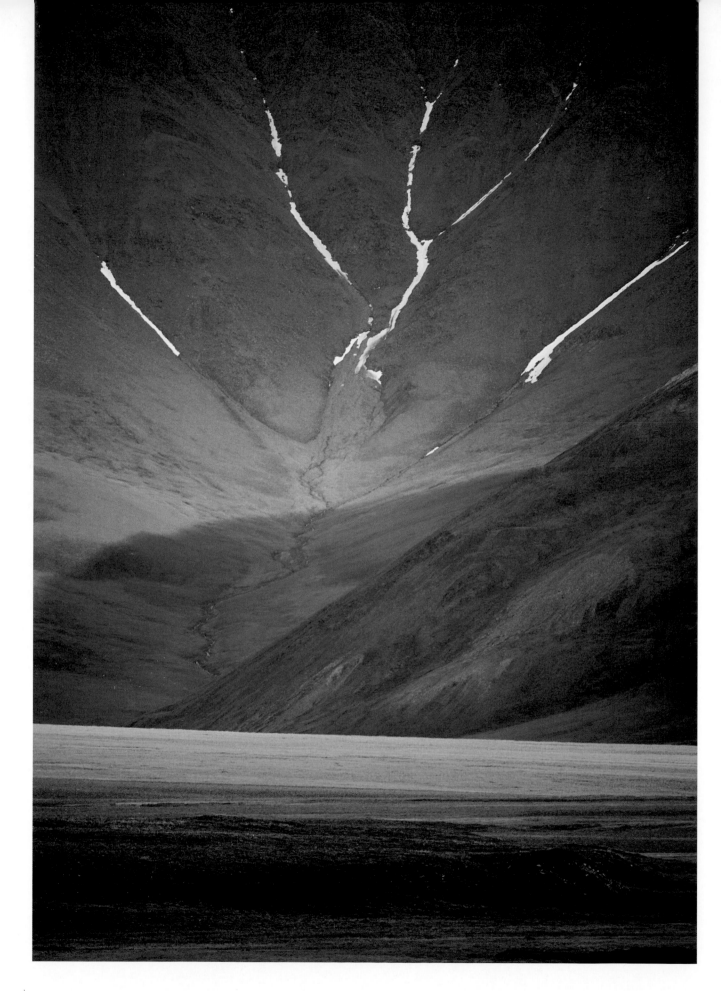

COMPLEXITY AND UNITY

Another way to structure compositions is with complexity. Art likes exploring complexity because it demands more work from the viewer. That does not mean he will create an image the viewer cannot understand, however. All of the same ideas about composition still apply. What complexity does is offer the viewer a chance to discover things. Since everything is not obvious from the first view of the image, a viewer can spend time with it, delighting in discovering new visual elements.

What complexity is *not* is simply adding more and more stuff to a picture. It does not mean standing at an overlook of a beautiful setting and just putting on a wide-angle lens to include it all. That is not complexity; that is simply a confusing way to look at a scene.

There can be many things going on in a photograph, but they still need to work together and create a sense of unity. Everything in the photograph should look like it belongs, or your viewers will wonder why you included it in the composition. When everything belongs together and makes sense, no matter how complex the composition, a sense of unity will meld the composition into a strong image.

A good example of a non-unified photograph is the typical shot that tourists take at the entry of a national park. A spouse and kids are lined up by the park's sign, a background of the park is included, and a snapshot is made. But when you look at the picture, you have no feeling that this is a photograph with pictorial elements that belong together. Instead, they are arbitrarily combined for a clichéd image that Rob's grandfather used to call an "I was there and you weren't" photograph.

A good example of a unified photograph would be a picture of a pattern and nothing else. That might also be a rather boring picture, but it would have unity. Since we are not going to suggest you start taking boring pictures, as you look for unity, make sure the picture also has some interesting things going on. Patterns can be interesting, but the composition must show us something interesting in that pattern and not just a snapshot of the pattern.

Art's experiments with black-and-white patterns and people are often extremely complex compositions. As in the two images shown on pages 76–77, there are bodies, there are designs, there are patterns—there is just a lot of stuff in the

MEGAPIXEL MADNESS

When you read the comment about Art shooting with a 60-megapixel camera, you might have been really impressed. Wow, 60 megapixels! I wonder when DSLRs will get sensors like that.

Whether they do or not, megapixels can be a distraction from the true goal of getting the shot. It won't matter how many megapixels you have if your picture is compelling. Even an iPhone can create compelling photography.

Art used the 60-megapixel camera for a very specific purpose: to create images that could be blown up to life size on a gallery wall. Megapixels are not about image quality per se, but about how big you can print or display an image without losing quality.

If the only thing you are doing is making 13 x 19-inch prints and displaying photos on your computer, a 10-megapixel camera provides plenty of pixels. For prints 16 x 20 inches or so, a good 15–18 megapixel camera will give results that will equal cameras with more megapixels.

It is true that you can crop a high-megapixel camera to a larger degree and get a quality result, compared to doing the same with a lower megapixel camera. However, that's not a good habit to get into. Everything in this book is about getting your best image as you shoot. If you rely on cropping—"fixing" the image afterward—you are missing what is happening in front of your camera as you shoot.

There is a discipline to filling up your viewfinder with your composition and subject so that you won't have to do much, if any, cropping. Really *look* at your subject and composition while you are with your subject, while you can make changes, rather than saving it for later.

compositions. However, these images also have a sense of unity. There is still a sense that everything in the photograph belongs. Art incorporates elements of design, influences from tribal designs throughout the world, camouflage, and tricks to encourage the viewer to discover small visual delights. His compositions can be confusing to the eye, but this is quite deliberate. Art includes disruptions to the patterns in order to encourage the viewer to stay with the image, for example, the center figure who has been painted both black and white, split down the middle.

As an aside, to create the images such as the one shown here, Art hires models who come into the studio and are spray-painted white or black (the black is a dye Art made very black, so it neutralizes everything). All of the designs are hand painted onto the bodies; that every spot is human created as opposed to digitally applied adds value and also allows the design to act unpredictably as the models move, the pattern taking on a life of its own. The images are shot with a 60-megapixel camera so the final image can be blown up to 10 feet by 14 feet on a museum wall and the humans can be life size.

ABOVE: *Human Canvas Pigment Study 35*
110mm lens, f/14 for 1/100 sec., ISO 50

RIGHT: *Human Canvas Abstract Study 5*
45mm lens, f/10 for 1/125 sec., ISO 100

AVOIDING DISTRACTIONS

A danger for all images is distractions that take away from the subject and the composition, an especially big challenge for complex compositions. Distractions can be small or large, but they always take the viewer out of the moment of experiencing your subject and composition.

The chaparral is an important part of Southern California landscapes.

Now, where did the sentence above come from? It might be an interesting fact, but it has nothing to do with this chapter. Did you notice how distracting it was? It made you stop and wonder what the heck was going on. That same thing happens when distractions are in a photograph. Distractions will destroy even the best compositions. Be vigilant in tracking them down: no stray sharp objects along the edges, no bright spots in the background, no sunlit objects in the foreground of a shadowed subject. In the image shown below, for example, note the distracting moped rider zipping through the frame.

Look for things that do not belong in your picture, things that sneak in along the edges of your frame to do their dirty work. Beware of bright and contrasty elements that are not part of your subject. The viewer's eye will always go to these parts of your picture, even if they have nothing to do with your subject. You can spot them if you look at your LCD playback, but if you are too focused on your subject, they will stealthily hide in the background until they start calling for your viewer's attention in the final image.

Signs, actual signs in the world such as "For Sale" or "Joe's Eatery," are other distractions to watch out for. Signs are usually bright and contrasty, designed to be visible and to be noticed. If you include a sign in your photograph, your viewers will try to read it. If a sign is in your photograph, make sure it is there for a good reason.

Finally, if you have a good photograph except for some ugliness along an edge, use your crop tool! This is what the crop tool was truly made for, not to "fix" a weak composition. No one will fault you for getting rid of junk that doesn't belong in your photo.

LEFT: *Photo shoot, Hanoi, Vietnam*
70–200mm F4L IS USM lens + 1.4x extender, f/18 for 1/15 sec., ISO 160

OPPOSITE: *Street signs, New York City*
70–200mm lens with 1.4 extender, f/25 for 1/13 sec., ISO 400

Are You Constructing the Best Images?

To help you discover subjects, ask yourself these questions:

1. Are you practicing different sorts of compositions all the time?

2. What is your point of view regarding the scene in front of you? Have you explored different ways of approaching the subject to emphasize your point of view?

3. Are you continually trying new and nontraditional points of view?

4. Are you looking for both horizontal and vertical compositions?

5. Have you changed your camera's auto-rotation setting from the default setting?

6. Are you working to get subjects out of the center of the frame?

7. Are you considering what your subject and setting need, rather than imposing a composition on them?

8. Are your images slicing order from the chaos of the world around us? Are you finding simplicity as you do this?

9. Are you considering complexity as a way of organizing your photo, but making sure that it is coherent and unified?

10. Are you ever-vigilant for distractions in your images, especially around the edges?

FEET OR HAIR: Listening to the Subject

I was in the Namib Desert in Africa, photographing some Himba girls. Their unique hairstyles were what first caught my attention, but as it turned out, the scene had "other ideas."

The girls were sitting quite naturally in their hut as I prepared to photograph them. As they sat down, they put their feet out in front of them. I could not help but notice how fascinating their feet were.

Himba people never wear shoes, and yet they walk in very rough, sharp areas. Their feet have adapted, becoming big and padded, and they cried out to become part of the shot, so I forgot about forcing the image to be about hair. Instead, I leaned my camera and wide-angle into the scene to create a distinctive point of view that emphasized the feet.

—Art Wolfe

OPPOSITE: *Portrait of Himba girls, Namibia*
70–200mm F2.8L IS USM lens, f/6.3 for 1/30 sec., ISO 200

LEFT: *Himba girls sitting in hut, Namibia*
17–40mm lens, f/13 for 1/60 sec., ISO 400

4

CAMERA AND LENS

When you consider how far digital photography has come in such a short time, it is truly remarkable. Cameras and lenses today are astounding tools that give us the ability to capture images quickly, effectively, and with very high quality.

Neither of us actually carries all that many different lenses and gear with us when we travel. With less gear, there are fewer decisions about how to photograph something. It is easy to grab a specific lens and start shooting, rather than spend time figuring out which lens you are going to use—or worse, which bag that lens is in!

The most important thing is to be comfortable with your gear and how you photograph. If you take a minimalist approach but your mind is uncomfortable with it, you will never be fully content while shooting in the field. And yet if you keep adding gear only because everyone says you need certain lenses and so forth, you are also not going to enjoy the experience. Find what makes you happy when you are photographing, and take that gear.

"The challenge to the photographer is to command the medium, to use whatever current equipment and technology furthers his creative objectives, without sacrificing the ability to make his own decisions."
—Ansel Adams

THE CAMERA

Going into a lot of detail about digital cameras here would take up a lot of space with information that will be out of date before too long anyway. All digital cameras today are capable of outstanding imagery. If you enjoy getting into camera-club–type debates about which manufacturer or which latest camera is best, go for it! Those can be stimulating conversations, though they won't have much of an effect on your compositions, or, usually, on photography itself. But such discussions can certainly be fun.

One important factor to consider, however, is the format of your camera. The format influences how specific focal lengths act as you create your composition. Sometimes you will hear photographers make statements implying that these formats are an arbitrary quality issue, but they aren't. They are simply formats. The three basic formats for digital photography are Full-35mm-Frame (also known as Full-Frame), APS-C, and Four Thirds.

Full-Frame

Full-Frame is the digital format based on a 35mm film size, so it is more accurately called Full-35mm-Frame. It is misleading because it implies that this is the biggest format (it isn't) and that other formats are inferior (they aren't).

Full-Frame has some advantages over the other formats. First, since the sensors are large, they can be made to really reduce the amount of noise (a granular pattern, similar to the grain you might get in film), especially at high ISO settings. In addition, these sensors allow the use of fast wide-angle lenses, depth of field is less for any given angle of view, and sensors typically have high numbers of pixels in them to allow heavy cropping (although, as discussed earlier, that is not the best way to get good compositions).

The biggest disadvantages of Full-Frame cameras are size, weight, and price. To get an equivalent angle of view and image quality, a lens for a Full-Frame camera will have a longer focal length and be physically larger, significantly heavier, and more expensive.

APS-C

You may hear the APS-C format referred to as the "cropped format." This is a poor choice of words—all formats are, in essence, cropped formats. For example, Full-Frame formats are cropped when compared to medium-format and 4x5 formats.

APS-C uses a sensor about two-thirds the size of Full-Frame. That means it uses a smaller area of what a lens sees if the same lens were used on both types of cameras. This is where the idea of cropped format comes from, though it really is its own format, albeit smaller than Full-Frame.

Today's APS-C sensors are quite remarkable and allow shooting with high ISOs and low noise, though they will not match a same-technology Full-Frame sensor. Cameras with this format allow smaller, lighter, and less expensive lenses for equal quality compared to Full-Frame. Because they are seeing less of an image area from a particular focal length, these cameras magnify what is seen on the image. This magnification or crop factor is typically 1.5x. The result of this is that you need a smaller focal length lens for the equivalent image area, and that results in more depth of field for any particular composition.

Four Thirds

Four Thirds is the smallest format of this group: slightly smaller than APS-C and about half the size of Full-Frame. Micro Four Thirds is a variant of the format that changes the way the cameras are made and the lens mounts, so that lenses are even smaller but the actual sensor size does not change.

Today's Four Thirds sensors are also quite remarkable and allow shooting with high ISOs and low noise, though again, they will not match a same-technology larger format sensor. Four Thirds allow some of the smallest, lightest, least expensive lenses for equal quality compared to larger sensors. These cameras also magnify what is seen on the image compared to larger formats. This magnification or crop factor is 2.0x. This also results in a smaller focal length for a particular angle of view that will give more depth of field for any particular composition.

LENS CHOICES

Having a range of focal lengths—from wide to telephoto—will give you options for composing an image that go way beyond simply how much you can see from a particular spot. We also both include zoom lenses as important parts of our camera bags.

Focal length choice is about much more than whether to zoom your lens in or out to frame a composition. You will get entirely different results if you are close to a subject using a wide-angle lens, versus walking farther away and using a telephoto lens. That walk, along with the specific focal length, can totally change how you compose your image.

ABOVE: *Paris by night*
70–200mm lens with 1.4 extender, f/16 for 4 seconds, ISO 400

PAGE 82: *Sadhu and trident, Varanasi, India*
70–200mm lens, f/2.8 for 1/250 sec., ISO 400

THE WIDE-ANGLE LENS

Wide-angle lenses offer a unique perspective to a scene when you get in close to your subjects. A wide-angle zoom allows you to use the wide-angle focal length for perspective purposes, but then precisely adjust your composition with the zoom. See the sidebar on page 88 to understand more about this important part of composition.

The strongest perspective effect occurs with focal lengths that are wider than 28mm for the 35mm or Full-Frame format, 18mm for APS-C, and 14mm for Four Thirds. The 16–35mm zoom range for Full-Frame, 10–22mm for APS-C, and 9–18mm for Four Thirds are ideal.

There are two key styles of composition that are strongly affected by wide-angle lenses, both also powerfully affected by perspective: the bold foreground and strong leading lines. Let's look at each of these below.

The Bold Foreground

So many photographers have been told to be careful about using wide-angle lenses up close because they "distort things." This is both true and not true. When you get in really close to a subject with a wide-angle lens, you're not actually distorting the world; you are changing the way you are perceiving perspective. The human eye can't see clearly with such a wide-

angle view up close to subjects, at least not in the way that the lens does. The lens defines this way of looking for us and creates a fascinating relationship of foreground and background. Besides, so what if things get a little distorted? Why make the same shot everybody else does when you can do something that will grab people's attention? Standard focal lengths can be boring! In today's world, we are bombarded by visuals. Sometimes it takes an image that is a bit out of the ordinary to break through that visual clutter.

So get in close to a main compositional element, and frame it so the element dominates the composition. The closer that element is to you and the wider your focal length, the more important it will become visually. This then allows the environment to sit quietly in the background, creating a strong sense of place. The wider the lens's angle, the more that background will show, though it will still be small relative to your main subject or key compositional element in the foreground. This is an important concept to keep in mind: a wide-angle lens shows off a "wide angle" of the scene in front of you, picking up lots of background or environment. When you add that to getting up close to a strong compositional element, you create a dramatic and bold image highlighting a subject in its environment.

LEFT: *Pomeranian dog, Yuanyang, China*
15mm F2.8 fish-eye lens, f/10 for 1/60 sec., ISO 100

OPPOSITE: *Patagonian landscape, El Chaltén, Argentina*
17–40mm F4L USM, f/22 for 6 sec., ISO 200

This might be called the "ecology effect" because for nature photographers, it truly shows a subject in its environment. The subject remains the most important element in the composition, but the environment is important as well, creating a strong feeling of connection between the subject and its environment. Note that the only way this will work is to get close to your subject. We have seen photographers put on wide-angle lenses and then back up to get more of the scene in their view. We suggest you put on a wide-angle lens and get closer! That is how you create dramatic perspective effects. Just be sure that whatever you are emphasizing in your foreground is truly a dominant compositional element.

Getting up close with a wide-angle lens also lends a strong sense of depth to a composition, something you won't necessarily get by simply using a wide-angle to capture a big angle of view. A sense of depth comes from the feeling that there is something very close to you and then a lot of distance between it and the background. That is exactly the feeling you create when you get in close to a subject with a wide-angle.

This will also add a feeling of space or vastness in a landscape or other setting. Again, the viewer sees this emphasis on space from foreground to background, an emphasis increased because of the size of the foreground object. You are literally stretching the impression of space, giving a feeling of vastness, because you have increased the size of that foreground object while decreasing the size of the stuff in the background. Regardless of the real space, you're giving an impression of a great deal of space.

PERSPECTIVE

"Perspective" is how three-dimensional objects are translated into two dimensions in a photograph. Perspective affects the appearance of depth as pictorial elements are closer or farther away. When an object is closer to you, it looks bigger; when the same object moves away from you, it looks smaller. That's perspective.

The classic example of perspective is the view of telephone poles receding into the distance. The poles close to you appear large, and as the poles recede, they get smaller and smaller, heading back toward the vanishing point. You may remember an art class in elementary school where you had to create a vanishing point with all lines leading toward that point.

If you walk close to a telephone pole, it will be very large, perhaps so large that you cannot even get it into your image without a very wide-angle lens. It will look huge compared to the more distant telephone poles. However, if you back away from that same pole, it will get smaller and smaller until it is more in proportion to the small poles in the distance.

As photographers, we can control this appearance of perspective by how close we are to our subject, then using focal length to control what we actually see of the subject. You can see this quite well in the two shots of a gorge in Australia's Northern Territory, shown opposite. Notice how the distance from foreground to background appears to change, even though you are seeing the same trees, the same rocks, the same gorge. This is entirely due to changing perspective by shifting both camera position and focal length.

This is a challenging area for many photographers. Rob has taught perspective and focal length in a number of classes, including those at BetterPhoto.com, and has found that this is one of the hardest things for today's photographers to learn. This is in large part due to the extensive use of zoom lenses, so photographers no longer move closer or farther away from the subject. For perspective effects to occur, you must change your camera position relative to the subject.

Telephone poles, Palouse, Washington
70–200mm lens + 2x extender, f/16 for 1/50 sec., ISO 100

Gums in gorge, MacDonnell
Ranges, Australia

LEFT: *A telephoto lens compresses distance.*
110mm lens, f/18 for 1.5 seconds, ISO 100

BELOW: *The same shot taken with a wide-angle lens.*
EF16–35mm F2.8L II USM lens at 27mm focal length, f/16 for 2.5 seconds, ISO 50

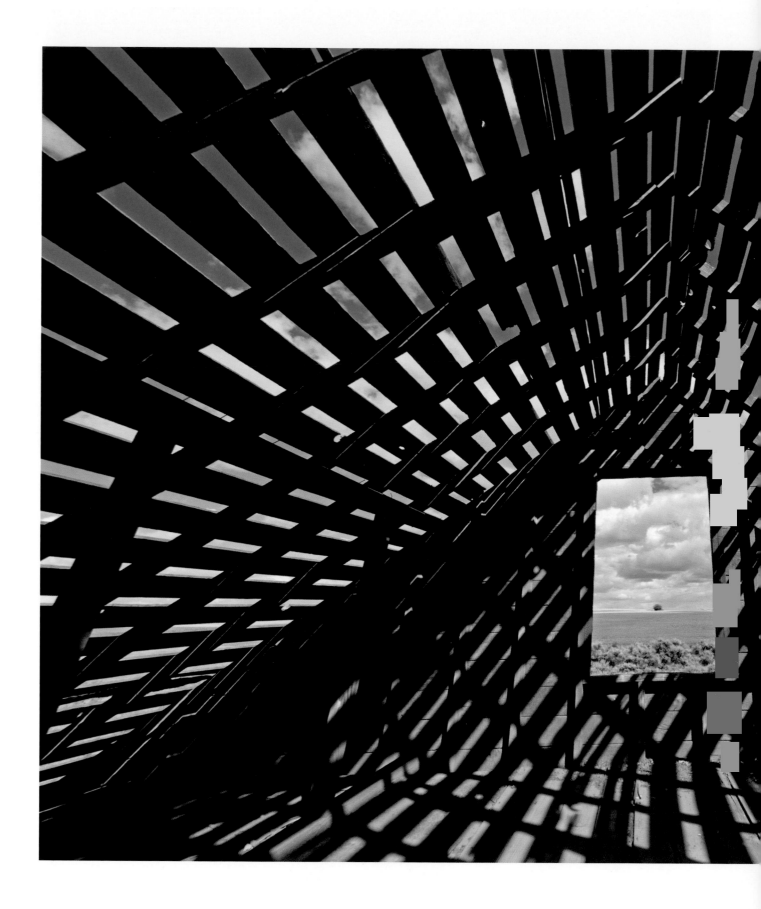

the art of the photograph

Abandoned farmhouse, Palouse, Washington
15mm F2.8 fish-eye lens, for 1/160 sec., ISO 200

THE TELEPHOTO DIFFERENCE

Put on a telephoto focal length, and everything changes. Obviously, an important use of a telephoto lens is cutting down the angle of view so you see only a portion of the huge scene in front of you. This lets you isolate certain aspects of the scene, such as wildlife. Wildlife photography is difficult without a telephoto lens because wildlife doesn't always allow you to get in close enough to make the subject big in the image area. Having a telephoto lens allows you to narrow your angle of view to the animal itself.

There are two important ways to work with a telephoto lens as you think about composition: framing simple compositions and compressing distance.

Framing Simple Compositions

As we started discussing in Chapter 3, a telephoto lens allows you to frame details out of the visual chaos of life around you. When using a Full-Frame camera, the 70–200mm lens works well to help isolate simple compositions. For APS-C cameras, that would be approximately 50–150mm; for Four Thirds cameras, 35–100mm. This focal length range is excellent for pulling details out of larger landscapes, showing off wildlife with a bit of environment around them, and working with people.

One thing many photographers do when they come to a landscape is to simply put on a wide-angle lens to capture that whole view. Unfortunately, those scenes are often shot too wide and viewers must guess what the photograph is about. Instead, put that telephoto zoom on your camera, set your camera on a tripod, and look for little slices of design within the landscape, simple compositions that your viewer will understand. Your objective should not be to cram the entire landscape into a single picture, but to find interesting images that will impact your viewer.

Because most wildlife will not allow you to get close, a moderate zoom such as the 70–200mm lens will enable you to magnify the scene enough to show off the animal as well as some of the setting. And it can be a lot of fun to use a super telephoto to get in close and create portrait-type shots of wildlife, certainly a valid reason for having that type of lens. However, compositions that place an animal in its setting create a feeling of connectedness between the animal and its environment as well as communicate a story about how this animal lives, a story that can't be seen in a super telephoto portrait of that same animal.

This is one place where you really have to pay attention to getting your subject out of the center of the frame, as discussed on page 64. It is so easy to become excited about having that wild bit of life in your viewfinder that you forget to look at the rest of the composition. Remember to quickly scan the edges

RIGHT: *Mountain gorilla and infant, Rwanda*
50mm F1.2L USM lens, f/1.6 for 1/100 sec., ISO 400

OPPOSITE: *Mother and daughter, Pushkar, India*
70–200mm F4L IS USM lens, f/8 for 1/50 sec., ISO 200

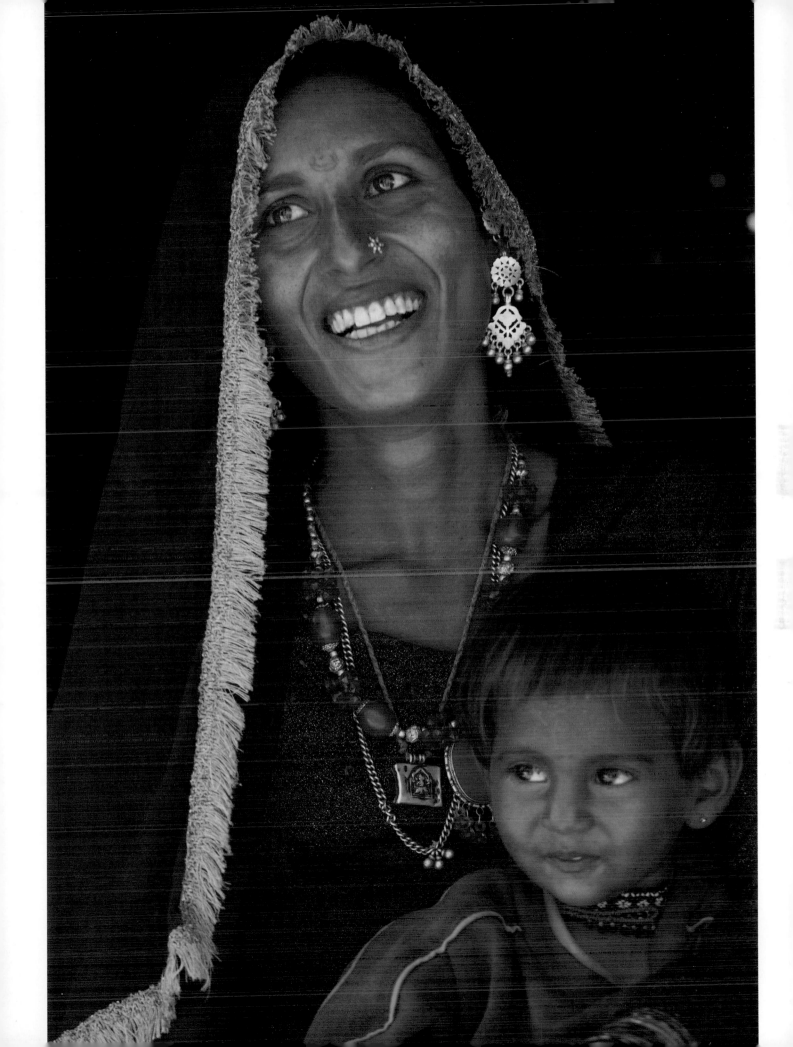

of your picture and look at the relationship of that wildlife to the rest of the frame. Don't allow it to be stuck in the middle, where the image will be far less interesting.

This focal length range also offers a comfortable way to work with people, allowing you to stay far enough away to avoid invading their space yet not so far away that your pictures seem voyeuristic, as in the image shown on page 95. You will have a connection with your subject, and that is important.

In addition, a moderate telephoto allows you to isolate people out of larger settings quite nicely. In real-life environments where people live and work, there can be so much going on that a composition is hard to define and structure. By using a moderate telephoto, you can hone in on the key people and their relationships. Once again, be careful not to put important subject matter dead center in your image frame.

Compressing Distance

Many photographers are aware that telephoto lenses will compress distance. This is the opposite of how wide-angle lenses increase the feeling of space. When you shoot with a telephoto lens, you limit what the viewer can see. You are also magnifying the size of the background. These two things together give the impression that the background is closer—meaning that distance is being compressed.

This is a very important use of a telephoto lens. Hollywood does this all the time. When you see an actor being chased by some terrible threat, such as a huge truck bearing down on him or her, that truck is not physically as close as it appears. By shooting with a telephoto lens, the filmmakers are able to compress the distance between the actor and the truck, making the truck look much closer and more threatening.

Compression can be used to bring a background visually closer behind the subject, to simplify the background, or to create a specific connection between the background and subject. For example, let's say you want to contrast a barn against a colorful fall background. With a moderate focal length, you might have to get in close to the barn in order to see it clearly, which will make the background appear smaller and farther away. If you put on a telephoto lens and back up, the barn will not only be shown clearly but the background will appear closer, making it look very close to the barn indeed.

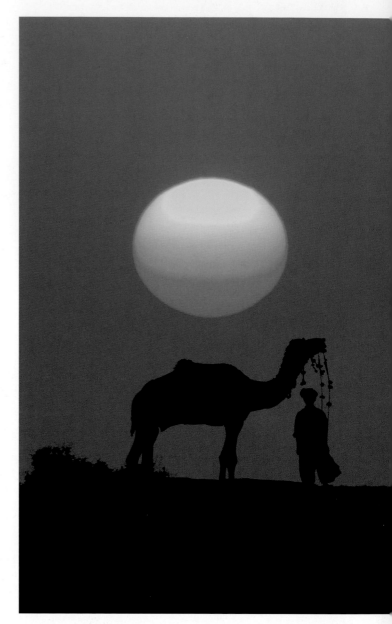

ABOVE: *Camel trader at sunset, Pushkar, India*
500mm lens + 2x extender, f/25 for 1/160 sec., ISO 400

OPPOSITE: *Seattle and Mount Rainier, Washington*
70–200mm lens + 2x extender, f/5.6 for 1/250 sec., ISO 100

Compression is very commonly used to condense a range of hills, ridges across a mountain range, a stand of trees, and so forth. You can pull in a background tree to make it tower over a foreground subject, when in fact the tree is really much farther away. Once you become aware of this sort of effect, you will start to look for these options. And the stronger the telephoto is, the stronger the effect.

Sometimes by using a telephoto lens and backing away from your subject, you can magnify the background enough to find a clearly contrasting part of that background to set off your subject. On the other hand, there may be something very important in the background that needs to relate to your subject in order to tell a complete story, and using a telephoto lens can bring those two things visually closer together.

For this effect to work, you have to back up. This is just the opposite of working with a wide-angle lens and getting in closer. By backing up, you can get your subject fully in view, and because you are using a telephoto lens, you're also magnifying the size of the background. You cannot do that by simply zooming your lens from a fixed position. All that does is crop what you see; it does not change the relationship between the subject and the background.

This is the challenge many photographers face when first trying to affect perspective and depth by changing their focal length. If all you ever do is stand in one place and zoom your lens in and out, or change to a new lens, you will not get the perspective effects being discussed here. To do this, you need to change your camera position, either by getting in close with a wide-angle lens or by backing up with a telephoto.

TRIPODS

Good tripods are important investments for photographers who care about quality images, yet they are treated as second-class gear. Photographers are willing to spend thousands of dollars on new cameras and lenses but are not willing to put that same investment into a good tripod and head. The fact is, all of that great gear might as well be money you are burning if you don't have a good tripod to get the most out of it. We can take the cheapest kit lens from a camera manufacturer and use it to get images of better quality than anybody with a top pro lens if we are shooting on a quality tripod and the person shooting with that pro lens is not.

We have both been to locations where there are many photographers and have noticed people with expensive gear on what look like Walmart tripods. Cheap tripods simply do not hold a camera steady enough to eliminate camera movement, and they can even *create* vibration, making it even worse than handholding the camera.

A good tripod is not going to be cheap, especially if you are getting a carbon fiber tripod. Carbon fiber tripods are a great advantage for anyone who is traveling and shooting outdoors. They are lightweight yet extremely sturdy and rigid. They also do not feel as cold on fingers when the temperature drops.

You should be able to set up a tripod to its maximum height and lean on it without feeling that the tripod is going to collapse, or seeing much give to the legs. Fewer leg sections will make a sturdier tripod, but more leg sections will allow you to collapse a tripod for easier transport when traveling.

A good tripod needs to be matched with an equally good tripod head. The head should be sturdy enough to handle your lenses, as well as be lightweight and easy to use. Both of us use Gitzo tripods, while Art uses a Kirk ballhead and Rob a Really Right Stuff head.

Just having a good tripod does not guarantee the best sharpness from your camera and lens, however. A big problem many photographers face today is shooting with the compact, extended-range zoom lenses. These are convenient and highly portable lenses, but they don't include a tripod mount. When you mount a camera with such a lens on a tripod, you have to mount it at the camera body. Unfortunately, that lens will then unbalance the camera because of the way it sticks out away from the camera and tripod, which often leads to camera movement during exposure. Two things that can help: use mirror lockup, if your camera has it, or use Live View. With Live View, the mirror is automatically locked up and you won't have the problem of camera vibration during exposure due to mirror bounce.

Art and his trusty tripod, Mali
(photo by John Greengo)

BIG TELEPHOTO LENSES

Strong telephoto focal lengths are needed for photographing wildlife and to create extreme compression effects. These include focal lengths of 400–500mm and above for Full-Frame cameras, 300mm and above for APS-C, and 200mm and above for Four Thirds. This is not a type of lens that everybody is going to need or use all of the time. They tend to be expensive, physically large, and heavy. They can be a problem to travel with, so if you don't think you're going to need such a lens, you may be better off without it.

However, there are definitely situations where the very long lens is important. It allows you to step back from wildlife and get very tight shots of the animals, portraits showing just the head and shoulders. Since birds are often small and difficult to approach closely, strong telephoto lenses can be a big benefit to photographing them as well. These lenses are also useful when photographing wildlife so you don't alter the animal's behavior with your proximity. As you get closer to an animal and cross its comfort zone, it will start changing its behavior in response to you rather than acting naturally. By shooting from farther away with a big telephoto, you'll be more easily able to capture interesting and natural behavior.

All of the compression effects discussed on page 97 are intensified as your lens's focal length increases. You can really bring backgrounds in very close to your subject when using a super telephoto, though you may have to actually back up to do that.

TELE-EXTENDER OPTION

One way of getting a longer focal length is to use a tele-extender or converter. These are special lenses that fit between your camera and a telephoto lens to magnify the focal length of the main lens. They cost much less than buying a whole new lens and are quite compact and easy to use. They typically come in two strengths: 1.4x and 2.0x.

Today's tele-extenders can be quite good, although there are a few challenges to using them. First, as soon as you put a tele-extender on your camera, you lose light to your sensor. A 1.4x extender loses one stop of light and a 2.0x extender loses two stops of light. If your main lens is not very fast (i.e., does not have a wide maximum aperture), then this loss of light can cause your camera to have difficulty using the lens for autofocusing, even to the point of not autofocusing at all.

In addition, a tele-extender magnifies the faults of the lens as well as the actual subject. Some lenses do quite well with a tele-extender while others do not. For example, many zoom lenses do not interact well with a tele-extender. Regardless, even the best lenses tend to do their best with a tele-extender when the lens is stopped down at least one stop, which means you are losing even more light. Happily, this is not necessarily a huge problem with today's digital cameras, which allow you to increase the ISO and still get quality images.

Grizzly bear, Arctic National Wildlife Refuge, Alaska
400mm lens + 2x extender, f/8 for 1/30 sec., ISO 400

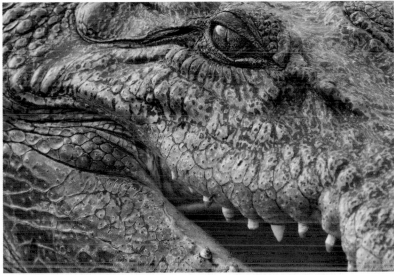

LEFT: *White herons, South Island,*
New Zealand
400mm F4 DO IS USM lens, f/4.0 for
1/2000 sec., ISO 400

ABOVE: *Saltwater crocodile,*
Kakadu National Park, Australia
500mm lens, f/16 for 1/80 sec.,
ISO 400

CLOSE-UPS AND MACRO SHOTS

Many photographers buy a single macro lens and use it for close-ups. That is certainly a fun and effective way to get close-up and macro images.

The challenge is that macro lenses offer only one focal length. This can be an issue when you are traveling because now it means you have one lens for close-ups, sometimes at a focal length that overlaps your other lenses, and it doesn't tend to be used much for anything else except close-ups. The result is added weight and space used by a lens that doesn't have the versatility of the other lenses. Even more importantly, as you've seen in this chapter, changing focal lengths has a big influence on your composition, affecting the appearance of space, perspective, and depth—whether up close or from a distance.

In the sidebar on the opposite page, you will learn of a number of possibilities for using most of your lenses up close. A big advantage of traveling with extension tubes, for example, is that you can quickly and easily get close-up photos without having an extra macro lens, yet the extension tubes take up very little weight and space.

When you can change focal lengths up close, you change how you see your close-up subjects. If you use a wide-angle lens up close, you can create a dramatic foreground subject against a smaller background. Once again, you can show off the environment or setting for your macro subject just as you did for larger subjects. You can also use leading lines up close, something few people think about because they don't show up as well with the common telephoto macro lens most people buy.

If you use a telephoto lens for close-up subjects, you can simplify compositions to graphic designs that work quite well isolated from the larger scene. You also get compression effects, bringing a background closer to your subject. Because depth of field is often narrow when you are focusing close, you might not be able to see much in that background, but you can pick out contrasting bits of background to help your subject show up better, something you might not be able to do with a wider focal length. And, of course, using a telephoto lens with a subject that might hurt you, such as a stinging insect, has its own benefits!

RIGHT: *Dew on lupine, Mount Rainier National Park, Washington*
100mm F2.8 Macro lens, f/32 for 0.5 sec., ISO 250

OPPOSITE: *Golden-crowned sparrow, Olympic National Park, Washington*
24–105mm F4L IS USM lens, f/22 for 8 seconds, ISO 100

CLOSE-UP GEAR

There are six basic ways that you can focus closer on your subject for both close-up and true macro photography. Technically, "macro" photography is when you are so close to your subject that it is as big on your sensor as it is in real life. However, in reality you will find that most photographers freely interchange these terms.

1. **MACRO LENS:** These are lenses designed to photograph from infinity down to macro distances without any accessories, making them very convenient and easy to use. They are also highly corrected to retain maximum sharpness throughout their f-stop range and their entire focusing range.

2. **EXTENSION TUBES:** Extension tubes fit between your lens and camera body to allow any lens to focus closer. They tend not to work well with wide-angle lenses because they push the lens too far away from the camera to focus. Because there are no added optics with these lenses, they are sturdy and durable, plus they allow maximum sharpness from a lens being used up close. Sharpness will be limited by the original lens, however, and lenses vary in how well they do when used up close.

3. **TELE-EXTENDER:** Sometimes people confuse tele-extenders with extension tubes. Extension tubes have no optics, but tele-extenders do. A tele-extender will magnify the view from a lens so the subject is magnified on your sensor. It won't allow your lens to focus any closer, but it will magnify what it does see

at any distance. Image quality is highly dependent on how well the extender optics interact with the optics of the main lens as well as the original quality of that lens.

4. **CLOSE-UP LENSES:** Traditional inexpensive close-up lenses (or filters, as they are sometimes called) screw onto the front of your lens and allow it to focus closer. These are an inexpensive way of getting close-ups, but image quality tends to be extremely variable because the lenses are not corrected. Sometimes stopping your lens down to the midrange of f-stops will help, but this is not the highest quality approach of the group.

5. **ACHROMATIC CLOSE-UP LENSES:** These are a unique type of close-up lens or filter that is extremely well corrected for sharpness and minimizing lens aberrations. They screw onto the front of your lens and allow you to focus up close without loss of light to the sensor (which happens with extension tubes, tele-extenders, and macro lenses). Image quality is quite high, though once again that is dependent on the main lens.

6. **CLOSE-FOCUSING STANDARD LENSES:** Many zoom lenses are designed to focus quite close without requiring accessories. These are not true macro lenses because they lack some of the special image correction features of a macro lens, but they can do a fine job of getting you in close.

SHUTTER SPEED

The shutter speed you choose has a big influence on many things in your image, from the sharpness of the picture to creative blurs. When choosing a shutter speed, you need to think about slow versus fast shutter speeds and what each will do for you. Fast shutter speeds are used to stop motion and create frozen moments in time. Slow shutter speeds are used to either balance a small f-stop for deep depth of field or to create blur. We'll talk about depth of field a little later in the chapter.

Fast shutter speeds are considered 1/500 sec. and faster, though it depends on the subject. A shutter speed of 1/500 sec. with a slow-moving giraffe is extremely fast, but it is quite slow if you are photographing a hummingbird. Faster shutter speeds are a more traditional vehicle for shooting wildlife. You get a frozen moment in time, showing every feather and claw of a diving eagle, for example. The image becomes like a trophy; many of us feel like cheering after we get a shot like that.

But as you go down the shutter speed dial to slow it, something happens. Your images move away from emphasizing detail to offer something more emotionally effective, with motion and blur beginning to appear. This depends a lot on the subject and its speed, but when you get down to around 1/25 sec., you will almost always see motion introduced. It might be just a little bit of motion along the edges of a subject, but it will still add drama. Sometimes the contrast between blurred motion and sharp focus gives an image depth, such as in the image shown at right. So with a bird in flight, for example, the wings become blurred, softening the image and making it more than just a trophy shot.

When shooting moving wildlife, try putting your camera on the tripod and loosening the tripod head so you can move it back and forth to follow the subject. The weight of the camera and lens is carried by the tripod and you can move it easily as you pan with a subject using slow shutter speeds.

For water and flowers blowing in the wind, you will typically need shutter speeds of 1/2 sec., 1 second, and slower. In these cases, you are actually photographing flow patterns, patterns that cannot be seen with the naked eye because we don't see time in that way. The slow shutter speed allows you to capture these interesting patterns that are a part of nature but not normally seen, as in the image of the Merced River, shown opposite.

Experiment with shutter speed to see what works with any particular subject. Thanks to digital photography, you can look at the metadata of any shot to see what the shutter speed was and its effect on the subject. That's a great learning tool.

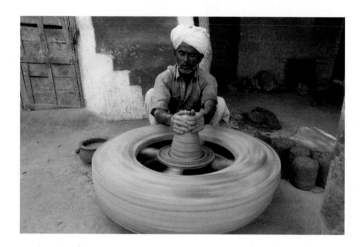

ABOVE: *Potter, Rajasthan, India*
24–70mm lens, f/20 for 1/50 sec.,
ISO 400

OPPOSITE: *Merced River, Yosemite National Park, California*
150mm lens, f/32 for 0.4 sec.,
ISO 400

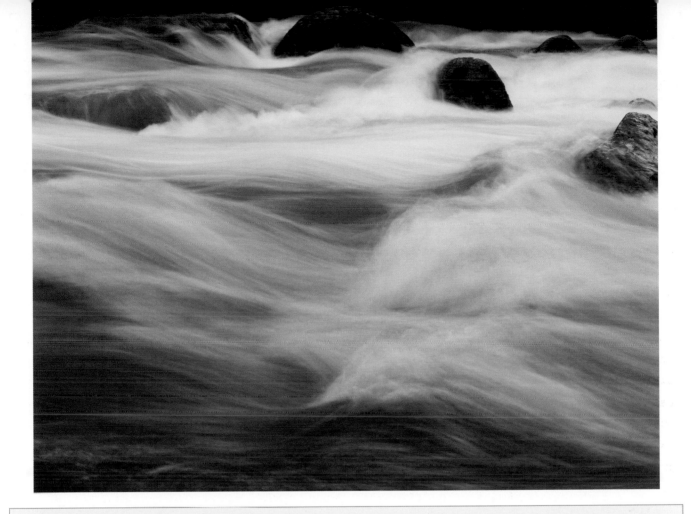

Avoiding Camera Blur

Camera movement during exposure is the number one cause of unsharp images, period. Amateur photographers often look at images from pros and wish they could afford the same type of gear, yet most pros are not shooting with anything different from what most amateurs have. The biggest difference is paying attention to camera movement.

You might know when your picture is blurry because the camera was not held still during exposure. What you may not recognize, however, is when the picture looks okay but is not gaining the maximum sharpness from a lens. We have even seen so-called lens tests on the Internet where people complain about the sharpness of the lens, though the problem had nothing to do with the lens and was caused by camera movement unrecognized by the photographer.

A sturdy, solid tripod and head is critical to help reduce and even eliminate camera movement during exposure. Photographers are often under the impression that they can handhold a camera at much slower shutter speeds than they really can and still get maximum sharp-

ness. Do some of your own tests and compare what you can get handheld at a variety of shutter speeds with what the camera can do locked down on a tripod. Magnify the resulting images and compare tiny details and highlights. You may be surprised with the results.

Using a fast shutter speed when handholding your camera is often more important than stopping your lens down for more depth of field. It is better to have at least your subject truly sharp than to get a fuzzy image that supposedly has deep depth of field.

If you are handholding a full-frame camera, a good guideline is to use a shutter speed no slower than 1/focal length of the lens. For example, if you are using a 200mm lens, make sure your shutter speed is 1/200 sec. or faster. For the smaller APS-C and Four Thirds formats, you need to go one-half to one full stop faster, meaning that the same 200mm lens should be used at no slower than 1/400–1/500 sec. Too often, photographers shoot telephoto focal lengths handheld at shutter speeds like 1/125 sec. and slower, sacrificing the full sharpness possible from their lens.

EXTREMELY LONG EXPOSURES

A four-hour exposure is a long exposure. This was possible in the days of film, and we used to shoot star trails that way. Very long exposures can be used to capture interesting movement at night, including auroras and clouds. The effect can be very cool.

Digital cameras can't yet do hour-long exposures (though this technology is constantly changing); the sensors don't allow it because they heat up. However, digital cameras are spectacular for exposures of several seconds to many minutes when shooting after the sun has set. Many photographers pack up their gear once the sun has gone down, yet this is a time of great opportunity for stunning photographs.

New cameras offer such great sensitivity with high ISOs and low noise that you can even photograph the stars in ways that were simply not possible with film. The trick is to shoot a fast enough shutter speed so the stars are pinpoints of light or, at most, little oblong stars. Usually this means an exposure of 20 seconds or less, but it depends on the focal length you are using. A wide-angle lets you get away with longer exposures.

Long exposures can be especially effective when shooting special events like volcanic eruptions and lightning strikes. Put the camera on Bulb for shutter speed, then use a cable release (preferably with a timer) to hold your shutter open for many seconds.

OPPOSITE: *Stars over Arches National Park, Utah*
15mm F2.8 fish-eye lens, f/2.8 for 30 seconds, ISO 800

ABOVE: *Lava, Hawaii Volcanoes National Park*
70–200mm lens, f/6.3 for 10 seconds, ISO 200

SELECTIVE FOCUS

Many photographers are unaware of how important a choice of depth of field is to a composition. Even if two shots of the same scene are framed up identically, the composition will be different with shallow depth of field versus deep depth of field. This is because of emphasis. Remember, composition is always about emphasis and how a viewer's eye is directed through the image. Depth of field has a strong influence on that.

"Depth of field" is the sharpness in depth in a photograph. When there is very little sharpness in depth, meaning that only a small area is sharp and most everything in front or behind that area is out of focus, the image has *shallow depth of field*. When just about everything is sharp from foreground to background, the image has *deep depth of field*. In the images opposite, the first one has a deep depth of field, with nearly everything in focus. The second image has a shallow depth of field, with only the foreground in focus and the rest blurred.

Depth of field is affected by three main things: focal length, distance to subject, and f-stop.

- **FOCAL LENGTH:** Wide-angle focal lengths have more depth of field than telephoto focal lengths.

- **DISTANCE TO SUBJECT:** Depth of field decreases as you get closer to your subject and your focus point becomes closer to the camera. When you are far away from your subject, on the other hand, such as with a distant landscape, depth of field is infinite and very little affects it.

- **F-STOP:** As you change your f-stop from a wide opening to a small opening, your depth of field increases. This gets a little confusing because of the way f-stops are numbered on your camera. A wide opening is an f-stop with a small number, such as f/2.8. A small opening is an f-stop with a large number, such as f/16. These numbers actually reflect fractions so they do make sense even if they are a little confusing. An easier way to think about this is that small numbers yield small amounts of depth of field and large numbers yield large amounts of depth of field.

While your choice of f-stop has a big bearing on depth of field, it's important to remember that focal length and distance to subject can also impact depth of field. You can stop your lens down to a small f-stop, such as f/16, and still have shallow depth of field because you are using a big telephoto lens close to the subject. Or you can shoot wide open, such as f/2.8, and still have deep depth of field because you are using a wide-angle lens at a distance from your subject.

One common problem with depth of field is losing sharpness in important parts of the scene. This is probably most common when something in the foreground needs to be sharp and it's not. Check your LCD, magnifying the view, to be sure you have sharpness where you want it.

Cobblestone street, New York City

LEFT: *Deep depth of field*
70–200mm lens + 1.4x extender, f/4.0
for 0.3 sec., ISO 400

RIGHT: *Shallow depth of field*
70–200mm lens + 1.4x extender, f/4.0
for 1/250 sec., ISO 400

the art of the photograph

Shallow Depth of Field

So often photographers think the only way to photograph things is to use a lot of depth of field. Sometimes that's appropriate; sometimes it isn't. Deep depth of field means that more things in the background are sharp—things that can distract from your subject. In addition, to get that deep depth of field, you may need to shoot at a slow shutter speed to match a small f-stop, which then can reflect camera movement and therefore decrease image sharpness.

By deliberately shooting with shallow depth of field, you can create a very strong emphasis on your subject. When your subject is sharp and everything else is out of focus, it is easy for the viewer to see what is important in the picture, such as in the penguin image at left. This does not mean that you have to shoot with your subject filling the frame and only a bit of out-of-focus background. The subject can be relatively small within the composition while everything else is out of focus; the subject will still instantly be seen in the composition and the rest of the image will become visual space to contrast with that subject.

Note that just because something is out of focus in the background does not mean it no longer has an impact on the photograph. It can still have changes in tonality and colors that can be either interesting additions to the scene or distracting elements that keep your picture from being its best. The only way to know is to pay close attention to that background.

Shallow depth of field creates an interesting challenge for photographers: you really have to watch your focus point. You need to be sure that whatever is sharp is important. If the sharp part of your picture looks odd or arbitrary, a viewer won't care for the image. This becomes increasingly critical as you move into close-up and macro photography. Hitting the wrong focus point can totally throw off a composition. Your camera's auto-focus may focus on a person's nose or beard and not on his or her eyes. The eyes of a portrait, even when you are shooting wildlife, must be sharp even if they're the only sharp element in the picture. If they are not sharp, the picture will not look right. This means that you may have to shoot manual focus when working with shallow depth of field.

King penguins, South Georgia Island
400mm lens, f/4.0 for 1/160 sec., ISO 100

Deep Depth of Field

Deliberately choosing more depth of field for a picture changes the complexion of your composition. It creates emphasis throughout the image because there is sharpness from foreground to background. You have to pay close attention to what is happening to pictorial elements within the image everywhere because they are sharp. When something is sharp in an image, it gains an emphasis, so the viewer will pay attention to it. Deep depth of field can also create deliberate confusion, such as in the image of the busy watering hole shown at right.

Foreground and background relationships become increasingly important as depth of field increases. You have to look at balance between the foreground and background, including looking at what is happening in the middle ground. Sometimes photographers pay so much attention to the foreground and background that they don't see distractions occurring in that middle ground, such as too much empty space, bright or colorful visual disturbance, strongly lit objects that take away from the rest of the image, and so forth. Deep depth of field is also a way to emphasize leading lines, discussed on page 90. You also get rid of leading lines by using shallow depth of field, so only part of the image is sharp and the lines go out of focus. Just be sure that, if the leading lines are important to your composition, they are sharp where they should be critically so.

An interesting side note is that if you have a strong foreground that is very sharp, the background can be softer and still accepted by viewers, as in the image of wildflowers shown opposite, below. People don't expect the background to be as sharp as an important foreground. So if you need to get the most sharpness throughout your image, be sure that the critical elements of the foreground are sharp when they need to be. You can then get the background as sharp as possible, but don't worry if it's not perfect.

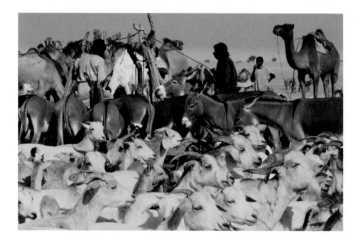

THE DIFFRACTION PROBLEM

You may sometimes run into problems when trying to get a deep depth of field by using a very small f-stop, particularly with a wide-angle lens. An f-stop is the relationship between the size of the hole, or aperture, in the lens and the actual focal length. A small f-stop on a wide-angle lens is physically smaller than the same f-stop on a telephoto lens.

When the f-stop gets very small, *diffraction* occurs. Light bends around the edges of the opening for the f-stop, causing a softening of the image. You may find that with certain lenses, for example, f/16 is fine, but f/22 gives a distinct drop in sharpness. So even though f/22 gives more depth of field, the overall image looks less sharp.

Nikon long had a reputation of not allowing very small f-stops on some of its lenses for this very reason.

You could not use f/22, for example, because it simply was not available. On the other hand, many manufacturers have allowed very small f-stops on the lenses because they know that people ask for them. Just because those f-stops are available does not mean they are the best for your photography.

The only way to know what your particular lenses do when stopped down to small f-stops is to take some shots and see. Set up your camera on a tripod so it is locked down in order to avoid camera movement. Shoot a series of exposures from f/11 to the smallest f-stops available on that lens. Bring those pictures back to your computer and enlarge them to look at fine detail. Compare that detail among the pictures to see what changes occurred at small f-stops.

ABOVE: *Brooklyn Bridge,
New York City*
17–40mm lens, f/11 for 1/125 sec.,
ISO 400

LEFT: *Wildflowers, Jasper National
Park, Canada*
16–35mm F2.8L II USM lens, f/32 for
1/60 sec., ISO 200

OPPOSITE: *Watering hole, Sahara
Desert, Mali*
70–200mm lens + 1.4x extender, f/20
for 1/80 sec., ISO 400

EXPOSURE CONTROL

A big challenge for photographers is that the camera simply cannot capture the range of brightness in the world that we can see. When we look at a subject with our own eyes, we can see all sorts of detail, from the brightest areas to the darkest areas. Unfortunately, the camera cannot. And when there is strong contrast between bright and dark areas, the camera will emphasize, even overemphasize, that contrast.

This can be especially problematic with bright skies and dark landscapes. It can be impossible to get a single exposure directly from your camera that captures both a good sky and good ground at the same time. Another problem can occur when you are photographing a subject in the shade against a bright, sunny background; the exposure range can be so extreme that, once again, there is no correct exposure to get a good image.

The first thing to do is accept that sometimes you just have to say no to a particular picture, recognizing that it may be impossible to get a good image given the lighting conditions since no exposure will be correct. If you can recognize this, you will start looking around for images that you can say *yes* to. That's an important decision to be able to make.

To get a better photograph, in certain situations, there are things you can do to control the way light comes into your camera. A traditional way for landscape photographers to deal with a bright sky is to use a graduated neutral density filter, which was used for both images shown on pages 116 and 119. This filter is half clear and half gray with a blend, or gradation, through the middle. By placing the dark part of the filter over the bright part of the scene, such as the sky, and the clear part of the filter over the darker part of the scene, such as the ground, you can balance the light coming through your lens so the camera can get a good exposure.

The challenge with a graduated neutral density filter is that it creates a line through the image. If you have a mountain or tree going into the sky, it will be darkened as well as the sky, for example. Unfortunately, this is starting to be a very dated look for photography. A graduated neutral density filter can still be helpful in knocking down bright light or brightly lit areas in the picture to balance them with the rest of the image, but you just have to use it carefully so the effect is not obvious.

Another way to deal with extreme ranges of brightness in a scene is to shoot several exposures of the scene and put them together in the computer. HDR, or high dynamic range, photography has become very popular as a way to create an image that captures a wide tonal range beyond the capability of just one exposure. (HDR can also be used to create rather abstract, unreal images, but both are always possible.)

One thing to be careful of with HDR photography is that it will often remove some of the very strong shadows that can be important to your composition. Strong use of dark areas can be critical to structuring a composition and creating a bold and lively photograph. We don't always want to get rid of those dark areas because they can be important pictorial elements.

Another way to work with multiple image exposures—and the one used for the series shown opposite—is to shoot an exposure for the bright areas, then an exposure for the dark areas. These two images are then combined in the computer by using the best of each. The difference between this process and HDR is that here you are using the strength of the dark parts of the image and not blending everything throughout the entire picture, as you would in HDR.

Shooting two images like this is actually quite easy to do. Start by locking your camera onto a tripod. Shoot one exposure that makes your sky look good, then shoot a second exposure that makes your ground look good. Bring the two images into Lightroom, where you can adjust the sky picture to make the sky look its best, and the ground picture to make the ground look its best.

Then you send the two pictures over to Photoshop or Photoshop Elements as layers. Put the two pictures on top of each other as layers and make sure they are lined up. Then simply remove the bad part of the top picture, revealing the good area of the bottom picture in that section of the image. You can do this in two ways. The down and dirty way is to simply use the Eraser tool by setting it to a large size and 0 hardness (a very soft brush). You then erase the bad part of the picture. The

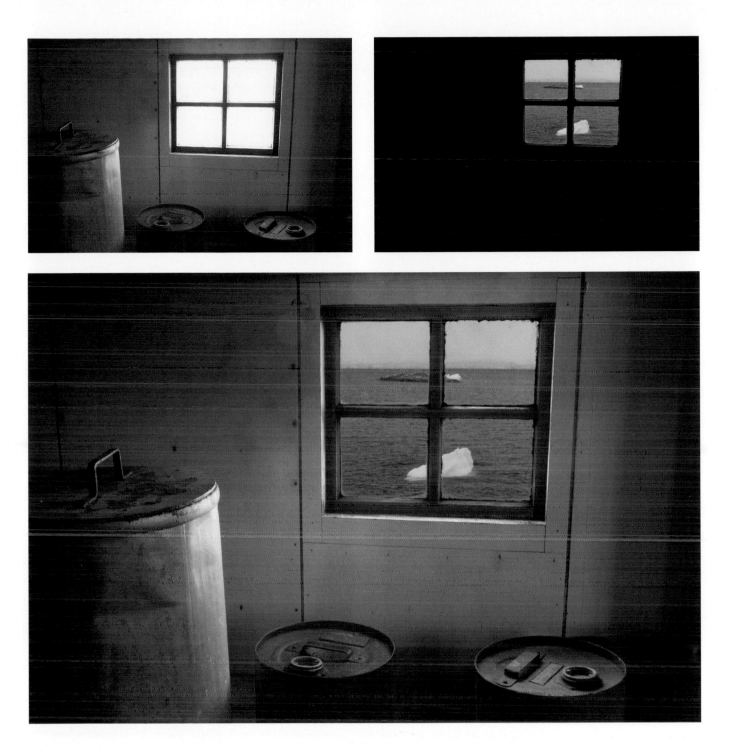

Old whalers' hut, South Shetland Islands

TOP LEFT: *Exposure made for the dark areas*
24–70mm lens, f/22 for 4 seconds, ISO 100

TOP RIGHT: *Exposure made for the bright areas*
24–70mm lens, f/13 for 3.2 seconds, ISO 100

ABOVE: *Combined result*

OVERLEAF: *Black-browed albatross rookery,
Falkland Islands*
24–70mm lens, 4-stop graduated neutral density
filter, f/9 for 1/50 sec., ISO 400

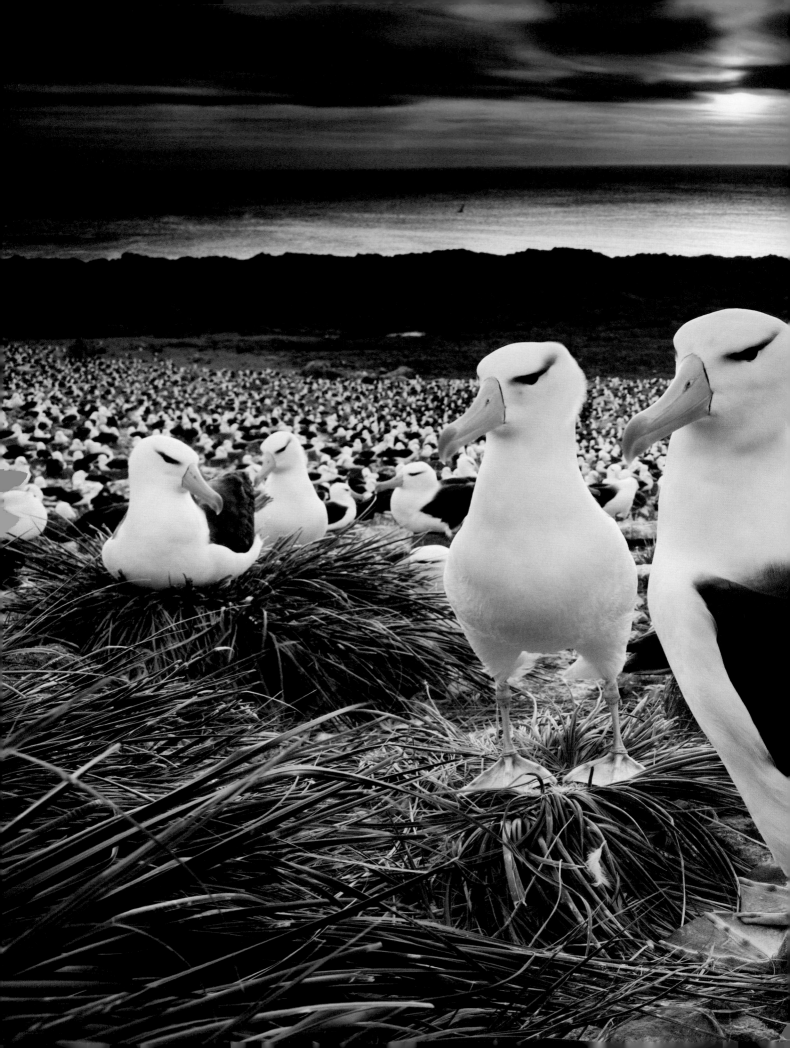

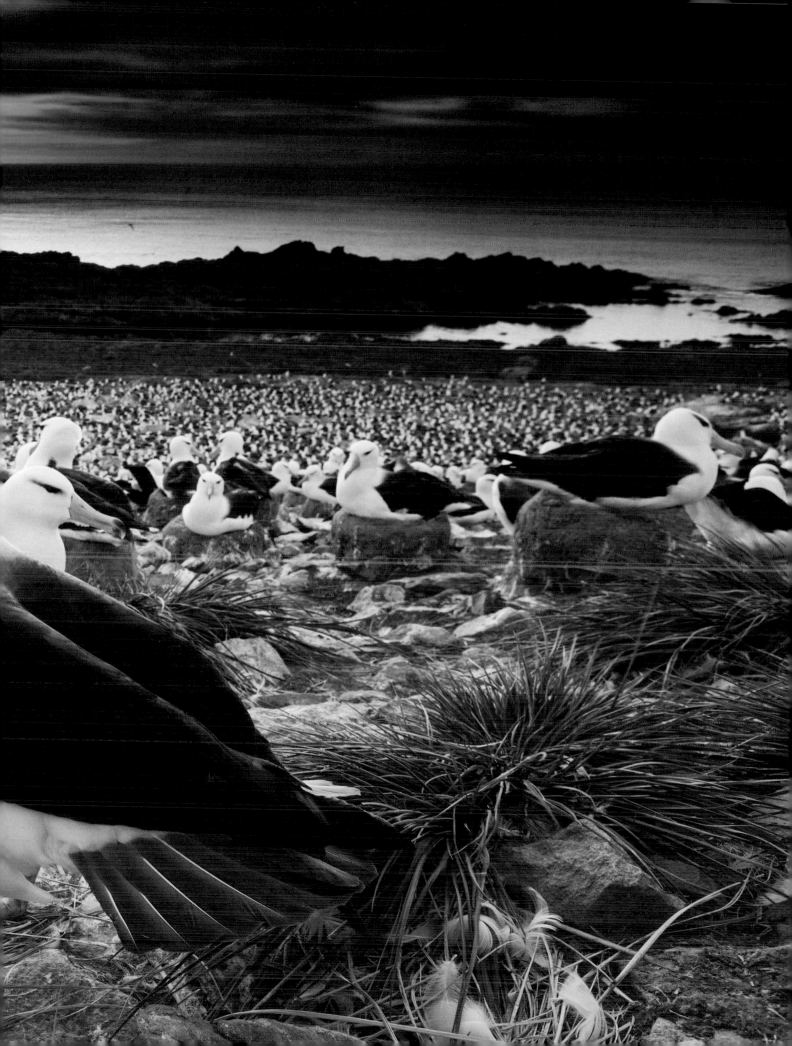

second way to do this is to use a layer mask. Add a layer mask to the top picture/layer and use a large, soft-edged (0 hardness) brush to paint black onto that layer mask and block the bad part of the top picture.

Lightroom also has additional controls that can be very useful in balancing the exposure over an image. The camera sometimes captures an adequate exposure of the scene but the brightness levels are out of balance from one another, which will cause problems with the composition. The Adjustment Brush and Graduated Filter controls in Lightroom are called "local controls" because they allow you to affect isolated parts of the picture without affecting anything else. This allows you to darken an overly bright area, lighten a too-dark area, and so forth. These controls are literally paint-on easy, unlike the steep learning curve required to use adjustment layers and layer masks in Photoshop.

Another option for dealing with this sort of problem includes plug-ins from Nik Software. These plug-ins will work with Lightroom and all Photoshop products. Viveza is one of their programs that allows you to use control points to specifically affect one part of an image and not another. Color Efex Pro now has a very effective filter called Detail Enhancer that will bring out all sorts of detail from bright and dark areas of the picture. You do have to be careful about overusing this, however.

Color Efex has long had an excellent set of graduated filter adjustments that gives you far more control than you can get in Lightroom or Photoshop. These adjustments allow you to darken a sky, for example, including adding some color that was washed out from the original exposure. You can even add a control point to remove the adjustment where this graduated filter goes across something like a mountain.

Are You Using Your Camera and Lens to the Fullest?

Ask yourself these questions to make sure you're using your camera and lens for the best compositions.

1. Do you understand the true advantages and disadvantages of your camera's format? When you know this, you will be better prepared to use your camera effectively.

2. Do you understand how your camera affects focal length and angle of view? If someone says they used a certain focal length for a particular composition, can you translate that into your format?

3. Do you know what perspective is and how to control it?

4. Are you simply zooming in and out from your scene or are you changing your camera position as you change your focal length? Do you understand what the difference means?

5. Are you getting close to subjects with a wide-angle lens to create a strong foreground-to-background relationship?

6. Are you using a wide-angle lens to emphasize leading lines in a composition?

7. Have you considered how a telephoto lens can change the perspective of the scene in front of you?

8. Have you experimented with different focal lengths when shooting close-ups?

9. Do you know why it can be a problem to shoot at very small f-stops, especially with a wide-angle lens?

10. Are you aware of the challenge that extreme brightness ranges can cause for exposure? Have you considered exploring ways to deal with this?

Acacia, Masai Mara National Reserve, Kenya
16–35mm lens, 2-stop graduated neutral density
filter, f/5.0 for 1/50 sec., ISO 125

COSSACKS IN MONGOLIA: Working the Subject

The Cossack culture takes eggs or chicks from golden eagle nests, and then the young birds are raised and trained to hunt fox and wolves for their fur. This practice is a dying element of the culture, something I wanted to communicate about these people.

My shoot started out with an old man and his grown son, a golden eagle, and a horse. I used a wide-angle lens up close to get a cultural portrait tight enough to show these folks but with enough background to show context. This is about using a wide-angle lens up close to communicate a story through a very specific composition.

As I worked the shot, the eagle was not cooperating, reacting to the camera every time I went in tight for the shot. That's a distraction, plus the son was mesmerized by the camera and kept looking right at it. The old man stood stoically; it was hard to know what he was thinking.

As I worked, the shots started to improve but still were not working. The son was too tuned in to the camera; the eagle cast a shadow over the old man; the old man cast a shadow over the son.

I lowered my position and the eagle instantly calmed down. Quickly, I grabbed a couple shots, including the first one that was really usable. I started to stand up again and the eagle was right on point, looking straight at me again. The eagle looked away but then the son was looking right at me again! I started to think it would be nice to just lean in and eliminate the son by not including him in the composition, but groups of two are not as visually interesting as elements of three or five.

As I kept working, I zoomed out wider. The old man was squinting so much that I had no idea if he was looking at the camera or not. I worked with them for about 20 minutes. Finally, the eagle looked "eagley" as it gazed off into the distance, the son looked off stoically, and the old man . . . well, I have no idea where he was looking.

—Art Wolfe

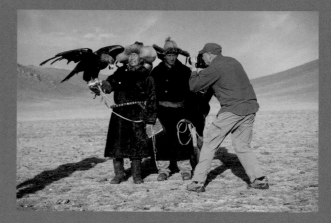

Eagle hunters, Mongolia

TOP: 16–35mm F2.8L II USM lens, f/6.3 for 1/320 sec., ISO 400

ABOVE: Art photographing eagle hunters (photo by Gavriel Jecan)

OPPOSITE, TOP LEFT: 16–35mm F2.8L II USM lens, f/9 for 1/200 sec., ISO 400

OPPOSITE, TOP RIGHT: 16–35mm F2.8L II USM lens, f/11 for 1/80 sec., ISO 400158

OPPOSITE, CENTER LEFT: 16–35mm F2.8L II USM lens, f/11 for 1/50 sec., ISO 400

OPPOSITE, CENTER RIGHT: 16–35mm F2.8L II USM lens, f/6.3 for 1/500 sec., ISO 400

OPPOSITE, BOTTOM: 16–35mm F2.8L II USM lens, f/6.3 for 1/500 sec., ISO 400

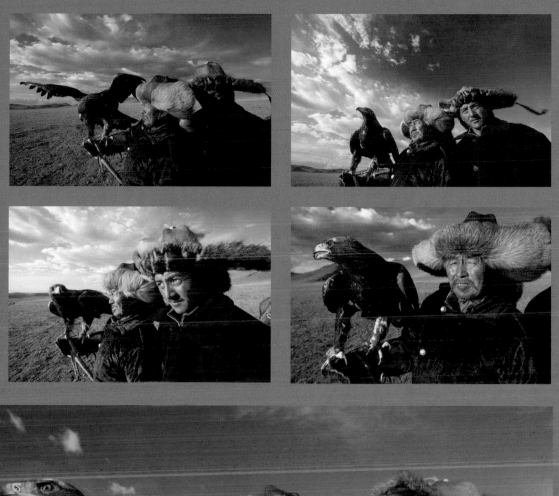

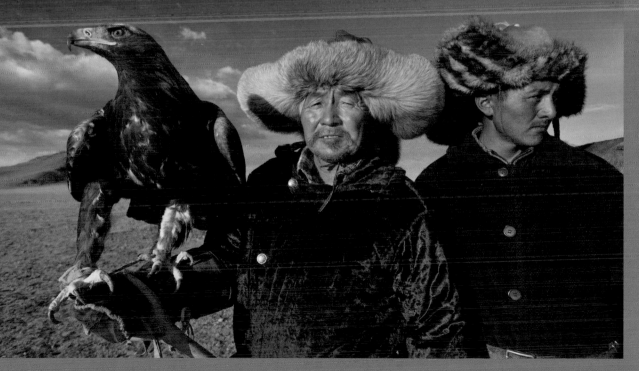

THE ELEMENTS OF DESIGN

Steve Jobs and Apple represent how important good design can be. Computers used to be considered boxes that did such amazing things that they did not have to look good. Yet, because of that, they appealed only to techno geeks. Jobs and Apple changed all that, so today people carry little computers with them, from iPhones to iPads and more.

Design is also very important to composition. Many photographers think of design as something fine art photographers do, especially with abstract photographs. Many nature photographers may feel that design is too esoteric, too removed from nature. But design is the glue that holds a photograph together. It provides structure and form to give an image coherence and strength, organizing it visually to make it understandable to a viewer. It is rare that we shoot anything without incorporating one of the design elements discussed in this chapter. The elements of design are often the first things we see in a scene. They are like blinking lights that say, "Look closer!" These visual signals trigger your eye and notify you that a photo is waiting there.

"Design is not just what it looks like and feels like.
Design is how it works."
—Steve Jobs

LINE

Let's first look at line, probably the most fundamental of the elements of design. When there are strong lines in a scene, there is almost always a photograph. In art school, Art had to sit down in front of many models and reduce their gesture and pose to just a few lines. It is very hard to use very simple lines that boil down the form in very elegant ways, yet that practice truly reinforced how important line is to images.

But line is about much more than outlining a subject. Lines have character and personality of their own. There can be graceful, soothing lines, and hard lines that look very graphic. There are gentle lines, sweeping lines, tortured lines, even lines like those created by painters such as Jackson Pollock.

People will look at a Pollock painting and say, "It looks like dribbled paint." Pollock would argue that his paintings were painted so that your mind and imagination could take over and go wherever you wanted with his paintings. He provided a platform from which your imagination took over. As you look at the lines in his images, really look at them, you will start to see movement, balance, and so much more.

You don't have to study fine art to know about lines. Check out optical illusions sometime to see how powerful simple lines are. They can fool you into thinking you see things that are not really there. At the end of this paragraph is a famous optical illusion of lines. The two main lines are identical in length, yet they do not look like it. The point is that just a

few strong lines, even if small, can totally change how we see something. That is the power of line in design.

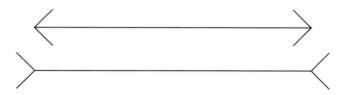

If you aren't careful about where lines are in your images, and how they interact with other lines, you can get unintended effects that can totally change your image. Lines can help your image communicate more powerfully, but they can also be a distraction and take away from your picture.

Lines have a strong impact on the movement of the viewer's eye through a scene. This is something to control, rather than leave to chance. If you don't, there may be lines in your photograph that actually take the viewer's eye *away* from your subject. That's a problem. Look at your photograph in terms of what the lines are doing to help your viewer understand the subject and the scene, and to give the image structure.

Line does not have to come from an obvious line from the real world. Certainly there are obvious lines, such as a plowed field, architectural lines, rows of plants in a field, or a winding path. But once you start looking for line, you will discover it everywhere. You can also create line in a photograph by the way you approach your subject (such as in the image shown at

SEEING LINES ON YOUR LCD

Your LCD can help you look at subject matter in the way the camera sees it, not just the way you see it in front of you. This is because the image is locked down into a two-dimensional representation.

Another advantage of the LCD is that it is small. The size of the LCD might seem like a disadvantage, and that is true for certain things, such as checking sharpness. However, when a composition is displayed small, it forces you to really look at what is going on, especially when looking at strong compositional elements such as lines.

Lines show up strongly when they are working well in a composition. This can help you see what the lines in your picture are truly doing.

This can also help you see if your lines are actually showing up in the photograph. Sometimes lines will look more obvious in real life than in the photograph. That small view on your LCD will help you see that. If the lines are not showing up, they're probably not a key part of your composition.

right, where the line of the horse's back creates an undulating horizontal line), the lens you choose, the angle to your subject, how light is affecting your subject, and so on. All of these things affect the appearance of line in a photograph. Use them to your advantage.

One hard part of talking about line is that there are so many different kinds, from the reflections of porch railings in water to an elegant stand of burned trees in winter. Every scene is going to show you something new about the way lines are used. It is important that you don't get stuck in a rut of seeing lines as one thing or another. Think about lines as important building blocks for your design, and not something arbitrary to add to a picture.

Be careful of seeing lines with your eye that your camera is not seeing. Photographers do this all the time. We might spot lines in a scene because of the way our eyes are made and because our heads are constantly moving as we look at that scene. Because of this, lines that overlap parts of the picture, such as the background, can be totally visible to us, because as our head moves, the relationship of that line to the background also moves. But the camera stops the movement, locking the relationship of that line into the background. If the line and background are similar in color or tone, the line will disappear against the background, even though we saw it perfectly well as we took the picture. We have to start looking at subject matter the way the camera sees it, not just the way we see it in front of us.

Lines are the basic structural element of any composition. Even if your photo has no distinct lines in the composition, there are always the four lines around the edges of the photograph. These edge lines visually interact with everything else in the photograph, which is why edges in an image are so critical.

Many photographers don't really look at the edges of an image. They concentrate so much on the subject and what is going on there that they don't always see what is going on around the subject, in the outer part of the picture. Yet the very distinctive lines that define the composition are obvious to anybody looking at a photograph. Any lines that you use within your composition will in part be defined by those edges of your image. That's why you have to pay attention to what is going on along those edges.

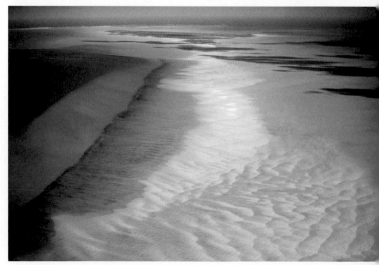

ABOVE: *Horses, Grand Teton
National Park, Wyoming*
24–70mm F2.8L USM lens, f/10 for
1/50 sec., ISO 400

LEFT: *Sand bar, Turks and Caicos*
70–200mm lens, f/2.8 for 1/4000 sec.,
ISO 250

SHAPE AND PATTERN

A shape is defined by three or more lines that are connected and may or may not have color or texture filling the space between them. Shapes are an extremely important part of a photograph because, given that photographs are two-dimensional, shapes are basically all you can display. We try to give shapes some form through light, but even forms become two-dimensional shapes in a photograph.

One place where shapes show up immediately is when you are flying. Grab a window seat and watch the landscape below, especially areas that have been impacted by humans. You will see amazing shapes, shapes you can capture by pulling out your camera and shooting through the window. This can be a wonderful exercise to help you explore shapes and what they might do for you in a composition.

Shapes can help define a composition, just as lines do. And, as with lines, we often see shapes differently than the camera does. It is important to be aware of this difference. In the past, we had to visualize how the camera would translate the scene in front of us. Today, the LCD on the back of your camera helps us do this.

What can you do with shapes? Look for various shapes, and be aware of how each one looks. As you first start doing this, it will be an obvious effort. However, as you practice finding shapes and composing them in your image, looking for them will start to become automatic. You will start automatically recognizing them in your scenes.

Some shapes are smooth; others are irregular. Smooth shapes have a calm, solid feeling whereas irregular shapes start having lives of their own. Smooth shapes are mellow and simple while irregular shapes can be complex and hard to define.

There are also round shapes and pointed shapes. Round shapes look inviting and gentle; we feel comfortable with them. Pointed shapes are dynamic and feel almost dangerous, because points can hurt us.

Shapes can be mostly horizontal, vertical, or square (or equally proportioned). Horizontal shapes are literally lying down, with no sense that they might fall over, and thus feel restful and calm. They remind us of things like the ocean and the savanna. Vertical shapes imply energy and lend a sense of upward movement to an image. They're definitely more edgy, because they could fall down. They can also create a feeling of stature. Square shapes feel stable and solid.

Shapes give us the opportunity to contrast one with another. You can contrast a smooth shape with an irregular shape, a round shape with a sharp shape, a horizontal shape with a vertical shape. You will find these sorts of shape interactions in the world as you start photographing them. Sometimes they are literally hidden in plain sight; we just need to open our eyes to the possibilities of shapes and their interactions with one another.

Shapes also overlap one another, which can be an important way to convey a sense of space and depth in a photograph. Whenever you can move so that shapes overlap, you convey to the viewer that one is in front of the other. And overlapping them can create stronger relationships between specific shapes, with their relationship clarified to a viewer.

Shapes also interact in space itself within an image. We talked a little bit about space in Chapters 3 and 4. Become conscious of what is happening to the shapes within the space defined by the edges of your composition. Where is each shape within frame? How close is it to the edge of your composition? Many photographers notice the shapes in a scene and use them within their composition, but forget to pay attention to what is happening to them along the edges of the picture. When a shape goes right up to an edge, just touching it or coming close to touching it, you create an uncomfortable connection between the shape and that edge. Generally, you either want a slight space between the edge and the shape, so the shape can float free visually from the edge, or you want to deliberately cut through the shape with your edge. When you do the latter, you typically use that shape as a frame or a way of defining the foreground from the background within your composition.

Repetition of shape becomes a pattern. This is largely what Art's book *Migrations* was about. There are shapes of animals repeated throughout the images, natural shapes and natural

patterns. As noted on page 29, *Migrations* became somewhat controversial because Photoshop was used to enhance some of the patterns, but all of the patterns began as natural repetitions of shapes.

There are so many places that you'll start to see patterns when you become aware of how useful they can be for compositions. Sometimes it means just zooming in to a tighter shot of a larger subject to emphasize a pattern there. Often you'll find interesting patterns in architecture as you travel. A telephoto lens can help isolate patterns of roofs and other architectural details. Not everything has to be a tight, tight shot of a pattern, but such a pattern will unite a scene as an image.

Be aware that photographs of patterns can also be boring. If the only thing in your image is the same pattern going all the way across the frame, there won't be much for the viewer to latch on to or explore. Look for something that has a distinct contrast to the overall pattern to visually break it up. This does not mean you should throw in some huge pictorial element to tear apart the pattern; you want to still keep the pattern as the major part of your composition. You are simply looking for some small thing with a strong contrast to help break up that pattern. This contrast will also intensify the overall pattern itself.

ABOVE: *Clay pots, Rajasthan, India*
70–200mm lens, f/25 for 0.8 sec., ISO 100

LEFT: *Bicycles, Paris, France*
70–200mm lens + 1.4x extender, f/45 for 3.2 sec., ISO 50

DIAGONALS

Often you will hear artists talking about diagonal lines within a composition. Diagonal lines can be important to an image because they affect the mood and visual impression of a scene. However, diagonals are not just about line. You can have diagonal shapes and patterns as well.

Diagonals are always dynamic elements within a picture. They create a strong feeling of movement because the eye wants to move along the diagonal. There is something about the human mind that wants to follow a diagonal line. We also tend to follow vertical lines up and down, though the eye won't really follow a horizontal line.

Most diagonals in the real world are objects with some sort of tension to them. We know that if most objects are placed on a diagonal surface, they are likely to move because of gravity, so a diagonal will typically be something that is moving or has the potential of movement. Diagonal objects in real life can look like they are ready to fall down, which adds to the sense of tension. That doesn't mean that diagonals used in your photograph suggest that things are going to fall or roll down; it just means that there is a tension and movement that people react to.

Something interesting happens when diagonals are combined with horizontal and vertical lines. They can look like support beams. Think about when you play the game hangman. Most people draw the hanging post with a diagonal line between the vertical and horizontal lines to make the post look like it has more support. Although putting a diagonal line in with a vertical or horizontal line will create dramatic contrast, such as in the image of the tulip fields shown opposite, it can also be distracting and disturbing for the viewer. Be careful about how you use diagonal lines, shapes, and patterns.

All of this discussion on diagonals may seem esoteric and not applicable to that landscape you are photographing with a stream running through it, yet as you look at scenes around you, you will start to see diagonals that can help structure your composition and create a stronger design. Once again, becoming aware of this element of design will help you use it to benefit your composition.

Blue Angels perform at Seafair, Seattle, Washington
400mm F4 DO IS USM lens, f/7.1
for 1/2000 sec., ISO 400

ABOVE: *Tulip fields, Skagit Valley, Washington*
70–200mm lens, f/2.8 for 1/2500 sec., ISO 400

RIGHT: *Insect tracks in dunes, Namib-Naukluft National Park, Namibia*
70–200mm F4L IS USM lens, f/20 for 1/4 sec., ISO 100

SPIRALS

Spirals can also define movement within a photograph. A spiral is a curved line or pattern that curls around toward a point, often getting smaller and tighter as it moves toward that point. A spiral definitely implies movement down the spiral toward its center.

There are many things that have spirals, both in nature and in man-made objects. The classic spiral comes from a snail's shell. A common spiral in architecture can be found in spiral staircases. Spirals, often seen as something spiritual with an innate power, have been used in primitive and ancient art for a long time. Indeed, there is no question that they provide power to an image because they strongly control what the viewer looks at within the image.

You may have heard of the Fibonacci spiral. Its definition is mathematical: The Fibonacci spiral is a geometric spiral whose growth is regulated by the Fibonacci series. The Fibonacci spiral has a sudden, almost exponential growth that repeats the rapid growth of the Fibonacci series itself. Okay, true confession: we had to look this up. We don't generally go around measuring Fibonacci spirals, let alone spelling the term correctly. We mention it here because you will hear artists and photographers talk about it as if it were some sort of elite compositional tool. There is no question that this type of spiral is unique and a part of nature, but it is extremely difficult to use as a photographer.

The important thing is to simply look for spirals, as they can be a very dynamic way to compose an image. Just be careful that everything within your image supports the spiral. If you have some lines that don't really go with that spiral, for example, they will be distractions and will not help your composition.

ABOVE: *Fiddleheads, Puerto Rico*
70–200mm lens, f/29 for 3.2 seconds,
ISO 100

LEFT: *Woman on spiral staircase,*
Kathmandu, Nepal
24–70mm lens, f/11 for 1/20 sec.,
ISO 400

OPPOSITE: *Succulent, California*
24–700mm lens, f/20 for 0.3 sec.,
ISO 50

THE POWER OF COLOR

Many photographers see color as the natural state of things. In other words, they photograph the color in front of them because it is the color that is in front of them! Shooting in color is, after all, the default state of shooting with a digital camera. And if you shoot with RAW files, your image is always in color because a RAW file can only be in color (though it can be translated into black-and-white).

This is a very limiting way to look at color. Color is a powerful part of imaging for many reasons, but the key to color's power comes from using it in ways that have a strong impact on your image. This can be as simple as moving your camera position left or right to include or exclude a certain color in the background.

To start to understand color and how to use what is in front of you in your photography, you need to become aware of that color and understand its potential. As that happens, you'll start to see color as more than simply the natural condition of your subject. You will start to appreciate how the inclusion of certain colors in the composition will affect your final results.

One of the most important aspects of color's power is its ability to affect a viewer emotionally. You don't have to be a deep thinker about color theory to understand that. Imagine a picture filled with red and how that would affect you. Then imagine a picture filled with blue and how that would affect you. Even if the subject matter were identical in both pictures, you would feel differently about the images simply because of the color.

Many of the feelings that we have about color are consistent throughout the world, even in different cultures, though, of course, there are unique aspects of color that different cultures embrace. For example, many colors are seen and used differently by European cultures than they are in Asian cultures. But there is still a core underlying psychology of color that extends throughout the world. There is something about human nature that is wired to respond to colors in a certain way.

To help you understand the power of color, let's look at some individual colors and what they can mean emotionally.

WHAT IS RGB?

We have been talking about the primary colors of red, blue, and yellow. In the computer world, you will see the primary colors listed as red, green, and blue or RGB. Why the difference?

Red, blue, and yellow are the primary colors for pigments and are the way we normally perceive colors. Our world is constructed largely of pigmented colors. Most research on color theory is based on these primary colors. Mixing these three primary colors, if they are pure, will theoretically result in black.

However, red, green, and blue are the primary colors for light. When you mix these colors together, you get white light. This is why they are so important for computers, because these colors are mixed on your monitor, which is using light, to create all of the colors you see, including white.

ABOVE: *Old paint, Ushuaia, Argentina*
24–105mm F4L IS USM lens, f/13 for 1/100 sec., ISO 250

PAGE 138: *Girl with parasol, Myanmar*
70–200mm F4L IS USM lens, f/13 for 1/15 sec., ISO 400

RED

Whenever one thinks of red, one almost immediately thinks of passion and action. Red is a lively color that grabs you; it is not about to sit peacefully in the background. Because of that, red can dominate an image very quickly, even if it isn't intended to be a major part of the scene.

Red is a color of alarm and warning. Think of stop signs, but also think of ladybird beetles, which use their colors to warn predators that they are not edible. Red is also color with positive connotations: just consider Santa Claus or Superman. People who wear red are generally seen as positive and energetic. In many Latin American countries, red is a major part of clothing and decoration because of its lively impact.

Red is the color of romance and passion, but it is also the color of blood and violence. It is a color of heat, especially when it tends toward red-orange, such as in the image of the forge, where you can practically feel the heat. When red starts heading toward purple, it gains an almost royal aspect.

Fill a composition with red, and you have a photograph with a lot of impact. Red in any photograph is going to attract attention, so be careful how you use it. Be aware of how strong red can be and use it deliberately.

Forge, Morocco
24–70mm lens, f/16 for 0.4 sec.,
ISO 100

GREEN

Green is the color of nature and therefore an important part of nature photography. It connotes life and growth.

Green is an extremely variable color, too. Green is what is called a secondary color, meaning that it comes from a combination of blue and yellow pigments and it has aspects of both colors. Greens range from almost yellow to almost blue. As green changes in color, it takes on more of the aspects of the color it is being blended with. Green with yellow will be brighter and livelier than green with blue. Green with yellow is a color of spring and fresh life. Green with blue is a relaxing color and the color of mountain lakes and streams.

Conversely, green is also seen as a solid color, in part because it is the color of grass and trees, which we think of as solid elements of our environment. Green is a color of renewal and health; think of a plant that is vibrant and strong, but when it starts to turn brown, you know it is unhealthy.

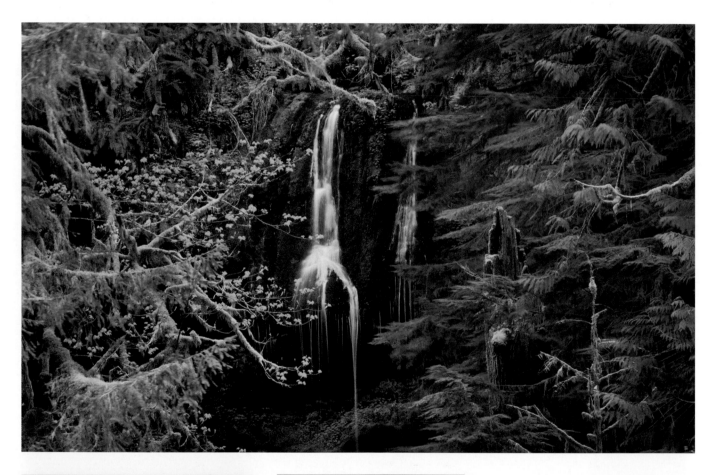

ABOVE: *Waterfall, Columbia River Gorge, Oregon*
24–105mm F4L IS USM lens, f/14 for 1.6 seconds, ISO 50

LEFT: *Thula sulphur butterfly, Firth River, Canada*
100mm lens, f/13 for 1/25 sec., ISO 200

ORANGE

Orange is the warmest color of the group. A secondary color, it combines the passion of red with the brightness of yellow. It definitely radiates heat. It also demands attention, much like red does.

Used for warnings, orange also conveys an element of danger. This is not simply a human aspect of the color—in the insect world, bright orange butterflies, such as the monarch butterfly, are warnings to predators that they are not edible.

Orange varies depending on the ratio of yellow to red. As it tends toward the yellow, it feels purer and brighter. As it tends toward red, it gets richer and more passionate.

ABOVE: *Torii gates, Kyoto, Japan*
70–200mm lens, f/20 for 2 seconds, ISO 200

RIGHT: *Tiger, Banhavgarh National Park, India*
70–200mm lens, f/2.8 for 1/800 sec., ISO 500

VIOLET

Technically, violet (rather than purple) is the term used to describe the combination of red and blue in color theory. For the purposes of our discussion, purple is essentially the same, though purists may consider purple to have more blue than violet does. Violet is a secondary color because it combines two primary colors and has long been considered the royal color, even more so than red (royal purple is a well-known term). Violet does have some cultural associations with being expensive; violet as a pigment was very difficult and expensive for artists to create many years ago, so it became associated with money and royalty. That is still common today; just think of the violet bags used for expensive liquors and perfumes.

Violet is a very moody color, perhaps because it combines the action of red with the peace of blue. Artists use violet when painting things like storms and emotionally evocative images. It is also a color that shows up in distant scenes after sunset.

Like green and orange, violet changes depending on how much blue or red is in the color. As violet gains more red, it gains passion and intensity. As violet gains more blue, it becomes moodier and potentially more restful, though because it also contains red, violet will never be as restful as a color like blue.

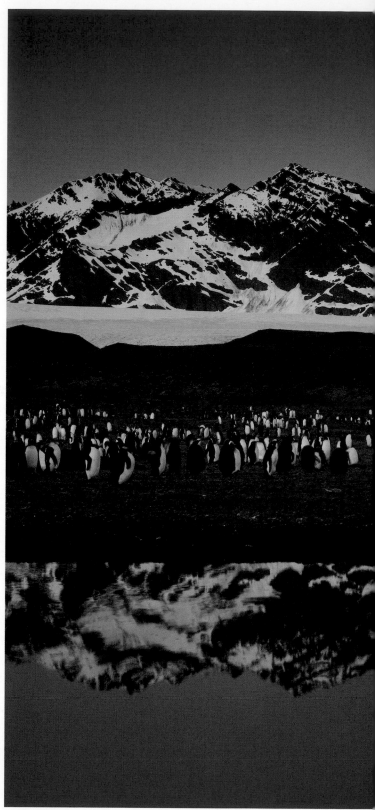

Tulip field, Skagit Valley, Washington
EF24–105mm F4L IS USM lens, f/18 for 1/60 sec., ISO 400

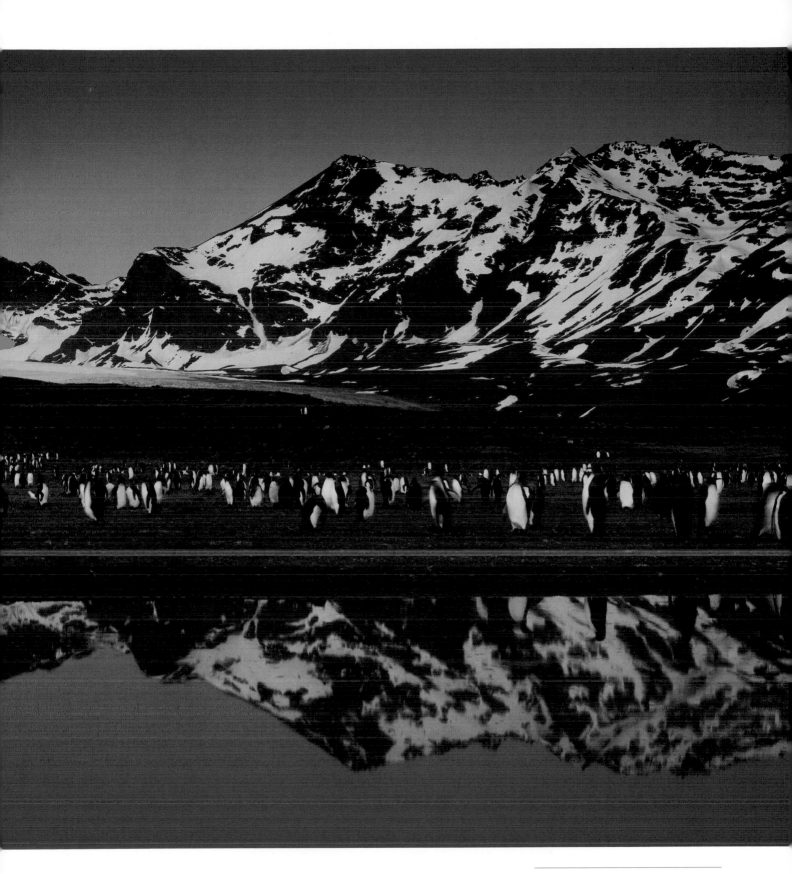

King penguins at twilight, South Georgia Island
70–200mm lens, f/8 for 1/4 sec., ISO 125

COLOR IS SUBJECTIVE

Colors do not exist in isolation from other colors in the world or in a photograph. That's an important thing to keep in mind because it means that as you use colors in your photograph, you are influencing every other color in that same photograph. Colors will change in their appearance and how we react to them because of other colors around them.

You just read on page 148 about neutral colors and their influence on other colors. Black and white are extremely important to the photographer. They are not simply shadows or bright areas of a photograph; they have very distinct effects on the colors in your image. This is important to remember when you are working with a large area of shade—for example, an area of darkness that contrasts with other colors. Many people are talking about using HDR for their photography. HDR is an amazing technology that does allow you to capture things in a scene that were not possible with traditional photography in the past. However, HDR can also lose blacks and whites in a photograph, blacks and whites that can have a big influence on the color of your image. Contrast is not always a bad thing, especially when color is concerned.

Another thing to keep in mind is that we see color very differently than the camera sees it. We see a color in all of its richness, whether it is in bright light or in shadow. The camera cannot do this. Digital cameras are especially limited in the way that they deal with color in dark and bright exposed areas of an image. The chroma, or the quality of a color, changes as it is recorded darker or lighter through exposure by your camera. The result is that you can get fooled into thinking that you have a great color in front of your camera, but the camera won't record it that way. This is another area in which your LCD can help. While an LCD is not precisely color corrected, it is a pretty good representation of the colors in front of you. If you can't see colors captured on your LCD, they probably are not in your image the way you saw them in real life.

As a side note, a lot of photographers complain that the LCD is hard to see in bright light. That's true! Get over it! You can learn to use your LCD in any condition. You can learn to interpret it when the light is bright, or you can shade it to help you better see it. It is often helpful to wear a hat if for no other reason than to use it to shade your LCD in bright sun.

Roses in reflected light, Morocco
70-200mm lens, f/25 for 8 seconds, ISO 160

COMPLEMENTARY COLORS

One way colors influence each other is through "complementary colors," the colors that are opposite each other on the color wheel. Combinations of complementary colors excite the retina of the human eye. This fact has long been known by colorists and was effectively used by Impressionist painters to create lively and interesting images. Complementary colors have a great deal of power, creating lively and strong contrast within a photograph. They can provide an intensity to an image that you simply don't get any other way.

Complementary colors are based on the color wheel and the primary colors of red, blue, and yellow. The key complementary colors are orange and blue, red and green, and yellow and violet. Notice that each pairing consists of a primary color with a secondary color.

Because these colors are opposites, they never actually mix to create unique colors, such as with yellow-orange or blue-green. When complementary colors are mixed, you will theoretically get a gray. But when you put complementary colors next to each other, they become their most vibrant because they share no colors. In other words, an orange fall tree looks even more orange when next to a blue sky, and red flowers are more strongly red when set against a bright green bush.

These complementary color combinations have some unique characteristics of their own. Orange and blue are not only opposite each other on the color wheel, they are also opposite each other in temperature. Orange is one of the warmest colors whereas blue is one of the coldest colors. Yellow and violet are not only opposite each other but they are also colors with the strongest brightness difference. Yellow is always much brighter than violet, so there is a tonal contrast as well as a color contrast when they come together. Finally, red and green are most alike in tonality. This means that a contrast between them is pure color and little else.

To use complementary colors in an image, be aware of both their power and intensity. Bringing complementary colors together can create a bold and lively image, but it can also create a garish image that is uncomfortable to look at. Not all subjects work well with such strong color contrast. In fact, sometimes an inadvertent inclusion of a complementary color in the background of your subject can damage an image and create a different emotion for your photograph than what you intended. The important thing is to be aware of these color effects and to use them appropriately.

Color wheel

Yellow and purple study, Washington
24–70mm lens, f/16 for 1/4 sec., ISO 50

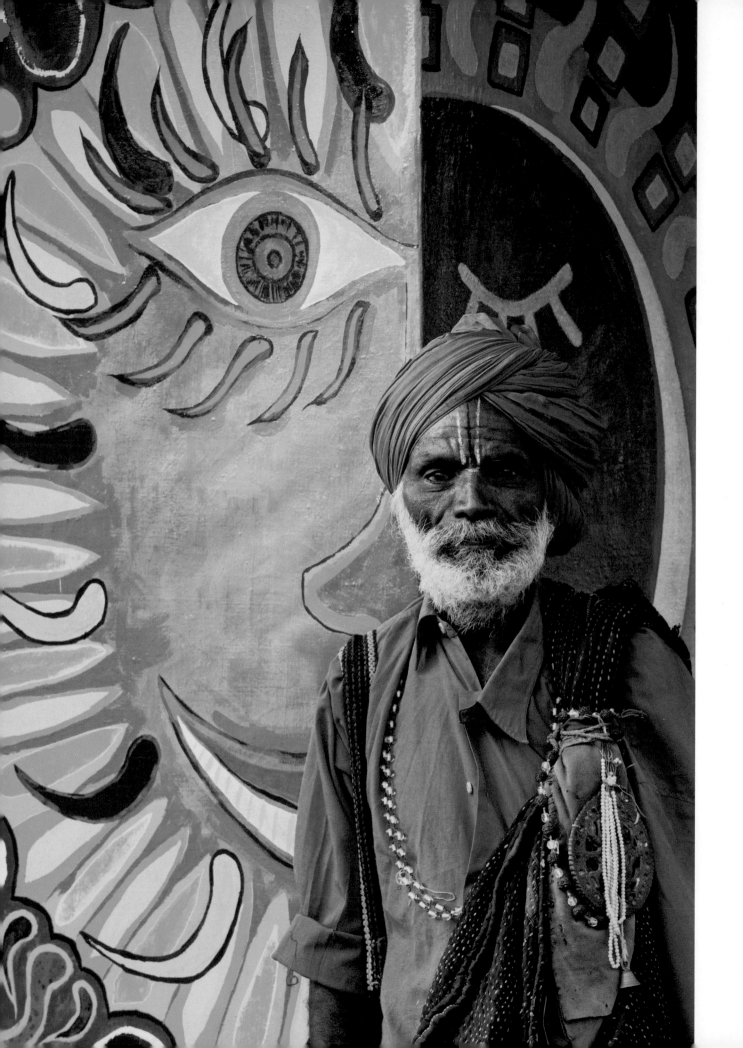

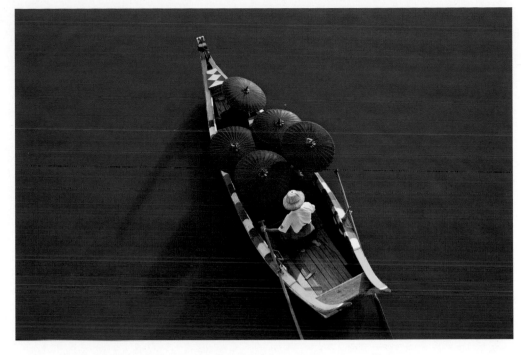

WHITE BALANCE AND COLOR

Auto white balance (AWB) is an amazing bit of digital camera technology. It is also a big problem if you care deeply about color. Auto white balance is designed to look at a scene and create a balanced approach to recording the colors of light. When you are dealing with unusual color, such as light at night or that found in many indoor settings, AWB can be a real lifesaver for getting good color. When we shot in film under both of those conditions, we never knew exactly what we were going to get.

However, when you are shooting in consistent conditions, such as in the sun or the shade, auto white balance has some distinct problems. First, it is inconsistent. If you zoom a lens to change your composition, your camera will get a different view of the scene, causing the auto white balance to shift its rendering of the color. You may end up with multiple pictures of the same scene that all have slightly different color. That can be a problem when you are processing the images in the computer.

Second, auto white balance has a tendency to give outdoor scenes a slightly bluish cast. We are not sure why this happens, but it is consistent across manufacturers. This blue cast is sneaky because it looks "okay enough" that photographers miss it and don't make the correction needed, even if they are shooting RAW.

A final problem is that it will remove important color casts that are true to the nature of the scene. For example, it will actually try to remove some of the color that occurs early and late in the day rather than retaining the natural warmth of conditions at those times.

After doing hundreds of classes with students who submit images for critiquing, Rob has found that auto white balance becomes painfully obvious all too often. Yes, it is possible to change your white balance when your image is in the computer, but there are two issues with that. First, you have to do it, which becomes a workflow issue. Second, you have to recognize that a color has been compromised. When Rob corrects students' photographs, they immediately see the problem with the blue cast of the auto white balance, but they weren't looking for it before the correction was made.

The solution is simply to set a specific white balance for whatever conditions you are shooting in, such as shooting Daylight for daytime sun or Cloudy for cloudy. You can also set a specific white balance that you know will work well with certain conditions, such as shooting Cloudy for sunrise and sunset times. Cloudy gives results at those times that are much closer to the way film captured sunrise and sunset.

BLACK-AND-WHITE IN COLOR

You might think this is a strange section for this chapter: black-and-white in color. Yet this is an aspect of color photography that can be quite effective for creating interesting and evocative images.

What does black-and-white in color mean? Basically, it means that you are photographing a scene that is essentially black and white with shades of gray and very little color, such as in the images of zebras and Adelie penguins shown on these pages. Yet each image is entirely different than a pure black-and-white photograph. Natural and artificial lights always have some sort of color to them. In addition, as in the subtly colored image of prayer flags, opposite, you will often find hints of color that will be captured in a color image but would disappear if that image were changed to black-and-white.

Many people credit the well-known master of color photography, Jay Maisel, with the concept of black-and-white in color. Maisel is famous for his sensitivity to color and how it can be used in a photograph. When he first started doing his innovative color work more than 50 years ago, he felt that there was a distinct way of seeing color that contrasted strongly with the prevailing use of black-and-white photography of the time. He felt you could use some of the ideas from black-and-white photography with scenes that had very little color in them to create a unique color image that was essentially black-and-white in color.

This type of photography is not an obvious use of color. Many photographers don't even consider it because when they come across a scene that is essentially shades of gray, they assume there is not much potential for a color photograph. Yet if you become aware of the subtleties of color, you can find very interesting color images in conditions like this.

This is definitely about a subtle use of color. It can take a lot of practice to find and capture interesting images that use a black-and-white-in-color approach. Sometimes such scenes just don't photograph well. They look dull and boring. One reason photographers struggle with this is that they become too aware of the subject and are not looking for the photograph that includes subtle touches of color.

Probably the most common times to photograph black-and-white in color are during weather conditions that subdue the light and color. Foggy days, rainy days, snowy days, and other weather conditions will limit the amount of color in a scene. Foggy days and snowy days have particularly great potential for pictures that are interesting in their use of color, even though the image is largely black-and-white.

Black-and-white in color means that you have to be very aware of what is happening with the tonalities, the bright and dark areas of your picture. Your composition has to have structure and form based on those tonalities, not on the color, because the color is not that strong. However, the color is still important and you need to be aware of color casts and small color details that contrast with the overall black-and-white feel of the picture. It can help to look at your LCD and examine it closely to see both the tonal contrasts of the black-and-white and the touches of color that will make the photograph work.

Zebra portrait, Ngorongoro Crater Conservation Area, Tanzania
500mm F4L IS USM lens + 1.4x extender, f/20 for 1/80 sec., ISO 400

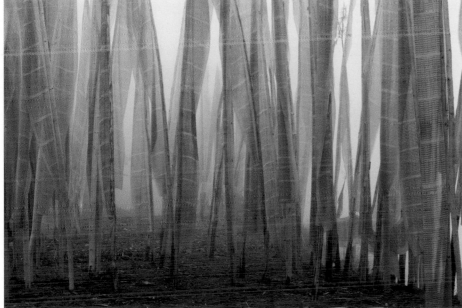

ABOVE: *Adélie penguins, Antarctica*
70–200mm lens, f/29 for 1/50 sec.,
ISO 500

LEFT: *Prayer flags, Paro Valley,
Bhutan*
70–200mm lens, f/22 for 1/4 sec.,
ISO 100

MONOCHROMATIC COLOR

You will sometimes hear black-and-white referred to as "monochrome." While it is true that black-and-white is a monochrome approach to photography, monochrome is not a synonym for black-and-white. Monochrome is also an important way of working with color in a color image.

Monochrome simply means "one color." A black-and-white image is one color, essentially shades of gray. However, you can have a monochrome image that is based on blue or orange or a host of other colors. The image has to be based on that one color with at most a very small percentage of any other color, and no complementary colors.

Monochromatic paintings are pretty unusual. Very few artists paint with such a limitation in color. Yet monochromatic images in photography are important and can be very effective and dramatic uses of color.

Probably the most common use of monochromatic color occurs at sunrise and sunset. During these times, the air can be filled with the color of the early or late light, permeating the entire scene, especially when you shoot with a telephoto lens. It is critical at these times that you do not shoot with auto white balance; you want to hold the color cast of the scene, while auto white balance will usually try to remove it.

Sunset is a time when you can often get strong monochromatic pictures. Dust and humidity increase during the day and fill the air with tiny particles that reflect and diffuse the light and color. If you can be at a place where there is activity of people and animals, you'll often get even more dust and humidity in the air, which increase the monochromatic effect.

Twilight is another time that often offers strong monochromatic effects. Just before sunrise, you'll sometimes see a strong blue color permeating the entire scene. Once again, a telephoto lens can be used to compress the distance, which will also intensify the color. You'll often get interesting colors after sunset as well, which can also be used in a monochromatic image.

Sometimes you will simply come across a scene filled with the same sorts of colors. Don't fight it: work with that monochromatic scene to find interesting compositions with just that color. An image filled with a single color can be a very bold and impactful photograph.

Dogwood blossoms, Washington
70–200mm lens + 1.4x extender, f/6.3
for 1/125 sec., ISO 100

ABOVE: *Broughton Archipelago,*
British Columbia, Canada
70–200mm lens, f/2.8 for 1/800 sec.,
ISO 200

RIGHT: *Dates in a market stall,*
Morocco
24–70mm lens, f/11 for 0.4 sec.,
ISO 200

BLACK-AND-WHITE PHOTOGRAPHY

It wasn't all that long ago that black-and-white was the "standard" everyone shot, while color was the "special" way of shooting. Now, color is the standard way of shooting while black-and-white is unique and special. Black-and-white photography is worth exploring because it can help you refine your sense of composition and become a better photographer.

Black-and-white is not simply the absence of color. That is an important concept to remember. Black-and-white is much more than that. Starting to think in black-and-white can even stimulate your thinking in color, just because of the contrasts in thinking.

It is important to remember that black-and-white is not the way we see the world. Even color-blind people do not see in black-and-white. Because of this, you have to start thinking about black-and-white as an *interpretation* of the world. You are not capturing reality, but a representation of reality.

At some point, spend some time just shooting in black-and-white. This will help you start thinking *in* black-and-white, rather than about how color changes to black-and-white. It is a little like learning a foreign language: you learn it faster and better when you are immersed in the language rather than constantly doing translations in your head.

On a digital camera, you can instantly see how a scene appears in black-and-white on your LCD.

Use RAW + JPEG if your camera allows this, then set the camera to black-and-white or monochrome. Your JPEG images will be in black-and-white, your LCD display will be in black-and-white, but your RAW will be in color. This will help you see in black-and-white as you shoot. Although it is important to start thinking in black-and-white, it can also be helpful to see your images in both color and black-and-white back at the computer, because that can remind you of what the original scene was like. Also, when you shoot in black-and-white, whether on film or JPEG, you are stuck with one interpretation of how colors are translated to black-and-white. If you have a RAW file, your options for better black-and-white are much greater.

Kids at play, Zanzibar, Tanzania
EF24–105mm F4L IS USM lens, f/8 for
1/250 sec., ISO 200

THE TRADITION OF BLACK-AND-WHITE PHOTOGRAPHERS

Black-and-white has a long and important history because it is where photography began. Black-and-white has a rich tradition of some of the finest photographers working to express themselves, and we can learn from them.

Three black-and-white photographers stand out because they show such diverse ways of using the black-and-white medium. All were known for how much time they spent in the darkroom to get the most from their images, but they were also all known for how much effort they put into getting the best shot they could, right from the start. Learn more about them and their work online or at the library or bookstore.

- **ANSEL ADAMS:** To this day, Adams exerts a great deal of influence on the public's perception of black-and-white. Many of his books are still in print, and every year you can buy calendars of his work. Adams was a photographer of light in black-and-white.

- **W. EUGENE SMITH:** Smith is considered the father of the photo essay and did work for *LIFE* magazine for many years. His black-and-white work is impeccable and he would often miss deadlines (to the frustration of his editors) because he was a perfectionist in how he worked on his images in the darkroom.

- **BILL BRANDT:** Brandt was a British photographer with a very stylized use of black-and-white. His images used very black areas and very white areas for dramatic contrast. He photographed everything from fashion to landscapes to photojournalistic subjects.

THREE KEY WAYS TO WORK WITH BLACK-AND-WHITE

Getting good black-and-white images requires the same disciplined approach to the elements of photography and composition that we have been discussing throughout this book. However, there are three key ways you can control your image in black-and-white to define and structure your composition. If you focus on these, rather than on the color in your scene, they can help enormously.

- **TONE OR BRIGHTNESS CONTRAST.** Wherever you have a contrast in tone or brightness in pictorial elements in your image, you will have separation and definition in black-and-white. This is one area that can be challenging when you are looking at color because sometimes colors lose their distinction when viewed in black-and-white. The classic example of this is red and green. They look totally different in color, yet often their brightness is the same and they blend together in black-and-white.

- **TEXTURE CONTRAST.** Texture is an excellent way to define areas of a photograph in black-and-white. Look for distinctive texture that is truly different. Photographers often see lots of texture from different elements in the photo, but they don't see that the textures are the same visually in black-and-white, even though the objects are different (this is often because color confuses the issue). When textures look the same, they do not separate from each other in a black-and-white photo.

- **SHARPNESS.** You control sharpness by keeping one part of the image sharp and the rest out of focus. This can be a very effective way to define a composition and, especially, to isolate a subject in black-and-white. You can't be wishy-washy about this, though. Having the subject in focus and the background *a little* out of focus is not enough. The background has to really be out of focus for this to work. A telephoto lens and wide f-stop (the smallest numbers) do this best.

If you start looking for contrasts in tonality, texture, and sharpness, you will start to see in black-and-white (and, by the way, it will also help you with color!). We guarantee that this is not easy at first. You will still be seeing things in color, even though you are working in black-and-white. It helps to use your LCD and set your camera to shoot in black-and-white with RAW + JPEG. Look at the LCD to make sure there are tonal contrasts that separate the subject and other pictorial elements in the image, and that contrasts in texture and sharpness are truly working in the scene.

OPPOSITE: *Cape of Good Hope, South Africa*
70–200mm F4L IS USM lens +1.4x extender,
f/36 for 5 seconds, ISO 100

BLACK-AND-WHITE CONVERSIONS

Now we are going to the computer to work on translating color to black-and-white. When you shoot in black-and-white with JPEG, you will start to *see* in terms of black-and-white as you shoot. You will learn specific controls that help you define black-and-white in your photos. And if you shot black-and-white and color at the same time by shooting black-and-white JPEGs as well as color RAW files, you will have a lot of flexibility in shooting color for black-and-white.

There is a huge variation possible when translating colors to tones or shades of gray. Every photo will need a different interpretation depending on what the photo is about and what you want the image to look like. This is an important concept: colors affect shades of gray, and you can control how a color changes into specific shades (not a shade) of gray.

There are some excellent programs available for converting color into black-and-white, all of which allow you to adjust how bright the various tones of gray end up. Many of these programs also have special effects, which can be very distracting. We have seen photographers get so distracted by the effects that they start changing the mood of their image before they control how effectively colors have been translated into shades of gray.

If you are interested in black-and-white, and converting color to black-and-white, this is extremely important. Be sure you control how the colors are translated into shades of gray. A red, for example, can become a light shade of gray, a medium shade of gray, or a dark shade of gray. One of those grays is likely to be correct; the others may be totally wrong for the image. The only way you will know is by playing with the conversion yourself.

Here is a brief rundown on how this works in several image processing programs. One tip is to work on the color image first—making your basic adjustments to bring out the best in brightness and tonality—before you convert it to black-and-white.

Adobe Photoshop Lightroom

Both of us feel that Lightroom is the best image processing program for the average photographer. Unlike Photoshop, Lightroom was designed from scratch for and by photographers. Lightroom has an outstanding set of controls for translating a color image to black-and-white. They are in the Develop module in the HSL/Color/B&W panel on the right.

This panel has eight sliders that affect the brightness of a color converted to a shade of gray. These sliders allow you to adjust contrast within an image based on how colors are changed. However, there is an even more important control available that makes black-and-white conversion easy and very effective. At the top-left corner of the B&W panel is a little circular button that looks like a target. Click on that and you activate your cursor.

Now, move your cursor over the photograph. As you move over different colors, you will see the colors highlighted by the sliders in the B&W panel. Once you are over a part of your picture that you want to make lighter or darker, simply click and drag your cursor up and down. Up will make that area brighter; down will make it darker. When you click, the cursor will disappear, but it is still active.

As you drag your cursor up and down, the color that Lightroom has found for you will be adjusted with the appropriate slider in the B&W panel. You don't have to do anything else. You simply go out into your picture with your cursor and click and drag on the photo while the appropriate slider automatically adjusts for you.

Adobe Photoshop

Photoshop has a similar set of adjustment sliders for translating color to black-and-white. The best way to do this is to use a Black & White adjustment layer over your color image. This includes an activated cursor option similar to what is used in Lightroom.

The Black & White adjustment panel includes six sliders that affect the brightness translation of a color to a shade of gray—two fewer than what is available in Lightroom. These sliders also allow you to adjust contrast in an image based on how colors are changed to shades of gray. At the left side of the panel, above the Reds slider, is a little hand icon. Click on that to activate your cursor.

Now, move your cursor over the photograph. When you are over a part of your picture that you want to make lighter or darker, simply click and drag your cursor left and right. Left will make that area brighter; right will make it darker.

As you drag your cursor left and right, Photoshop finds the color for you and adjusts the appropriate slider in the Black & White panel. As in Lightroom, you don't have to do anything else. You simply go out into your picture with your cursor and click and drag on the photo while the appropriate slider automatically adjusts for you.

Cemetery during Day of the Dead holiday, Pátzcuaro, Mexico
LEFT: 24–105mm F4L IS USM lens, f/16 for 1/125 sec., ISO 400

BELOW: Black-and-white conversion using Photoshop

Adobe Photoshop Elements

Photoshop Elements is an excellent program for the price. Today's version of this software does nearly everything most photographers need. It does have a unique black-and-white adjustment panel, though it is harder to use than the ones in Photoshop and Lightroom.

Photoshop Elements has its black-and-white adjustments under the Enhance menu with a choice called Convert to Black and White. When you select that, you get an entirely new window. This shows you a color "before" image on the left and a converted black-and-white image on the right. There is a set of color sliders below, along with some preset options at the left.

These color sliders are based on the red, green, and blue colors of the computer. They don't work like the color sliders in Lightroom or Photoshop for black-and-white work. If you move any of the sliders to the right, that color (and any other color that includes the slider color in it) will be brightened. Move that slider to the left, and those colors will be darkened. The challenge is that the whole picture can look darker or brighter at the same time. You have to work these sliders by always working with more than one. If you make one slider go to the right, you need to balance it with another slider going to the left.

Abandoned farmhouse, Palouse, Washington
RIGHT: 16–35mm F2.8L II USM lens, f/14 for 1/8 sec., ISO 100

BELOW: Black-and-white conversion using Photoshop and Silver Efex Pro plug-in

Nik Software Silver Efex Pro

Both of us feel that Silver Efex Pro is the best black-and-white conversion software available, bar none. One nice thing about recommending this program is that we can do it without it costing you anything. Nik Software offers a free trial so you can try Silver Efex Pro and see if you like it without taking our word for it. They also have free webinars on their website to help you learn to use the program.

Silver Efex Pro has been designed specifically to enable you to get the most out of your image when you are both translating a picture from color to black-and-white and in adjusting the converted black-and-white image to look its best. Silver Efex Pro is a software plug-in, which means that it must work within a host program, such as Lightroom, Photoshop, or Photoshop Elements. The easiest way to get to it with Lightroom is to right-click on your picture and go to the Edit In option of the menu that appears (if you have a Mac and don't have a right-click mouse, get one). In both Photoshop and Photoshop Elements, you can find Silver Efex Pro in the Nik Software section of the Filter menu.

When Silver Efex Pro opens, you will find a set of thumbnail images on the left side of your picture that give a quick overview of possible translations of your image into black-and-white. They are a good place to start. However, do not stop there. The most important part of the color translation is in how colors are actually translated, which in this case is affected by the color filter section of the right panel.

Go to that section and try clicking on the little color filters that are there. Often those color translations will give you an excellent conversion of your image. You can also try the color slider below these filters. This slider is like an infinite range of color filters that affect how bright and dark colors are rendered into shades of gray. Do not neglect this step.

After you have converted your image into black-and-white, go up to the controls at the upper part of the right panel that allow you to adjust components like brightness, contrast, and structure. Structure is a unique part of Nik Software products and is extremely helpful in defining tonalities in landscape and travel photography.

Are You Making the Most of Color and Black-and-White?

Ask yourself these questions to learn to get the most from color and black-and-white.

1. Have you thought about how powerful color is in your life, and how that applies to photography?

2. Are you becoming aware of the emotional potential of color?

3. Do you know why red, blue, and yellow are so important as primary colors?

4. Are you looking at black as an important color that affects the appearance of other colors?

5. Are you aware of the problems that auto white balance can cause?

6. Can you explain how colors are subjective and highly influenced by colors around them?

7. Have you considered how complementary colors can create lively and exciting compositions?

8. Have you considered the possibility of shooting an image that is black-and-white in color?

9. Can you find a monochromatic image that is filled with color?

10. Have you considered how important color is to converting an image into black-and-white?

11. Have you tried setting your camera to shoot in black-and-white, with your camera set to record in RAW + JPEG? The JPEG will be in black-and-white and the RAW in color.

SUNRISE ON THE GANGES: Preplanning the Shot

I was walking along the Ganges River in Varanasi, India, at dawn one morning when I saw the color. The sun rose through a layer of smoke and haze, and I thought, "Wow, that is a beautiful red orb." I had to get that shot.

I was at this location during the Kumbh Mela, a massive gathering of Hindus along the Ganges that happens every 12 years. This is a time of great spiritual and cultural significance when holy men gather to bless the millions of people who have made the pilgrimage to the location. Many pilgrims had traveled to Varanasi and upriver to Allahabad. Many were crossing the river to their encampments on the far side. I contacted one of these people the night before, offering a dollar to act as my model the next morning, one hour before sunrise.

The next morning, I positioned the boat with my new model in the dark mud along the shore. I used a polarizer to take the shine off the water in the foreground, creating the illusion that the boat was floating.

To get the deep depth of field that I wanted, I shot with a wide-angle lens and a small f-stop of f/22, getting an exposure of one or two seconds, during which my model had to remain still. The foreground point of the boat is every bit as sharp as the distant horizon. I had to work quickly because the color of the sun was so important, and it lasted only a short time. Once the sun rose above that layer of haze, it lost its color.

I loved creating this image, stylizing something these pilgrims did every day during Kumbh Mela, making the image more memorable. You don't know whether the person is a woman or a man, which helps the viewer see him- or herself in that place.

My best shots are not of the grand landscapes around the world, but of quiet moments in a forest or a desert that could be anywhere. The way you respond to an image is to put yourself in it, to let it tap into your memories. By avoiding a specific face or gender in this shot, it becomes open to anyone's interpretation.

—Art Wolfe

Spiritual Journey
17–35mm lens, f/22 for
1 second, Fujichrome Velvia

LIGHT AND COMPOSITION

Light is basic to everything photographic. In fact, we can't photograph anything without light of some kind. Even when using the newest DSLRs with their ultra-sensitive sensors and extreme ISO settings, you still need some source of light.

And light definitely affects the composition of your photographs! As you will learn in this chapter, light can trump almost anything else you are doing in composition to such a degree that all of the time you spend working on composition could be lost because of the wrong light. To get the most out of your photography, it is important to understand the characteristics of different kinds of light so you can use them to create outstanding images.

"Light makes photography. Embrace light. Admire it. Love it. But above all, know light. Know it for all you are worth, and you will know the key to photography."
—George Eastman

LOOKING AT LIGHT

We are going to arbitrarily examine light from three directions: front light, side light, and backlight. Light can hit a subject from an infinite number of angles, but by looking at these three specific angles, we can get an idea of what light can and cannot do for a subject and a scene.

Front light is light that hits the front of your subject as you look at it. This is light coming from behind you and striking the subject head-on. *Side light* is light that comes directly from one side or the other; it comes from both the side of the subject as well as your side. *Backlight*, such as that shown in this image of lions, comes from behind your subject and heads toward you and your camera.

As you start thinking about these types of light, also think about other combinations that lie between these definitions. In-between light typically has aspects of both types of light, but won't show the maximum effects of pure front light, side light, or backlight.

Lions, Chobe National Park, Botswana
400mm lens, f/4.0 for 1/640 sec., ISO 400

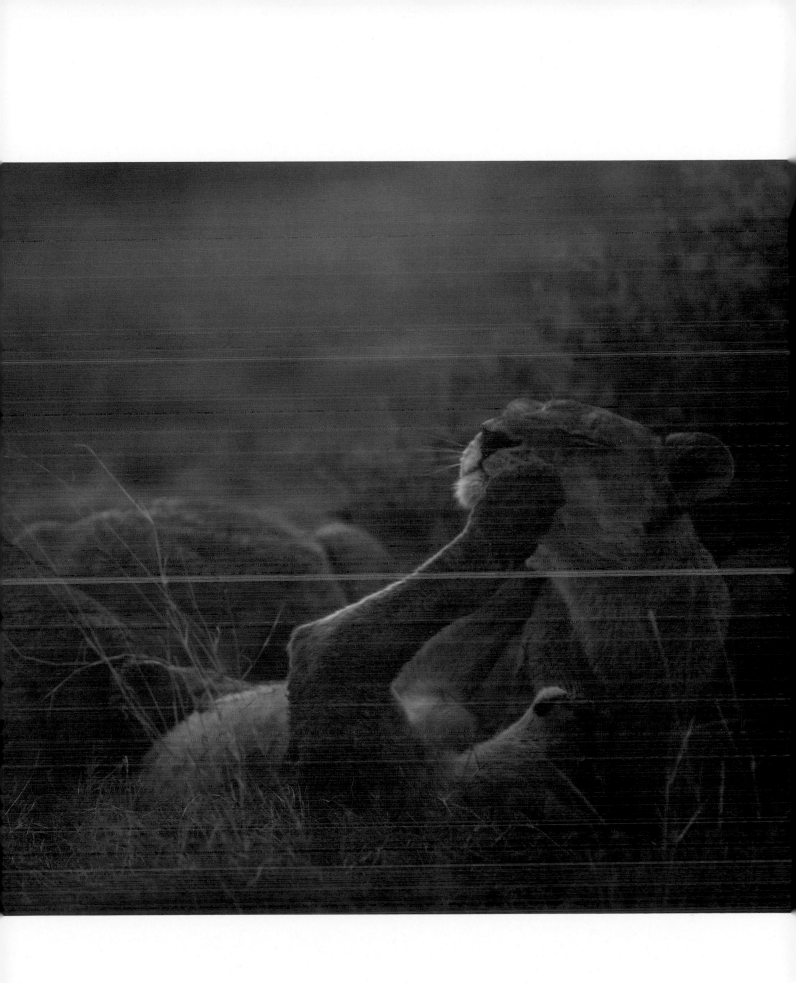

FRONT LIGHT

Front light has some positive and wonderful qualities, but can also be rather boring and unattractive when not used well. With the very simple cameras used for snapshots by our parents' and grandparents' generations, front light was not a bad idea because cameras had difficulty dealing with other types of light. In fact, folks of this generation would often tell other photographers that the sun had to come from over their shoulder—in other words, front light.

The problem with front light is that since the light is coming from behind you, hitting the subject on its front, shadows tend to fall behind the subject. The entire scene is lit up, leaving little shadow to add contrast, dimension, and interest. This is especially deadly during the middle of the day when the light is high, creating some of the least attractive light known to photography.

Front light becomes attractive when it is low. Early or late light, when the sun is just above the horizon, will give very strong front light that can have color and interest. You still won't have much in the way of shadows, but the way that this low light affects the scene can be dramatic.

Front light has long been used for fashion photography because it fills in shadows that might hide details on the clothes; it also fills in wrinkles and other unwanted details of the models. Landscape photographers have often recognized this type of dramatic light when shooting late in the afternoon after a storm has passed. The sun is setting in the West, which in the United States is the direction that weather mostly comes from. That means the dark storm clouds are now in the East. It can be very dramatic when low front light from a sunset highlights a landscape against dark storm clouds in the background.

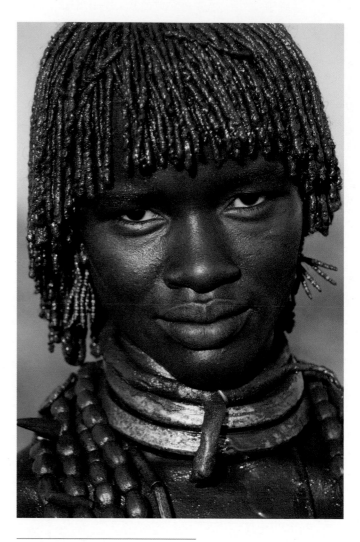

Hamer tribeswoman, Omo River Valley, Ethiopia
70–200mm lens, f/9 for 1/80 sec., ISO 400

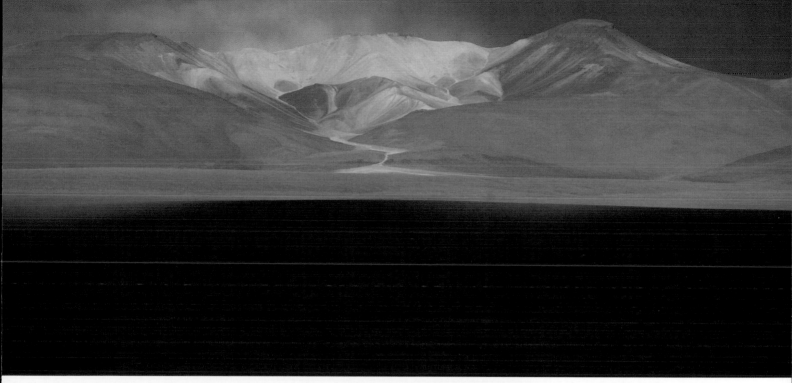

ABOVE. *Altiplano, Bolivia*
400mm F4 DO IS USM lens,
f/6.3 for 1/50 sec., ISO 125

LEFT: *King penguin chick,*
South Georgia Island
24–70mm lens, f/14 for 1/15
sec., ISO 400

SIDE LIGHT

Side light is a key light for dimension and texture, shedding both light and shadow on the subject. For an object to appear three-dimensional, it needs to have one side in light and another in shadow, a key result of side light.

Texture also only appears when there is light and shadow to define it. In fact, one way to get rid of texture in a scene is to use front light, which adds very little shadow. The strongest texture occurs with a low side light, which skims over the surface with texture. Low side light is a traditional light of landscape and architectural photography because of these qualities of dimension and texture. Many landscapes include strongly three-dimensional objects that are important to the identity of a particular location. If those three-dimensional objects are not defined by light, the landscape risks not being defined in a photograph.

We see three dimensions very differently than the camera does. The camera locks down a particular view of a scene when the shutter is released. When we look at a scene, we don't hold our heads perfectly steady. This slight movement causes objects to appear three-dimensional because of the way they subtly shift in relation to one another. In addition, our two eyes combine to create a three-dimensional view that cannot be seen with one eye. Neither of these things happens with the camera. The camera gives us an image that has no movement and is shot from one "eye." Side light is one way of defining dimension that the camera can see and capture.

Red-crowned cranes, Hokkaido, Japan
600mm F4L IS USM lens, f/8 for 1/400
sec., ISO 400

ABOVE: *Mount Adams and Mount Rainier, Washington*
70–200mm lens, f/5.0 for 1/1000 sec., ISO 400

LEFT: *Petroglyphs, Canyon de Chelly National Monument, Arizona*
400mm lens + 2.0x extender, f/14 for 0.3 sec., ISO 50

BACKLIGHT

Backlight is a dramatic light that scares many photographers. There are definitely some challenges with backlight, such as flare and exposure problems. Because of these challenges, many photographers simply don't shoot toward the sun. Yet professional photographers shoot constantly toward the light because of backlight's inherent drama.

Backlight can give you dimensional light . . . or not. It can give you texture . . . or not. It all depends on how high the light is. If the light is high enough, it will illuminate part of the subject and leave other parts in shade, lending dimension, form, and texture to objects within a scene. However, if the light is so low that it drops behind the subject or some large object behind it, you will lose all sense of form and texture.

Backlight is an outstanding separation light, allowing you to separate pictorial elements within your composition. When a backlight hits the top of any object, it makes the top of the object brighter, a brightness that can contrast with the shadows behind it. That contrast can strongly separate parts of your picture from other parts, whether the ridges in a mountain range or an animal in a field. Backlight, by the way, is an extremely important part of wildlife photography, since so many animals have coloration that makes them blend in with their surroundings.

An extreme form of backlight is "rim light." This is when the sun is very low behind your subject and creates just a narrow rim of light along an edge of the subject. This usually occurs because that edge of the subject is somewhat translucent and can contrast strongly with something such as a dark shadow behind it.

Prayer flags, Paro Valley, Bhutan
70–200mm lens + 1.4x extender, f/20 for 1/20 sec., ISO 100

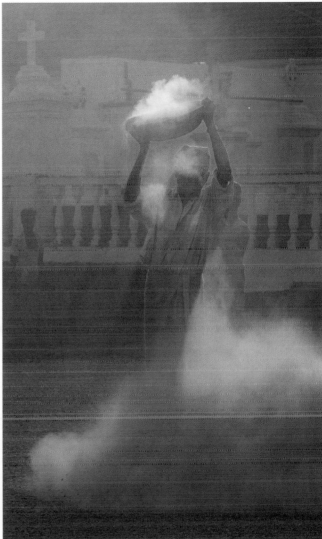

ABOVE, RIGHT: *Laborer, Goa, India*
70–200mm lens, f/14 for 1/250 sec.,
ISO 400

RIGHT: *Brown bear and cubs, Lake
Clark National Park, Alaska*
500mm F4L IS USM lens, f/20 for
1/100 sec., ISO 1600

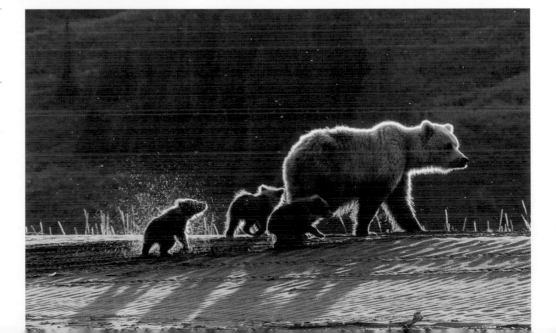

SILHOUETTES

One thing that sometimes happens with backlight is that you get *silhouettes*. A common situation in which you might get silhouettes is when you are shooting trees against a sunset. The sunset creates backlight, but the sun is so low that no sunlight is hitting any part of the subject that can be seen from the camera's position. The subject thus becomes very dark against the background, turning into a silhouette.

Silhouettes occur whenever there is an extreme brightness difference between a subject in shade and a brightly lit background. An effective way of creating impact and defining a composition, a silhouette stands out strongly within a composition and shows off what is important to the image.

Silhouettes can be fascinating when they fill up your entire composition, creating interesting light-and-dark contrasts that play with our ideas of positive and negative spaces. Since silhouettes are so dramatic, they also can be a relatively small part of your composition and still demand attention from the viewer. That said, if you have a silhouette in part of your picture that is not key to your composition, it can be a big distraction, drawing attention no matter where it is.

Samadhi, Varanasi, India
70–200mm lens + 2x extender, f/22
for 1/60 sec., ISO 200

ABOVE: *Cowboy coffee, Pantanal, Brazil*
16–35mm lens, f/4.0 for 1/40 sec., ISO 400

RIGHT: *Oxcart, Baobab Alley, Madagascar*
16–35mm F2.8L II USM lens, f/14 for 1/640 sec., ISO 100

SHADOW

When photographers talk about light, they talk about light and shadow in relation to each other, but they rarely talk much about shadow alone. However, shadow can be an extremely important part of a composition. It can even be the subject matter of a photograph.

With the popularity of HDR photography, many photographers are losing awareness of how important dark shadows can be to structuring a composition. In HDR, strong shadows disappear. While there certainly are places for HDR photography, there is also still a place for the use of a strong shadow in a photograph.

When the light is low, you can often get large areas filled with shadow, which can be wonderful backdrops for sunlit subjects. Sometimes photographers instead think only in terms of shooting a rather close shot of the subject, with just a small bit of the dark background. Yet there are interesting compositions to be made when the subject is small in the context of a large expanse of dark shadow.

Low light can also create wonderful shadows that stretch out across your scene. The most obvious tend to come from backlight, which makes shadows stretch toward you. In these conditions, photographers sometimes worry about not getting enough light in the shadows on the subject. Forget about that. Work with the shadows! Pay attention to what the shadows are doing and compose your image so that it is not important to see detail in the shadow areas.

Art photographing Lusitanos on the beach,
Bahia, Brazil
16–35mm lens, f/9 for 1/60 sec., ISO 100

S

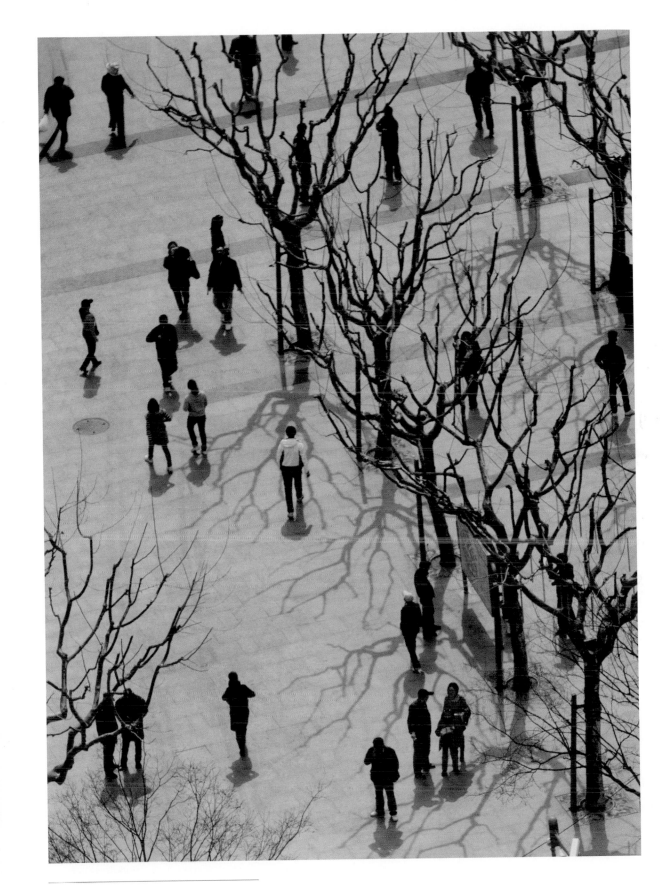

Yo
be
ma
ca
ing
ing
wa
is

co
or
da
lig
Th
siti
bri
As
an

Pedestrian zone, Shanghai, China
70–200mm F2.8L IS II USM lens + 1.4x,
f/6.3 for 1/3200 sec., ISO 400

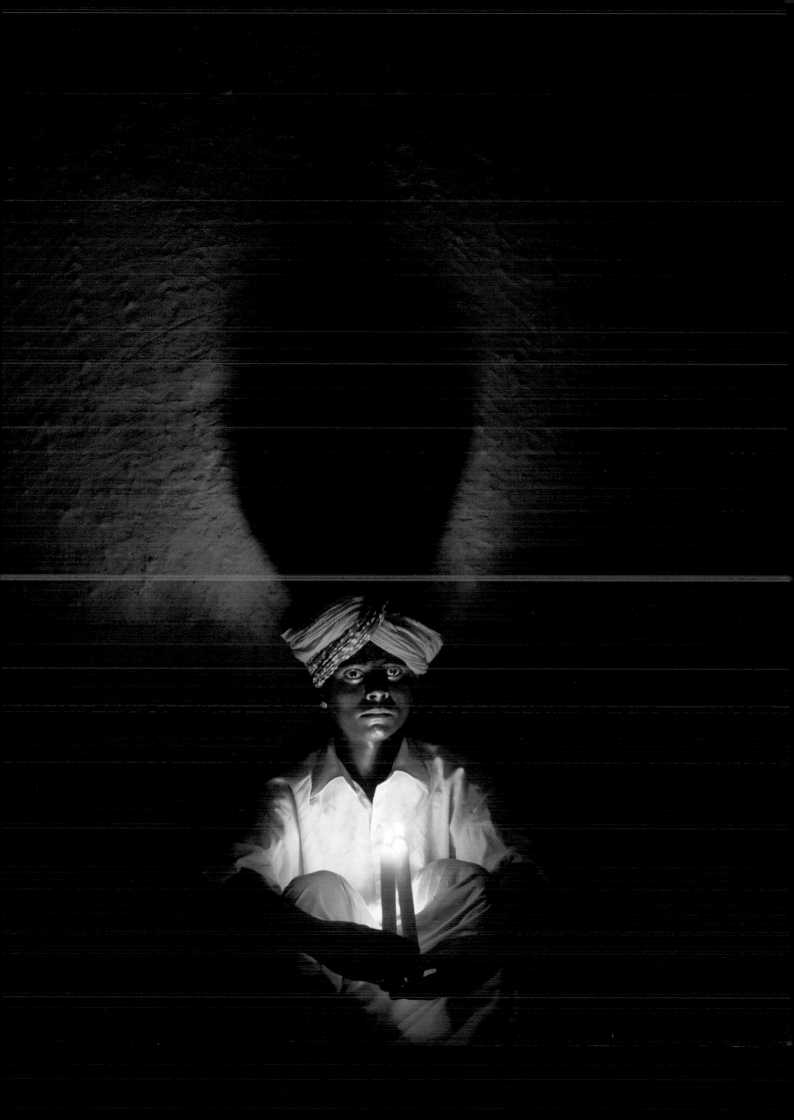

DIFFUSED LIGHT

We've been talking about some very strong contrasts of light. Light can also be diffused, which will definitely take the edge off of it. Light can be diffused by clouds, by translucent objects, even through the use of diffusers. We tend not to use a lot of diffusers simply because they are extra gear to carry, but the principles of diffused light apply to all of these sources.

Light is often described as "specular" or "diffuse." A specular light is a spot of light such as the sun in the sky, a small incandescent light at night, or a flash on the camera. Specular lights are small in size relative to the size of the subject. Specular light strongly influences the effects discussed throughout this chapter because of the way it affects shadows. Specular light creates sharp edges to shadows. This is exactly what you will see if you stand with the sun to your back and hold up your hand to see its shadow; with specular light, you will be able to count the fingers on the shadow cast by your hand.

Diffuse light is light that is spread out, or, normally, diffused. As soon as clouds move in front of the sun, for example, the light from the sun is spread across those clouds. With light clouds, you can see a large bright spot where the sun is and where this light has been spread out. That spot is much bigger than the actual size of the sun in the sky. As clouds intensify, this light is spread out even farther, until the entire sky becomes the light source. In these cases, the light is diffused throughout the clouds. Now if you stand with the sun to your back (or at least where you think it is) and hold up a hand, you probably won't be able to even see the shadow of your hand, let alone count the fingers.

If you are shooting in a shaded area where the sun has been blocked from your subject, the light is also diffuse, although in this case the light has been spread across the clear, open sky. Though this is technically not "diffused" light, but "diffuse" light, it is easier to talk about how all types of diffuse light work if we think of it as diffused light.

As light becomes diffused and spread out, the big change is in how light affects the edges of shadows. Edges start to get softer. With a little bit of diffusion, you can still see the edge of a shadow, but as the diffusion gets stronger and the light spreads out more, edges of shadows disappear, ultimately to the point that shadows might no longer become a critical part of a composition.

Often photographers make the mistake of thinking of diffused light as a soft light without any contrast or shadows. However, the term "soft light" comes from the way shadow edges are softened by diffused light, and aspects such as a chiaroscuro effect disappear, but shadows can still be important with diffused light. If you shoot with a diffuse light source, such as on a sunny day with light clouds in front of the sun, you will still get strong shadows. And even if you shoot with a strongly diffuse light source, such as on a moderately cloudy day, there will be shadows if you look for them. You can actually create stronger shadows if you are in an area where you can shoot toward the light (such as shooting with a diffused backlight).

Diffused light is a mellower light, a gentler light for subjects. It can be a wonderful light for photographing people because it removes shadows that can be unattractive. This is a light that is often used in studio work because it allows the light to wrap around a person's face and fill in details with brightness, so the face is fully revealed. This has been an important light for Art's photography of cultures around the world as well as in his new project combining art and people.

On the other hand, diffused light can be an extremely difficult light to use with landscapes because you lose the ability to create dimension and texture. This is one reason why photographers are so disappointed in photographs of beautiful landscapes taken when the weather conditions just don't give the right light. The landscape may *look* beautiful, but it does not *photograph* beautifully.

This doesn't mean that diffused light cannot be used with landscapes. You just have to be aware of what the light is doing to the shadows and how important the shadows are to your composition. When you have a lot of interesting color and pattern in the landscape, a diffused light can actually help because it will highlight that color and pattern rather than creating its own pattern from light and shade. This can be very effective,

for example, on an autumn landscape that has a beautiful range of colors throughout the bushes and trees.

Diffused light can also be effective for other types of nature photography. Tight close-ups of animals look good with diffused light, just like close-ups of people often do. Once again, that softer light wraps around the body of the animal and reveals patterns and colors. The same thing can happen with macro photography, allowing the subject's colors and patterns to be revealed rather than showing off strong light effects.

A big challenge with diffused light, especially when you are outdoors shooting on cloudy days, is that it can be so diffuse that the light has no "guts." Sometimes cloudy days just are gray and gloomy and give no good light. When this happens, the light makes subjects look boring and gray, and pictures become boring and gray. Be aware of this possibility and, once again, look at your LCD. If the image on your LCD looks boring and gray, it isn't going to get any better when you get it back on your computer!

Iceberg, Antarctica
70–200mm lens, f/32 for 1/30 sec.,
ISO 100

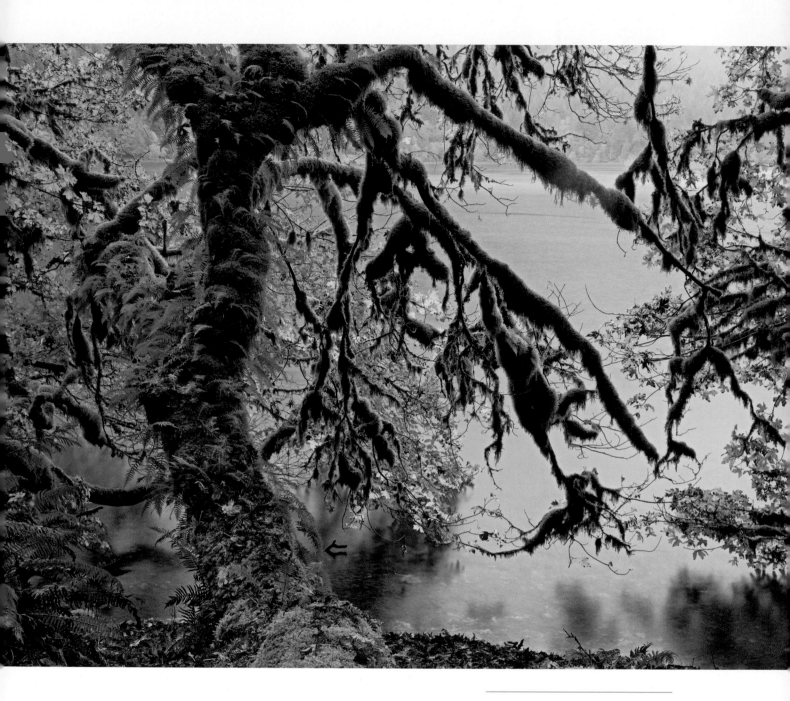

*Trees at water's edge, Lake
Crescent, Washington*
24–105mm F4L IS USM lens, f/13 for
3.2 seconds, ISO 50

ABOVE: *Hani children, Yuangyang, China*
24–105mm F4L IS USM lens, f/5.0 for 1/160 sec., ISO 250

LEFT: *Three-toed sloth, Manú National Park, Peru*
70–200mm F2.8L IS II USM lens + 1.4x extender, f/11 for 1/60 sec., ISO 400

REFLECTIVE LIGHT

Reflective light is a diffuse sort of light that happens when light reflects off of something. This type of light is often used by studio photographers, who bounce light from big reflectors and spread it out. Many of the ideas about diffuse light, such as soft shadow edges, apply to reflective light as well.

But there's something special about reflective light when you're using natural light in the real world. Often this light adds some color and dimension to the subject that you wouldn't get otherwise. For example, if you were shooting in a deep canyon that got no sunlight, the sun would hit one side of that canyon and make it very bright. Many photographers try to photograph the shadow and brightly lit areas because they want to "show the whole canyon." They then feel disappointed because the contrast range is so great that the camera won't do a good job with the scene. Yet those same conditions can be ideal for reflective light, with light bouncing from the sunlit wall into the shadowed part of the canyon. If those canyon walls are made of red rock, this light will have a warm quality. If the canyon walls are closer to off-white, there will be less color to the light. There will also be dimension to this light. You will see front light, side light, and backlight from such reflected light, as well as shadows, though they will have soft edges, typical of diffused light.

Using reflected light is more about being aware of it than anything else. Look for a bright light hitting something light colored near a subject in the shade, and you will start seeing the effects of reflective light. This can happen in a city, in the mountains, in the desert—almost anywhere you have the potential for large areas of shadow near large areas lit by the sun.

Young woman, Mali
70–200mm lens, f/4.0 for
1/15 sec., ISO 500

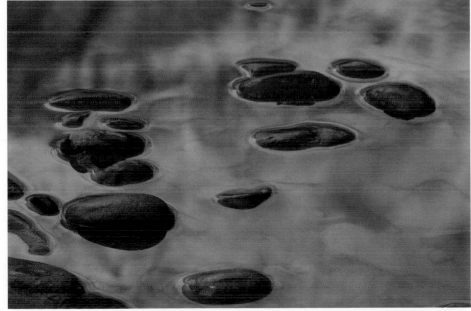

ABOVE: *Pictographs, Baja California, Mexico*
16–35mm F2.8L II USM lens, f/14 for 1/8 sec., ISO 200

LEFT: *Canyon walls reflection, Zion National Park, Utah*
70–200mm lens, f/25 for 0.8 sec., ISO 50

TWILIGHT

Twilight is an amazing time of day. After the sun has set, you can get incredible light for many, many subjects. This is a gently colored, diffuse light that is still quite directional, casting shadows with very soft edges. The combination of the color with the diffuse light can be absolutely stunning. Happily, with today's digital cameras and their ability to shoot at higher ISO settings, the possibilities for shooting during the crepuscular hours have increased greatly.

How many times have you been at a beautiful location at sunset along with many photographers waiting for that moment when the sun hits the horizon? We've seen this repeatedly. And then once this moment passes, almost everyone packs up his gear and leaves. Yet some of the most beautiful light occurs after that sun has set. These photographers are leaving when the potential for great images may be just beginning.

Of course, twilight conditions also occur before sunrise. Getting to a location before sunrise can be challenging for obvious reasons, and twilight after sunset is often an easier time to shoot, but both are worth considering.

A challenge for many photographers shooting at twilight is that there is less light, which may limit the shutter speed you can use. Luckily, today's digital cameras offer excellent results with higher ISOs, so you can shoot at faster shutter speeds if needed. Another challenge is that you can never predict how good the light will actually be unless you are there at twilight. A great sunset may or may not give you great twilight conditions. You may stay after the sunset and discover that the light never really gets very good. Or you may find that it's amazing.

Note that when the sun first drops below the horizon, the light often looks dull and dingy. Twilight light starts to look really good about five to fifteen minutes after the sun has set. Be patient as the light starts to improve because the sky is changing to the west.

That's also important to keep in mind: twilight after sunset will be coming from the western sky, while twilight light before sunrise will be coming from the east. You need to have an open view to the west or east, respectively, in order to use this light.

Once the light starts getting rich in color and dimension, keep shooting. Digital cameras are amazing in their ability to hold detail out of a very dark scene as the light drops after sunset, for example. Don't be afraid of exposures that last 20 to 30 seconds or more.

As your exposure time increases, you will likely have more noise in your images. Digital cameras have gotten a lot better in dealing with noise that comes from long exposures, but you will still have increased noise compared to shooting more typical shutter speeds of one second and faster. Most cameras have settings that allow the camera to process the image file slightly to reduce noise, which will usually work on both RAW and JPEG files. The only catch is that when the noise is reduced, small details are sometimes affected as well. Experiment with your gear to find out how your particular camera deals with noise and long exposures.

Another important issue with twilight photography is auto white balance. The short version? Don't use it. Auto white balance is designed to look at a scene and get rid of color casts. That's exactly what you *don't* want to happen with twilight photography. The subtle color casts of this light are too quickly and easily removed by auto white balance.

Shoot a specific white balance. Set your camera to Day-

light or Cloudy. Believe it or not, Cloudy white balance actually gives a very rich color to twilight photography. Some photographers think they don't need to worry about white balance because they shoot RAW and can always adjust the picture later in the computer. There are two problems with this. First, you have to make adjustments. Second, since you have no standard to adjust against and you haven't actually seen how the camera is capturing those colors, what do you adjust? Any adjustment will be artificial and have little to do with what was actually there.

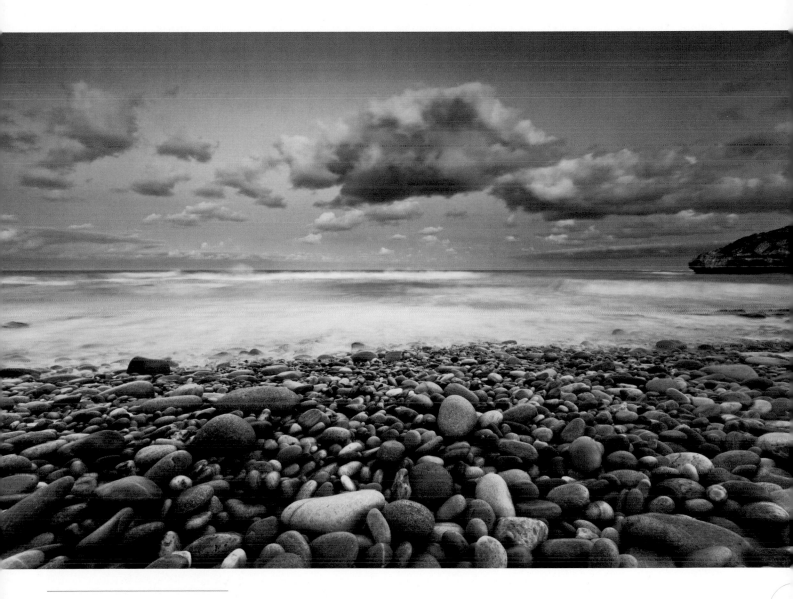

Cape of Good Hope, South Africa
16–35mm F2.8L II USM lens, f/14 for
5 seconds, ISO 160

ARTIFICIAL LIGHT

Sooner or later, most of us find ourselves dealing with artificial light, whether incandescent or firelight. Everything we have discussed about light applies to artificial light as well. You can get everything—from chiaroscuro effects to diffused light—from artificial light, just as you can from natural sunlight.

One of the great things about digital cameras is that they handle shooting under artificial light conditions extremely well—in fact, they handle artificial light much better than film ever did. When we shot film, we typically had to use filters or special films to get better color. Film did not deal well with the different colors of artificial light. In addition, high-ISO color film didn't always work well, setting real limitations on what we could actually photograph when the light got low.

Artificial light does not have to be considered in isolation from natural light. Some of the most wonderful images occur when artificial light balances the natural light. As light levels drop at the end of the day, for example, the relationship of the brightness of artificial light changes as it is seen against the fading natural light. There will be a time when the artificial light and natural light actually balance each other. This is not an easy thing to predict, however. First you have to know that there is this possibility of balance, then you have to start shooting when the natural light is too bright and keep shooting until the artificial light is too bright for the natural light. You may be surprised when you look at your pictures later to see which images work the best.

This approach can also give you great images on days when the natural light is not all that good. Sometimes the clouds are just too heavy and nothing looks good when photographed in the natural light. Adding a bit of artificial light, such as a local person's lantern, suddenly adds color and dimension that did not exist otherwise.

This is one place to consider white balance a creative tool, as choosing a specific white balance can give you better images. When you shoot with RAW, a specific white balance is always recorded with each image file, just as when you shoot with JPEG. If you're shooting with auto white balance, the camera picks that specific setting. Of course, the nice thing about RAW is that even if you do set something specific, you can tweak the adjustment later with no effect on image quality.

Auto white balance can be a terrific tool when you need to get neutral colors under artificial light and you aren't sure of the light sources, or the sources are constantly changing. This is when auto white balance truly shines. It is designed to handle these conditions, giving you neutral colors regardless of the light sources. There are many situations where this is important because the subject matter is more important than a colorful mood.

As with twilight light, artificial light may not be a good time to use auto white balance. Sometimes there is a richness to the color of artificial light that will make your pictures look better. If you shoot with a white balance that removes a nightlight's warm glow, for example, the picture will not look right. Sometimes shooting with a Daylight white balance will actually give you an emotionally correct image, even if it is not technically correct.

LEFT: *Pike Place Market, Seattle, Washington*
70–200mm lens, f/20 for 2 seconds, ISO 50

OPPOSITE: *Tuaregs making tea, Sahara Desert, Mali*
16–35mm lens, f/2.8 for 1/20 sec., ISO 400

ABOVE: *Pigeons, Times Square,*
New York City
70–200mm + 1.4 extender, f/4 for 1/640 sec.,
ISO 800

OPPOSITE: *Young monks, Myanmar*
24–70mm F2.8L USM lens, f/2.8 for
1/4 sec., ISO 800

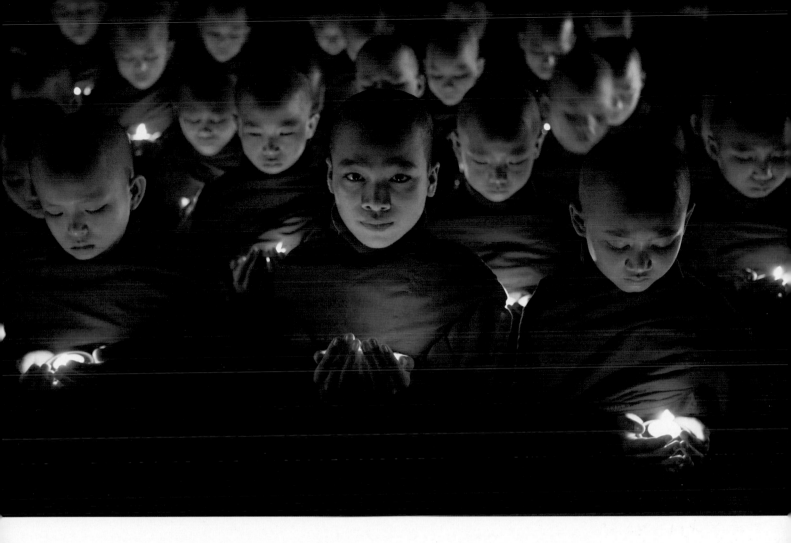

Are You Getting the Most from Light?

Ask yourself these questions to help you learn to get the most from light.

1. Have you begun to look at the light and not just subject matter in front of your camera?

2. Are you looking at your LCD to see the light?

3. Can you describe how front light, side light, and backlight affect the subject differently?

4. Do you know when front light looks its best?

5. When is side light best?

6. Why do pros like backlight?

7. Have you considered the possibilities of silhouettes?

8. Can you think of ways to incorporate chiaroscuro light into your images?

9. Can you recognize what diffused light can do and cannot do for your subject?

10. Are you shooting before sunrise or past sunset into twilight times?

11. Do you recognize the key problem of auto white balance removing important color casts that light can create?

INDIAN WOMEN AND WATER POTS:
Seeing the Light

India is a place where water can be a problem. In the United States, people rarely worry about getting water for their family, but it can be a daily issue in parts of India. While in Rajasthan's Thar Desert, I learned about a village where the women made a daily trek across sand dunes to the only water well in the area. Every morning, they picked up their water pots, crossed miles of dunes to fill them up, then headed back home, where their entire family depended on the water they brought.

I caught up with them one night and asked if I could go with them the next day, offering to pay them a little money if I could pose them, and they said yes.

I began making the trek the next morning and was struck by the color of the women's robes against the lines of the desert. I shot many images of color, line, and pattern, such as the image shown below. I really thought that was what the photograph was all about.

But the light had other ideas. As I moved around the walking women, looking for the best shots, I started to see wonderful shadows as they went up the steep slopes. The image shown opposite, bottom right, emphasizes the women and their water pots. It is not the usual shot we expect to see of women carrying pots on their heads; they look like Martians! I loved the look and began working this particular shot. I went a little higher, then shot into them with a 16mm wide-angle lens. Then I leaned in ever so slightly to the right and brought in the bit of the sun. These were shots that I never expected to get when I first went out that morning.

The point is that you can conceive of all the shots you want, but you have to be open to the situation, to the light. There are times when serendipity rules the day, and you need to be receptive to that.

—Art Wolfe

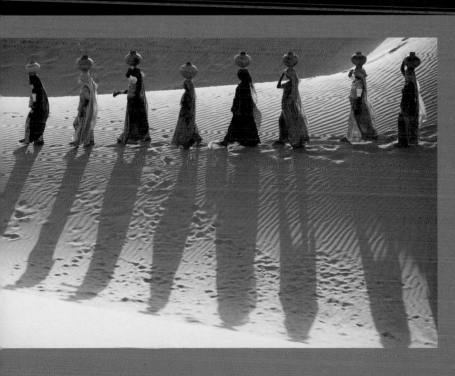

Water bearers, Thar Desert, India

OPPOSITE: 70–200mm lens, f/4.0 for 1/100 sec., ISO 100

TOP: 24–70mm lens, f/18 for 1/60 sec., ISO 400

LEFT: 70–200mm lens, f/4.0 for 1/125 sec., ISO 100

ABOVE: 24–70mm lens, f/18 for 1/160 sec., ISO 400

CREATIVE SOLUTIONS

Some photographers feel they are somehow being pure by using a picture exactly as it came from the camera. But the fact is, your camera is interpreting the scene no matter what you do. There is no such thing as a purely objective photograph. Simply the change of light into digital form with your sensor and camera circuits changes the world. Decisions made by camera engineers and designers affect how that digital signal interprets what is seen on the sensor.

Both of us like a direct approach to photographing the world. We are less interested in fanciful effects that go beyond simply interpreting reality to changing its appearance into fantastic and even surreal images. (There is certainly a place for that type of photography, and we do not disrespect photographers who do this.) However, stronger enhancement and control of an image can communicate something better to a viewer about the world, from the details of a macro shot to the press of humanity at a big cultural event. We want to share our discoveries of the world through photography, something all photographers can do. And to do this well, you must be able to control the image, which may mean using creative approaches.

"Without a constant search for new or better ways of expression, photography would remain at a standstill."
—Andreas Feininger

FROM CONCEPT TO CREATION

Good photographs start before you actually take the picture, when you make decisions about what to do (or not to do) as you take that picture. If a photograph is dull and uninspiring, it is often because the photographer's conception of that image was also dull and uninspiring. In other words, don't simply set up your camera and start photographing on autopilot.

When you're conceiving of a specific image of a subject or scene, there are two things to consider: how you approach the subject and how you use your gear. Both of these are very important and strongly affect the creation of your image.

First, take a moment and think about your vision of the subject. What is it that you really want from the subject? Having an approach in mind will then direct you in choosing from your equipment and technique options, making your choices much clearer and easier. If you have no idea of what you want from a picture other than to make it pretty, your choices are infinite, and that can be intimidating as you take the picture. If you have a very specific conception of what that image should look like, your choices will be much narrower and focused on what is needed to actually accomplish that goal.

*Concept drawing for
Kathmandu sadhus*

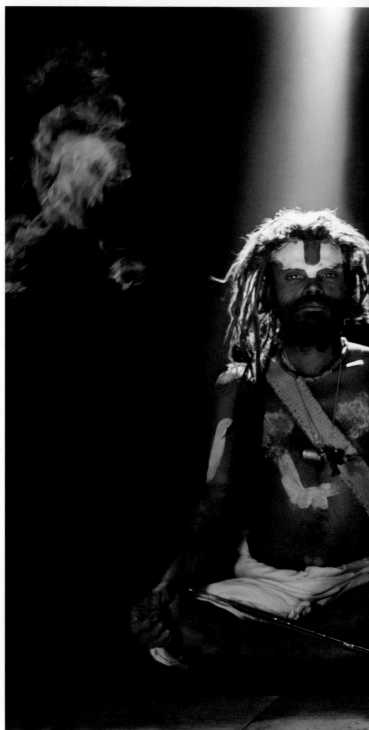

BELOW: *Sadhus in the spotlight, Nepal*
24–70mm lens, f/2.8 for 1/13 sec.,
ISO 400

PAGE 204: *Mosaic of man, photo montage*

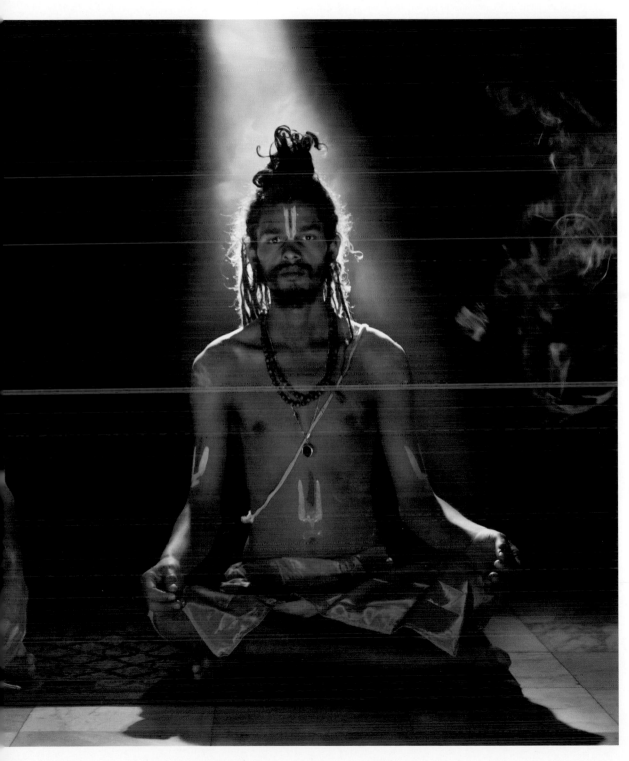

LOOKING AT THE SUBJECT

What exactly is it about your subject that can be used to create an attractive photograph? This is not always a simple decision. First, you have to decide what aspects and characteristics of your subject are important to show. Does your subject have unique characteristics that need to be shown for your concept of that subject to be revealed? That is an approach based on very real and direct observation of your subject.

But don't be limited by the obvious features of a subject. You might also want to portray its intangible qualities, such as strength, power, joy, sadness, and so forth. These can be hard to capture photographically unless you spend some time conceiving of possibilities for your image. Another possibility might be to portray its mood and atmosphere, or its design, color, and abstract graphic qualities. How you conceive of your image strongly affects the way you approach it to capture these sorts of visual concepts.

There is no limit to the possibilities for your photograph—anything is appropriate as long as your choices result in a clear, meaningful image that communicates something unique about your subject in a graphically interesting way.

CARING ABOUT YOUR PHOTOGRAPH

One of the things that strongly influences how you approach a subject is how much you *care* about that subject or photograph. Interest in your subject sparks your imagination, motivating you to apply the effort needed to create a better photograph.

Too often we see photographers take pictures of subject matter simply because it is something everybody else photographs at a location, such as an iconic overlook in a national park; you feel you have to get the shot, too, even if you are not particularly inspired by the location. Or photographers take certain types of pictures because they are told they need to by fellow members of their camera club.

Instead, think about conceiving interesting images from whatever it is that you are looking at. We guarantee you will find things that interest you beyond your expectations. And you'll find better pictures.

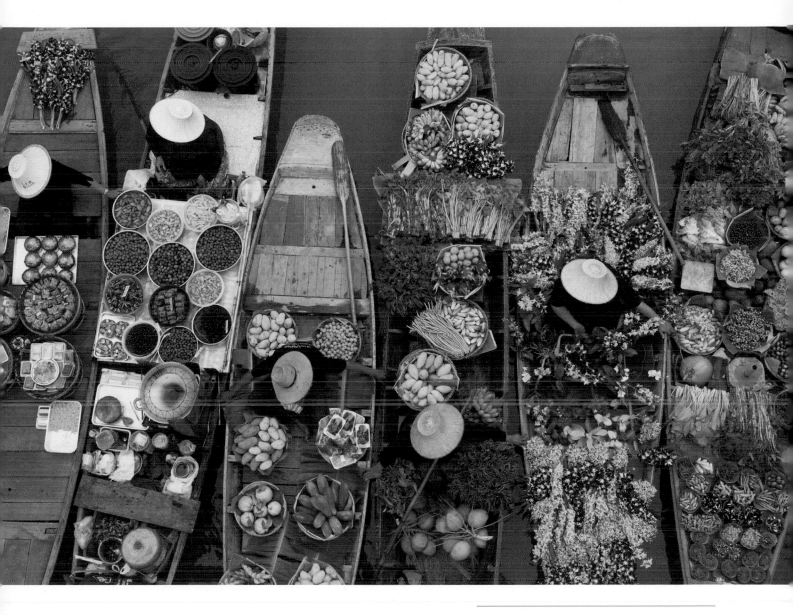

Floating market vendors, Thailand
ABOVE: 24–70 mm lens, f/4.5 for 1/100 sec.,
ISO 400

OPPOSITE: 24–70mm lens, f/2.8 for 1/160 sec.,
ISO 400

ILLUSTRATION AND PHOTOGRAPHY

Photographs can be manipulated in programs like Photoshop to help illustrate concepts that cannot be captured directly as you photograph. Some photographers like this approach to photography; others don't care for it at all.

This was the basis of many of the images in Art's book *Migrations*, as mentioned earlier. Another conceptual project of Art's was to connect culturally important portraits of people to the landscapes where they lived. He was interested in a more stylized and controlled approach than he felt he could get photographing people in a landscape, so in Photoshop he combined striking portraits of people with equally striking landscapes.

These are illustration sorts of photographs. Some publications make a big deal about labeling these types of shots as photo illustrations. There is nothing wrong with that. They are simply conceptual images that have been created based on strong photos that allow the images to communicate clearly.

What is interesting about approaches like these is that they can strongly influence how you photograph. In other words, when you start putting together images in Photoshop, the process will spur ideas for other possibilities that you can look for while shooting, ideas that you may not have considered otherwise. While we don't do a lot of this type of Photoshop work, just conceiving of such images puts us into new modes of thinking that can result in more creative shooting, with or without Photoshop.

LIGHTROOM

Lightroom is a fantastic program for photographers. Both of us use it as our major image processing program because it allows us to quickly and effectively achieve natural-looking results. Photoshop was never designed for photographers—it was designed for people using photography, an entirely different thing. Lightroom was designed from scratch by and for photographers.

A big advantage of Lightroom is your ability to move back and forth between the Library, where your images can be quickly referenced, and the Develop function, where images are processed. This creates a real connection to your images that can quickly put you in touch with their potential for creative expression.

Lightroom also encourages you to process images in a very natural way, whereas Photoshop does that much less, although it is a capability. You definitely have a different mind-set when working on an image in Lightroom than when editing one in Photoshop.

Another advantage of Lightroom is the ability to use local controls, which allow you to literally drag-and-drop adjustments onto one part of the photo without altering the entire image. You can quickly make one area darker or lighter, warmer or cooler, even more or less sharp, without affecting the rest of the image. Lightroom allows you to use local controls quickly and intuitively in ways that are impossible to do in Photoshop, given the time required to create adjustment layers and layer masks. That said, Photoshop enables you to make very precise changes in small areas, which are difficult to do in Lightroom, though we do not find such measures required frequently.

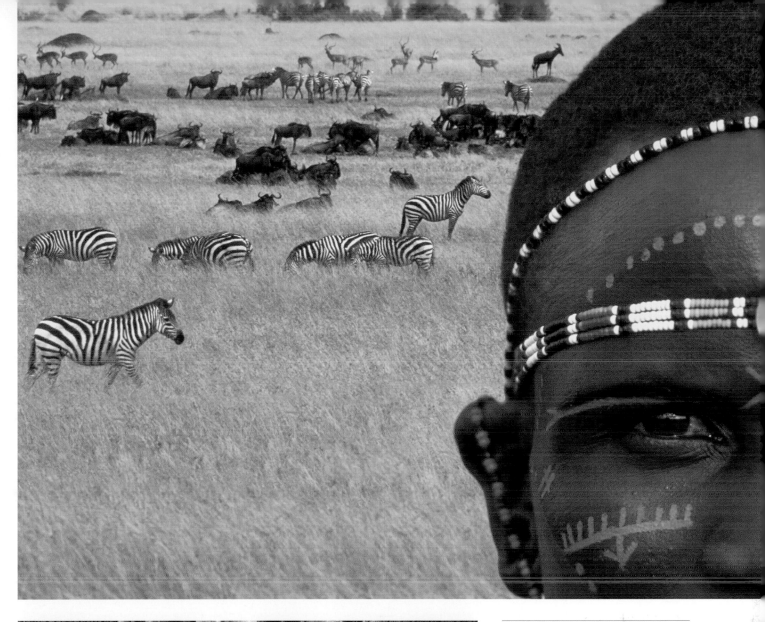

ABOVE: *Samburu and East African savanna montage*

LEFT: *Brown bear and North American forest montage*

PAINTERLY SOFTWARE

Well before computers, photographers were putting strange items in front of their lenses, using special lenses to distort images, processing their film in odd ways, and doing things in the darkroom to change the way a print looked—not to mention adding materials to prints afterward, such as paints and dyes.

Sometimes photographers would do these things simply to "be different." And sometimes that is the goal of today's photographers using computer software as well. You have to be careful of that. There is a danger that the software and its manipulation becomes an end in itself, rather than a way to create better photographs. To keep your focus on the photograph, look at manipulation as guided by your creative judgment and vision for what photography truly is. Do the effects create an image that affects your viewer, communicating something unique about the subject?

When we think about manipulating an image, the two software programs that immediately come to mind are Photoshop and Photoshop Elements. You can make an image look like a painting; you can make it look surreal; you can even change around pictorial elements in the composition.

Photoshop and Photoshop Elements include a variety of painterly looking effects in the Filters menu, with image transformations that look like watercolor, sketches, mosaics, and more. Many photographers discover that the best-looking images do not come from a single application of one of these filters, but from multiple applications of different filters. You have to experiment, combining various filters, to see what you like.

To create unique looks, there are also a number of software plug-ins that can be used inside Photoshop and Photoshop Elements. One versatile "artistic" program is Alien Skin Snap Art, which creates painterly images from an original photograph. It offers a great range of possibilities, from effects that look like oil paintings to others that suggest art crayons or cartoons. This program has the ability to create very realistic looking brushstrokes, which is important for making your picture look like it was actually painted as well as giving texture and patina to the image that cannot be achieved any other way.

While these sorts of image manipulations are not a major portion of our work, they can be interesting to play with for a number of reasons. First, they will change how an image appears to you, which can affect how you interact with the image as well as how it communicates. Sometimes painterly effects can get people to move away from the realistic aspects of the subject matter to dig deeper into what the photograph is really about.

Painterly effects can also create mood and atmosphere for an image that cannot be replicated any other way. A good way to work on an image is to create a layer in Photoshop that applies the effect to only that layer. Then, by changing the opacity of that layer, you control its intensity.

While it is easy to apply these effects to an image, it is not so easy to do it well enough that the image looks good. Sometimes photographers say that such effects can be used to "save" a bad photo. That's rarely true. Usually you just end up with a funky-looking bad photo rather than a realistic-looking bad photo. Start with an image that has visual strength so that when you apply an effect, that strength stays with the image—and is perhaps even better revealed.

INFRARED PHOTOGRAPHY

Black-and-white infrared photography is a striking and unusual way of showing off a scene in a way that cannot be seen with the naked eye. It turns anything that reflects a lot of infrared light into a bright, even white, and anything that absorbs that light, dark. The result is dramatic, strongly impactful pictures of white foliage and black skies, for example. In addition, infrared cuts through haze. You can photograph a very hazy scene that can barely be seen with the naked eye, then see it suddenly revealed with infrared.

All digital cameras are sensitive to infrared light to a degree, but most cameras have an infrared cut-off filter installed over the sensor that keeps a lot of the infrared light from your picture. While you could use an infrared filter over your camera's lens to get an infrared shot, the exposures will be very long and often won't yield the full effect. Most photographers who shoot a significant amount of infrared black-and-white photography will modify their cameras by having the infrared cut-off filter over the sensor removed. Thus modified, you basically shoot as you normally do, but you get infra-red. An older camera you are no longer using can be good for this. We have used LifePixel.com to modify older cameras for infrared with success, though there are other websites that offer this service as well.

Black-and-white infrared photography has a look unlike any other and is instantly identifiable as infrared. One thing that is interesting about infrared photography is that it can be done during times of the day that you might otherwise not be photographing, as infrared light is best captured from mid-morning until midafternoon. In addition, infrared tends to look its best on sunny days where there is a lot of infrared light bouncing off of foliage and other objects.

Infrared works really well with cameras that have Live View. This allows you to see the infrared as you compose your photograph because it will be displayed on your LCD as you shoot. That is quite a difference compared to having to take the picture and then look at how it appears on your LCD. Though truthfully, either way is considerably easier than dealing with the old infrared film.

Rural road, Point Reyes Peninsula, California
16–35mm lens, f/9 for 15 seconds, ISO 400

EXPOSURE CONTROL: HDR

You can creatively control your image right from the start when you control the exposure. We're not talking about getting the best exposure for the scene; that's a different issue. Here we're talking about more creative uses of exposure control to affect your image. HDR, or high dynamic range photography, has become extremely popular among photographers. It offers a unique way of dealing with exposure challenges that allows you to capture images that are not possible directly from the camera. We mentioned it briefly on page 184, especially that HDR can be a problem if it removes dark areas of the picture that are important for your composition. You may have seen the funky HDR-manipulated images, but HDR can also be used in a very natural way to enhance the capabilities of the camera to capture a high-contrast scene.

HDR can be extremely helpful in capturing a range of tonality that is beyond the capability of your camera and sensor. Often, photographers will see a beautiful scene spread out in front of them, but the camera can't capture what they see. With HDR, you lock your camera down on a tripod and shoot a series of exposures to capture the scene's full range of tonalities, from dark to bright. You take an exposure that captures the brightest parts of the scene well, ignoring what is happening in the rest of the picture. You also take an exposure that captures the darkest parts of the scene, ignoring the rest of the picture. You complete the shooting by taking a series of pictures in between those extremes.

Next you take these images into the computer and use software to combine them into one image that shows off the full range of the scene's tonality from dark to bright. There are a number of programs that do this, including Photoshop, Photoshop Elements (the Photomerge Exposure feature), HDRSoft Photomatix, and Nik Software HDR Efex Pro 2. All of these programs work, though their capabilities vary considerably. We prefer Nik Software HDR for its great range and versatility, but photographers have achieved excellent results with all of them.

We'll give the same warning that we gave before: Be careful that HDR does not become an effect for its own sake. We have found it interesting that most people who are not photographers have not been as excited about HDR as photographers seem to be. When you do a wild and crazy HDR effect, be sure that it is being used to communicate to your viewer what is important about your subject, or the viewer simply won't care.

Our preference is to look for a natural way of portraying any scene so that a person looking at the photograph will get a feeling of what that place looks like, rather than a feeling of what HDR looks like.

The Subway, Zion National Park, Utah

TOP LEFT: 17–40mm lens, f/11 for 0.8 sec., ISO 100

TOP CENTER: 17–40mm lens, f/11 for 2.5 seconds, ISO 100

TOP RIGHT: 17–40mm lens, f/11 for 4 seconds, ISO 100

ABOVE: Final shot in HDR

EXPOSURE CONTROL: COMBINING TWO PHOTOGRAPHS

Another way of dealing with a distinct area within a photograph that is brighter or darker than the rest of the image is to combine two exposures. This works well when you have a very bright sky, for example, and a dark landscape.

To do this, first lock down your camera onto a tripod and then shoot two exposures. The first exposure should be made to make the bright area look its best. Similar to HDR photography, ignore what is happening in the rest of the photograph. In the second image, expose for the darker part of the scene, ignoring what is happening in the bright areas, which will be washed out.

You then work on those two images together in the computer. First, process each image individually, making the highlights look their best in the photograph exposed for the highlights, and the dark areas their best in the photograph exposed for the darks. This can be done in Lightroom first, then transferred to Photoshop. (You do need Photoshop or Photoshop Elements for this technique because you need to use layers.)

Next, put the darker image (the one exposed for the bright areas) over the brighter image (the one exposed for the dark areas) as layers. Erase the problem parts of the top, darker layer to reveal the good parts of the brighter layer underneath. You can do this with the Eraser tool, though you will gain more control if you use a layer mask with the top layer.

You have to understand a bit about using layers in order to use this technique, although Photoshop Elements has a section of their Photomerge feature that walks you through this without having to understand layers. Whether you are using the Eraser tool or a brush with a layer mask, it usually helps to have a very soft edge to the brush (the Eraser is also a brush) to allow blending to look better.

Often people ask us, why not use HDR for this type of picture? You certainly could. However, there is a very different look between combining two images to deal with extreme changes in brightness and HDR. HDR processes the entire image, so the effect goes everywhere. When you use two distinct exposures and process each one to get the best out of each exposure, you gain the optimum look for both the dark and the bright areas without unwanted blending. This can help give your picture better contrast.

Jeffrey pine, Yosemite National Park, California

TOP LEFT: 16–35mm F2.8L II USM lens, f/14 for 1/30 sec., ISO 400

TOP RIGHT: 16–35mm F2.8L II USM lens, f/14 for 1/160 sec., ISO 400

ABOVE: Final result from Photoshop

EXPOSURE CONTROL: POLARIZERS

The polarizing filter is another important tool for photographers. Many photographers know that a polarizing filter will darken skies under certain conditions. However, a polarizing filter can do a lot more than that, including the following:

1. Darken blue skies at 90° to the sun.
2. Remove glare from shiny objects, such as water and shiny leaves.
3. Remove reflections from water and glass.
4. Cut haze.

A polarizer screws onto the front of your lens and has a rotating mount. You need to rotate that filter as you look through your viewfinder to see what the effect is on the scene. You don't always want the maximum amount of polarization, which might look too harsh or dark for your particular scene. To quickly see the effect of a polarizer on a scene, hold it up in front of your eye and simply rotate it to see what happens.

Dark blue skies in a scene can be important. They can help balance a bright sky to the ground, as well as create interesting color and tonal relationships within the composition. The polarizer can also make clouds stand out in the sky. It can be amazing to see the difference when you use a polarizer on a partly cloudy sky.

One thing to remember is that this effect occurs at its maximum at 90° to the sun and has no effect when you are either looking at the sun or away from the sun. You can use your polarizer all you want, rotated as much as you can, but if you are not looking in the right direction, you will get no effect. Look for this effect on the sky when the sun is directly to your side.

Removing glare from shiny objects is another important function. In landscape photography, you'll often get leaves reflecting the brightness of the sky, which dulls their color. By using a polarizer, you can cut that reflection or glare and give the leaves more saturation in your photograph. It can also be interesting to use a polarizing filter when photographing water—just be careful not to overpolarize the water, which causes the clearest parts of the water to literally disappear from the photograph. Usually you need some sort of sheen on the water for it to actually look like water.

A polarizing filter can also cut haze to a limited degree. It won't get rid of it entirely on a hazy day, but it will make the haze a little less strong and give your picture a bit more contrast.

A polarizer will cut the light to your sensor by about two f-stops. That can be significant if you need the light for a faster shutter speed to stop subject movement or camera movement when handholding the camera.

Canyon de Chelley National
Monument, Arizona

LEFT: *Without polarizing filter*
70–200mm lens, f/32 for 1/4 sec.,
ISO 400

BELOW: *With polarizing filter*
70–200mm lens, f/32 for 0.4 sec.,
polarizing filter, ISO 400

ABOVE: *Iceberg, Antarctica*
16–35mm lens, f/3.5 for 1/800 sec.,
ISO 160, polarizing filter

RIGHT: *Piraputangas, Jardim,
Brazil*
70–200mm F4L USM, f/7.1 for 1/160
sec., ISO 800, polarizing filter

OPPOSITE: *Fitz Roy, Los Glaciares
National Park, Argentina*
EF70-200mm F4L USM lens with
polarizer, f/11 for 1/50 sec., ISO 200

Are You Using Creative Solutions to Control Your Images?

Ask yourself these questions to help you learn to get the most from creative solutions to controlling the image:

1. Are you starting the process of taking the picture before you bring the camera up to your eye?

2. How are you approaching your subject? Are you consciously aware of how the act of taking the photo affects what you get?

3. Have you thought about how a concept for your image can change the way you photograph the subject?

4. Do you like your subject? Or have you at least found something to like about photographing it?

5. Do you want your subject to be seen literally, or is there something intangible about it that you would like to express in your image?

6. Did you know that Lightroom was designed specifically to enhance the photographer's experience in working with digital images?

7. Have you considered the possibilities of HDR to control the brightness levels of a scene and make the photograph look more like the real light conditions?

8. Have you tried shooting two exposures of a scene in order to have the right detail for bright and dark areas, and later combine them in Photoshop?

9. Do you have and use a graduated ND filter to help balance brightness in a scene?

10. Do you know how to control a polarizer to get the most from skies?

DANCERS IN BHUTAN: Finding the Essence of the Subject

These dancers from Bhutan were in traditional clothing and a unique set of deer antler headdresses, prepared for the dancing that is customary for a New Year's Eve celebration at a monastery. I loved the headdresses and my concept was to show off the young men with their antlers in a way that would respect them and their art. I worked with them through an interpreter.

In the first picture, shown below, I posed them in the entrance to the monastery for a dramatic bit of light. This used the contrast between the natural light and the shadows behind them. This was an okay shot, but did not satisfy the deeper concept of really showing off the young men and their headdresses in a unique yet still respectful way.

I then decided to abstract the image, featuring the beautiful repetitive design of their headdresses, by getting above them. I positioned them in a very symmetrical abstract way, then shot from a monastery wall directly above them, shown opposite, top left. This got closer to what I wanted, but it was missing something of the context of the environment.

There was a beautiful, cloud-swept sky that day, which is common to the Himalayas. I posed them in somewhat of a half circle and used a flash to balance the brightness of the dancers against the sky, shown opposite, top right. I then moved right below them so I could shoot directly up at them against the sky. This time I chose to turn off the flash and see what the dancers with their headdresses would look like silhouetted against the beautiful sky (shown opposite, center). This was interesting from a design standpoint, but it did not convey the same feel for the dancers and their art.

In the final, most successful shot (opposite, below), I turned the flash back on to create a balance in brightness between the dancers and the clouds and blue sky above. The flash was not so bright as to overpower the dancers and make them brighter than the sky, but was set to create a dramatic look that worked well with the sky.

—Art Wolfe

Dancers, Paro Valley, Bhutan

LEFT: 70–200mm F4L USM lens, f/9 for 1/160 sec., ISO 800

OPPOSITE, TOP LEFT: 24–70mm F2.8L USM lens, f/16 for 1/50 sec., ISO 400

OPPOSITE, TOP RIGHT: 16–35mm F2.8L II USM lens, f/14 for 1/250 sec., with flash, ISO 400

OPPOSITE, CENTER: 16–35mm F2.8L II USM lens, f/18 for 1/200 sec., ISO 400

OPPOSITE, BOTTOM: 16–35mm F2.8L II USM lens, f/18 for 1/250 sec., with flash, ISO 400

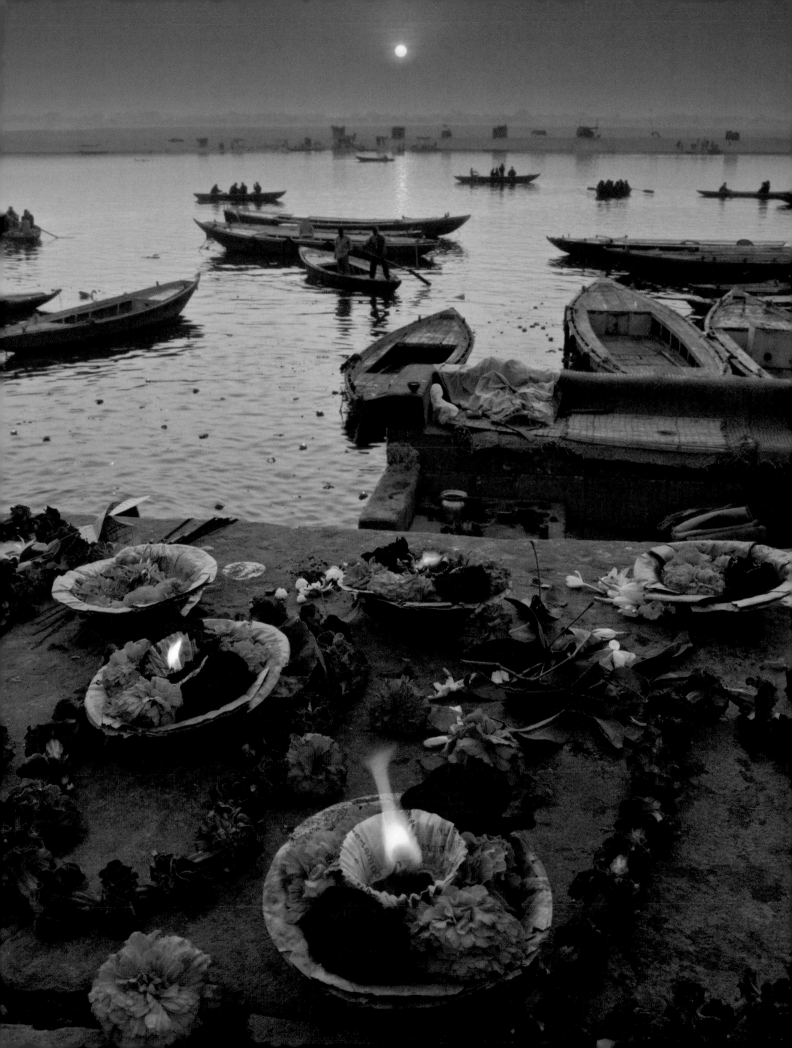

THE 10 DEADLY SINS OF COMPOSITION

Now we're going to put you to the test. Like any good student, you have been paying strict attention to everything in this book, so now you will have the opportunity to determine how well you have mastered the art of composition.

Just kidding. There is no real test, but if you want to think of it that way, your test is what you do when you start photographing using the ideas presented in this book. This is a totally open-ended test, graded only by personal satisfaction. Get out and take some pictures, experiment, and have fun.

A popular segment of Art's talks is his 10 Deadly Sins of Composition, which we thought would be a good way to wrap up the book. These ideas will challenge you think about what you've read as they summarize many important concepts we have discussed.

"The picture should stop you, not the subject."
—Gregory Heisler

1. SUBJECT IN THE MIDDLE

Is this some outdated notion that we have to follow? The subject in the middle is bad for one main reason: your eye goes straight to the subject and stops, such as in the first image at right. A viewer sees what is in the center, thinks he or she knows everything that you care about in the picture, and then moves on.

You want a viewer's eye to move throughout the composition. This keeps him tuned in and allows you to incorporate all the pictorial elements in the frame so they are noticed. When that happens, your viewer enjoys being with your photograph longer. Isn't that something you want?

That said, sometimes you will find a subject and setting that demands to be centered. There are times where there's a beautiful symmetry in a landscape, for example, and sometimes you can emphasize that situation, bringing in tension by working around the middle. In such cases, the entire image must support that centered object. Because of that, the viewer's eye looks over the entire image as well.

Putting the subject off-center gives an important feeling of movement to the shot. If you've got an unusual subject, you may be so attracted by it that you forget and leave it in the center of the picture. Pull yourself away from that subject, look at the entire image area, and avoid putting it bull's-eye in the center.

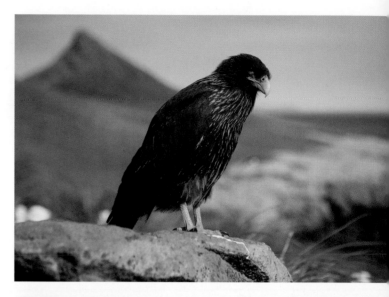

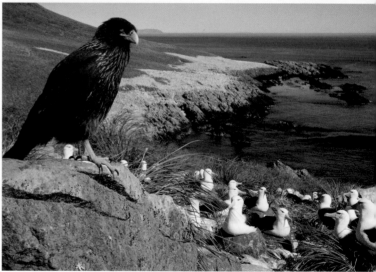

TOP: *Caracara, centered, Falkand Islands*
24–70mm lens, f/3.5 for 1/800 sec., ISO 200

CENTER: *Caracara, off-center, Falkand Islands*
24–70mm lens, f/22 for 1/20 sec., ISO 200

RIGHT: *Black vulture, Baja California, Mexico*
500mm F4L IS USM lens +1.4x extender, f/14 for 1/1600 sec., ISO 200

PAGE 226: *Ghats, Varanasi, India*
24–70mm lens, f/22 for 1/13 sec., ISO 400

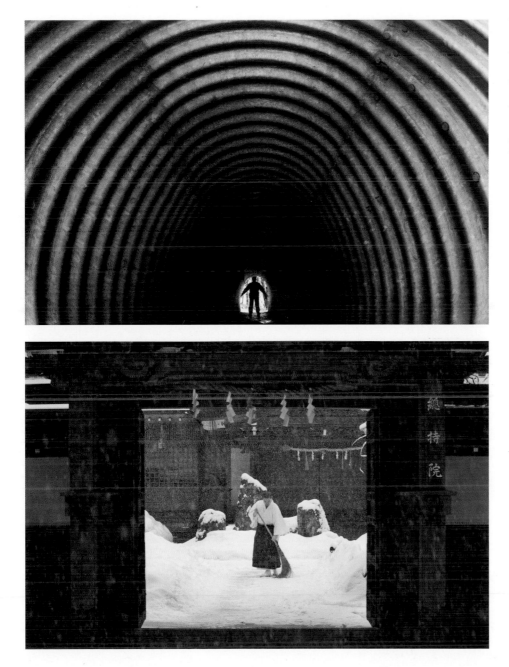

2. HORIZON IN THE MIDDLE

The same issues apply for horizons as for a subject. So often we see images with the horizon right through the middle of the picture, creating equal parts sky and ground. This is a one-dimensional way of photographing a landscape, one that doesn't put emphasis anywhere or help your viewer perceive what it is that is important about the scene. When you get the horizon out of the center, your pictures will be more engaging.

With a low horizon, as shown at right, you are emphasizing the sky and a feeling of looking up over the landscape. With a high horizon, as below, you are emphasizing the ground, which can allow you to incorporate more of the foreground and create a sense of depth. If the foreground has nothing, but the sky has the drama, then shift the emphasis to the sky.

As with centered subjects, however, there are also scenes where a centered horizon will work: only when the entire subject within the image area supports that centered horizon.

LEFT: *Steppe, Mongolia*
16–35mm F2.8L II USM lens, f/11 for 1/250 sec., ISO 400

BELOW: *Canyon reflection, Kimberley, Australia*
70–200mm lens, f/16 for 1/60 sec., ISO 100

OPPOSITE, TOP: *Tulip fields with a centered horizon, Skagit Valley, Washington*
70–200mm F4L IS USM lens, f/5.0 for 1/1600 sec., ISO 400

OPPOSITE, BELOW: *Tulip fields with a high horizon, Skagit Valley, Washington*
70–200mm F4L IS USM lens, f/18 for 1/160 sec., ISO 800

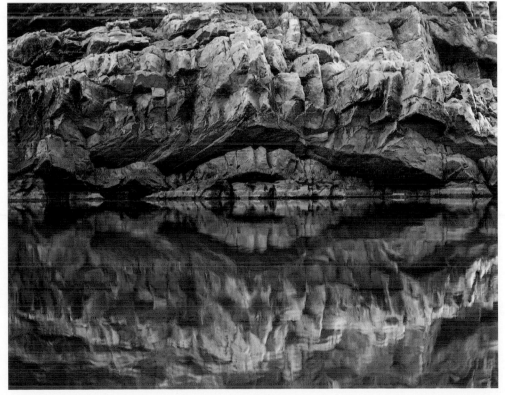

3. CROOKED HORIZON LINES

As you look at your horizon, always check to be sure that it is horizontal. Crooked or tilted horizons can drive you nuts—and your viewer will notice. They will think that something is off about your picture, though they might not be able to point it out precisely, as in the image below.

Of course, there are always exceptions to the rule. Sometimes a deliberately tilted camera can create a striking and unusual image. But if you want to experiment with that, be sure the horizon is so tilted that it looks like you are doing it deliberately for effect, rather than as a mistake.

Many digital cameras have a built-in level to help you keep your horizons straight. In addition, correcting a crooked horizon is very easy to do in any image-processing software. There is no excuse for crooked horizons today.

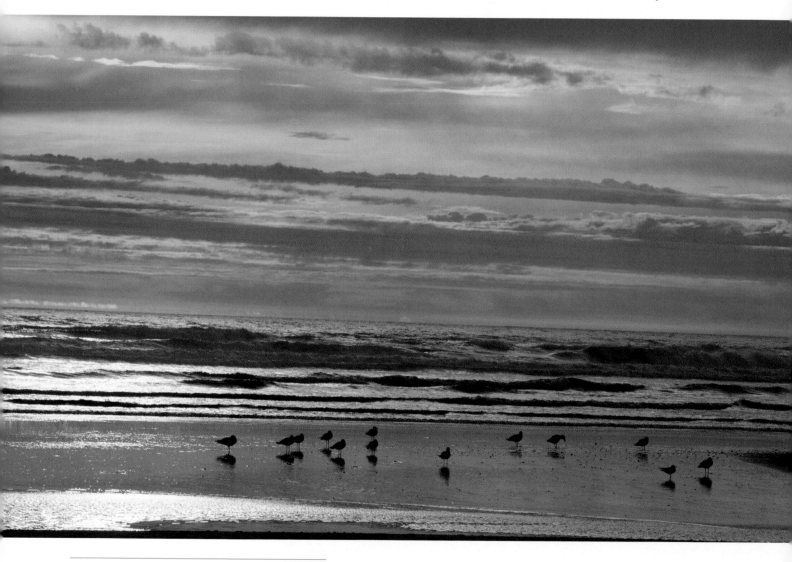

Shorebirds, Olympic Peninsula, Washington
70–200mm lens, f/16 for 1/60 sec., ISO 100

LEFT: *Trekking poles and Cerro Torre, Patagonian Icecap, Argentina*
17–40mm F4L USM lens, f/11 for 1/250 sec., ISO 200

BELOW: *Galapagos sea lion, Isla Seymour, Ecuador*
20mm lens, underwater housing, f/8 for 1/150 sec., single flash unit, Fujichrome MS100/1000 film exposed at ISO 400

4. DISTRACTING ELEMENTS

What's distracting? Anything that competes with your subject. Distracting elements often creep in along the edges of your photograph. It is easy to concentrate so much on your subject that you don't notice the edges of the frame.

Once you have your subject framed up, get in the habit of scanning the edges of your image area. Professional photojournalists do this all the time because while it is critical that they capture an image quickly, it must be an image that features the subject without any distractions.

Look out for out-of-focus branches or twigs that don't belong in your picture. Be especially aware of bright and contrasty areas away from your subject, which will attract a viewer's eye. These can be especially dangerous along the edges of your image as they will pull your viewer's eye toward the edge and off the picture.

If there is a big ugly stick in the stream that you are photographing, such as in the rain forest stream image shown opposite, above right, get out there and pick it up. Get rid of it. Art has been known to chase old men with hairy eyebrows with tweezers when those eyebrows become distracting. No, not really, but the point is important: Look for and get rid of distractions in your photograph by physically removing them, such as getting rid of a Coke can in a natural scene, or by framing your composition to exclude them. When photographing travel and cultural situations, photographers often inadvertently include signs in the pictures. These can be big distractions. Think about it: A sign is designed to be read and call attention to itself! You don't want one fighting with your subject.

No matter what the distracting element in your composition, either get rid of it, re-frame the shot, or move enough to block the distraction as you shoot. In the image of junk boats, opposite, above left, a distracting lighthouse was removed by simply waiting until the boats drifted in front of it.

If a composition requires you to shoot a certain way but there is an annoying distraction in your frame, consider removing it digitally later. Ansel Adams's very famous photograph of Mount Whitney from Lone Pine originally showed the initials "L.P.," which had been "painted" with white rocks on a hill, until he retouched it out of his picture. It was simply a distraction that did not go with the mood or the real truth of the scene.

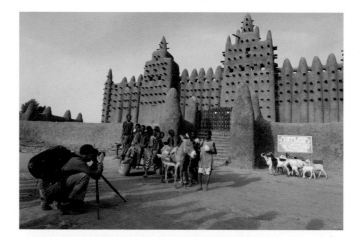

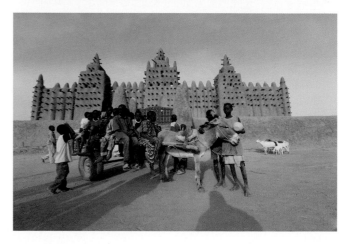

TOP: *Art photographing the Great Mosque, Djenné, Mali*
Photo by John Greengo

ABOVE: *Great Mosque, Djenné, Mali*
16–35mm lens, f/9 for 1/125 sec., ISO 400

TOP AND ABOVE: *Junk blocks, Halong Bay, Vietnam*
70–200mm F4L IS USM lens, f/13 for 1/80 sec., ISO 400

TOP RIGHT AND RIGHT: *Rain forest stream, Olympic National Park, Washington*
24–70mm F2.8L USM lens, f/22 for 4 seconds, ISO 400

5. INAPPROPRIATE LIGHT

We see a lot of instances where people don't use light very well. People see subjects very well, as we discussed earlier, but the camera doesn't. The camera sees light and dark, and will overemphasize inappropriate light on your subject even if you can see the subject just fine. One of the challenges all photographers face is to truly see the light and not just the subject.

One thing that happens when you see only the subject, and not the light, is that you may try to force the shot. Don't try to make something out of a scene that your camera can't handle. You will try to get a photograph of that subject even if the light is not cooperating. If all you want is a snapshot, fine, but you are not going to get a particularly effective photograph that way.

Work with the light; don't fight it. A good example might be photographing forests and the interior of forests on bright sunny days. Scenes like this can be a real nightmare, with all of their spots of light and dark. A cloud cover can soften the light and make such subjects photographable, as with the jaguar shown at right.

Whenever you face a complex environment in your photograph, simple lighting usually works best; the complexity of the environment doesn't need added complexity from the light. Look for ways to shoot in the shade or block the light, such as in the image of Lake Crescent, shown opposite, below, where Art moved to block the distracting bright sky. Or simply shoot at a different time of day.

Watch out for light that fractures the subject into myriad small bright and dark areas. This is not unusual when you are doing close-up images. Bright sun can create a hodgepodge of highlights and shadows that will be very confusing. In such situations, use a diffuser to soften the light and simplify the image. Try to make the light appropriate for the subject.

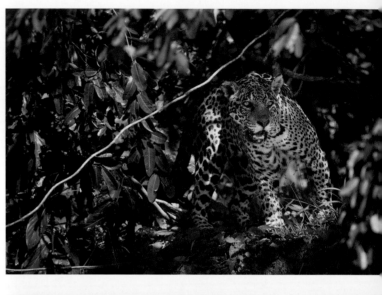

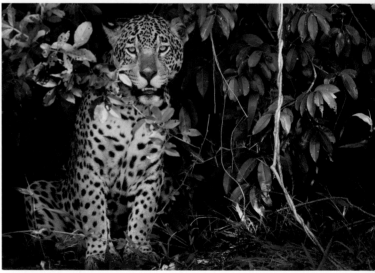

Jaguar, Pantanal, Brazil
TOP: 500mm F4L IS USM lens, f/4.0 for 1/1600 sec., ISO 800

ABOVE: 500mm F4L IS USM lens + 1.4x extender, f/5.6 for 1/1600 sec., ISO 1600

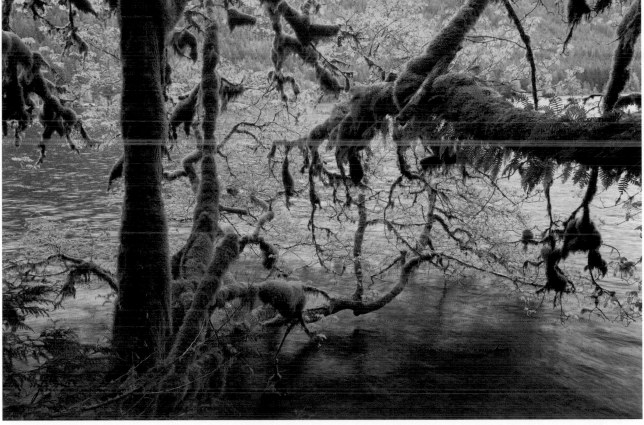

TOP AND ABOVE: *Rain forest stream, Olympic National Park, Washington*
24–70mm F2.8L USM lens, f/22 for 4 seconds, ISO 400

6. CAMERA MOVEMENT DURING EXPOSURE

Camera movement during exposure is the number one cause of a lack of sharpness for photographs, period. One of the challenges of autoexposure is it can make many photographers unconcerned with the shutter speed chosen by the camera for the exposure. That shutter speed then gets to be too slow for the conditions.

Camera movement can occur when you're handholding a camera, but it can also occur when your camera is on a tripod. For example, most of the compact zoom lenses that are so popular today have no tripod mount. When you zoom in on a subject with them, the lens sticks out from the camera body mounted to the tripod and creates leverage that can cause camera vibration during exposure. Because of this, even though the lens may be perfectly capable of sharp images, you may find it more challenging to actually get sharp images at the telephoto setting.

If you're having problems with camera movement during exposure, change to a higher ISO setting and set a faster shutter speed. Don't be afraid of those high ISO settings if they give you sharp pictures. It's better to have a sharp picture with a little bit of extra noise than a fuzzy picture that never looks quite right.

Of course, be sure that you have a good tripod. So often photographers will put all of their investment into a camera and lens then buy a cheap tripod. That's a terrible investment. A good, solid tripod may seem expensive, and is not a very sexy purchase you can talk about at the camera club, but it is an investment that will better enable you to get consistently sharp images.

Many photographers think that this lake of sharpness from camera movement during exposure is always obvious. It isn't, yet it can still degrade an image's quality. You can have camera movement that slightly dulls your entire picture, even though it looks sharp. This is not uncommon with a cheap tripod or when you try to handhold a lens at a slower shutter speed than you should be using.

The best approach is to minimize camera movement during exposure by shooting with a tripod and using a faster shutter speed. If you aren't sure if an image is critically sharp, enlarge it on the back of your camera and check.

LEFT: *Driving in Tokyo, Japan*
17–40mm lens, f/4.0 for 1/4 sec., ISO 400

OPPOSITE: *Lions, Okavango Delta, Botswana*

TOP: Unsharp version

BOTTOM: Sharp version

BOTH IMAGES: 400mm lens, f/4.0 for 1/200 sec., ISO 400

7. INAPPROPRIATE FOCUS

One thing we often see with amateurs' photographs is focus on the wrong part of the subject. They are doing a close-up of a grasshopper, for example, and the hind legs of the grasshopper are sharp, rather than the head. Or they got a great shot of a local native doing a culturally important activity, but the focus is on the background and not on the activity.

You cannot always rely on your camera's autofocus. You need to check and be sure that the camera is focused where it should be. If you take autofocus for granted, you may often get focus in the wrong place.

Consider a portrait. Your camera will frequently focus on the tip of the person's nose, not on their eyes. Whenever you are photographing people, or any type of animal, and the eyes are visible, they need to be sharp. Otherwise your picture just won't look right.

One challenge with portraits is that you are often shooting with somewhat of a telephoto lens close to the subject. That really restricts your depth of field. You need to either be very careful that the eyes are sharp or stop down your lens to f/11 or f/16 to get more of the face in focus.

Appropriate focus is important for more than faces. The focus point in an image is a critical part of the composition, totally determining its emphasis. Be sure that the emphasis is where you want it by choosing where your focus point will be.

ABOVE: *Snake charmer, Morocco*
70–200mm lens, f/18 for 1/30 sec., ISO 400

RIGHT: *Gavriel's face, deep depth of field*
70–200mm F2.8L IS II USM lens, f/20 for 1/25 sec., ISO 1000

FAR RIGHT: *Gavriel's nose, shallow depth of field*
70–200mm F2.8L IS II USM lens, f/2.8 for 1/125 sec., ISO 100

8. INAPPROPRIATE DEPTH OF FIELD

Depth of field is not arbitrarily good or bad. You can have deep depth of field, you can have shallow depth of field, and both can be perfect for a picture or totally inappropriate. It is important to think about depth of field as a way of controlling your image, not simply getting as much as you can or blurring a background.

Try this sometime: shoot the same scene at f/2.8 and then at f/22. You will immediately see how profoundly different they are if you are close enough to your subject. (If you shoot something at a distance, you will not see any change. Distant scenes are all in focus at any f-stop.)

Some photos, like patterns, need to have everything in focus. Every element, every duck, every sunflower in the field, is equally important and therefore needs to be sharp, especially with patterns. Other times, you need to isolate a single subject with focus. Then you want shallow depth of field. A viewer asking the photographer, "What's your subject?" is a bad sign.

We see many flower shots, for example, that are not very well organized. When we ask, "What is your subject?" the photographer responds, "Oh, it's the flowers." Yeah, but which one? The flower is not a pattern in and of itself, so this is not a photograph of a pattern. And no particular flower stands out, so there is no real emphasis.

Another example is when a photographer shoots something with limited depth of field and thinks that because the background is out of focus, there is nothing to worry about. That's never true. Just because something is out of focus does not mean that it does not show in your picture. Sometimes changing your aperture by one f-stop can make the difference between an out-of-focus background that shows too much detail and one that really does set off your subject.

Or another thing may happen: you've got your subject perfectly sharp, but there is a very bright area in the out-of-focus background. Blurring the background further won't help; the only thing you can do is reframe to make sure that bright area is not in your composition.

Photographers often think that they have to use a deep depth of field, or at least stop their lens down from the widest aperture, to get "sharp" photos. But don't be afraid of shooting your lens wide open. Shallow depth of field holds a viewer's eye to something specific in the image while lots of depth of field leads the eye throughout the photo. You have the choice.

Creek, Arizona

TOP: *Shallow depth of field*
70–200mm lens, f/2.8 for 1/800 sec., ISO 400

ABOVE: *Deep depth of field*
70–200mm lens, f/32 for 1/6 sec., ISO 400

Row of buddhas, Thailand

TOP: *Deep depth of field*
70–200mm lens + 1.4x extender,
f/29 for 1/13 sec., ISO 100

ABOVE: *Shallow depth of field*
70–200mm lens + 1.4x extender,
f/4 for 1/640 sec., ISO 100

Devil's club shoots, Washington

LEFT: *Deep depth of field*
70–200mm F4L IS USM lens + 1.4x
extender, f/2.8 for 1/800 sec., ISO 400

RIGHT: *Shallow depth of field*
70–200mm F4L IS USM lens + 1.4x
extender, f/7.1 for 1/30 sec., ISO 125

9. CONFUSING SUBJECT

A question all photographers need to ask themselves is, "What is my photograph about?" This is not, "What is my subject?" That is easier, but what is the photograph actually about beyond the subject itself?

Often we see photos where people are in a great location and they stop at the same stunning vista where everyone stops. They hop out of the car, stand on the edge of the parking lot, and take the picture. That might be okay as a snapshot to remember the location, but it's probably not a good composition and will often lead to a confusing image. Imagine asking us to critique that photo: We don't want to spend any more time critiquing it than you did thinking about the picture!

What is your photo really about? Make your image clear and simple. There may be photos in that big scene, but they won't come from pointing a wide-angle lens at it and hoping for the best! Find something you connect to. Maybe you're a contractor and you like architecture, so you put on a telephoto lens and make a bold statement about the architecture of the location. Make the image unequivocal so nobody has to wonder what the subject is. Don't be afraid to hit the viewer over the head with what you think is important, being clear about exactly why you thought the shot was interesting.

Photographic possibilities, Paro Valley, Bhutan

TOP LEFT: *Farmhouses and prayer flags*
70–200mm F4L IS USM lens +1.4x extender, f/16 for 1.6 seconds, ISO 50

CENTER LEFT: *Farms and terraced fields*
70–200mm F4L IS USM lens +1.4x extender, f/13 for 0.8 sec., ISO 50

BOTTOM LEFT: *Monastery*
70–200mm F4L IS USM lens +1.4x extender, f/16 for 0.8 sec., ISO 50

TOP RIGHT: *Swiftly flowing river*
70–200mm F4L IS USM lens +1.4x extender, f/32 for 3.2 seconds, ISO 50

CENTER RIGHT: *Corrugated barn roof*
70–200mm F4L IS USM lens +1.4x extender, f/22 for 0.4 sec., ISO 50

BOTTOM RIGHT: *Cultivated fields*
70–200mm F4L IS USM lens +1.4x extender, f/14 for 0.3 sec., ISO 50

the 10 deadly sins of composition | 245

10. LACK OF EMOTIONAL IMPACT

This is the most critical of the deadly sins. If you don't care about your subject and scene, why should anyone else? Does it turn you on? If so, why? Otherwise there is nothing. You might show us a clear photograph of a blue sky and a fresh stream, all perfectly sharp, but it is clinical, technical; there's no feeling there.

Take pictures that matter. If it's a landscape, capture it in a unique, beautiful, awe-inspiring way. Get up early, stay out late, shoot the moment, shoot impactful images. Look for things that inspire you, uplift you, or make you smile. Look for photos that make you think.

As photographers, we have an amazing tool that we can use to impact the lives of others, and that's a great gift. You can win a campaign or champion a cause, or just go out and entertain yourself in a stressful world. When we take pictures, we want to affect people. We want to connect them with the world around us, make them laugh, make them cry, help them feel involved with the subject.

Any photo that elicits an emotional response, whether laughter or awe or sadness, is effective, powerful, and majestic. All photos can elicit some sort of reaction. But first and foremost, take photos that move *you*. If it doesn't move you, then don't shoot it. We've got plenty of photos in the world already, so if you don't care about the image, nobody's going to care about the image you shoot. You've got to have something that makes you want to shoot that image.

LEFT: *Young performer,
Allahabad, India*
70–200mm lens + 1.4x
extender, f/4.0 for 1/125 sec.,
ISO 250

BELOW: *Mount Rainier
National Park, Washington*
17–40mm lens, f/13 for 2.5
seconds, ISO 50

OPPOSITE: *Uninspired fall
landscape, Mount Rainier
National Park, Washington*
70–200mm F4L IS USM lens,
f/14 for 1/30 sec., ISO 100

EQUIPMENT AND WORKFLOW

Do you shoot Nikon or Canon? Or are you one of those oddball photographers who shoot something else, like one of those DSLMs or digital single lens mirrorless cameras? Okay, we're being facetious (Rob actually has become a DSLM shooter). But how often have you been in a group of photographers who start discussing these things as if gear were a life-or-death decision? Both of us got dragged into the technology because we had to go there. We have always needed to keep up with the basics of technology as it has changed and affected our business. In addition, Rob had to keep up with technology over the years when he was editor of *Outdoor Photographer* magazine as the digital change occurred.

Arnold Newman's quote below has it exactly right. Photography is about much more than equipment. Who is in charge? The equipment? The software? Or is it your photography? Don't let yourself be intimidated by those techno-geeks at the camera club who know everything about the latest cameras and software. They enjoy doing that and that makes them feel happy. Good for them! But it doesn't have to affect your photography.

"A good photograph doesn't come from a camera, but from the heart and mind."
—Arnold Newman

WHAT IS IN ART'S CAMERA BAG?

Photographers always like to know what kind of gear is in another photographer's bag. This can be helpful if it informs your decisions on how to deal with certain types of equipment for specific subjects. It can also be harmful, however, if you use that information to either make yourself feel better about the gear you own or make yourself feel worse because you don't own certain gear.

The best equipment for your photography is the equipment that you have. It is more important to get out and take pictures with whatever you have than it is to worry that you don't have the "best" gear that someone else has. Keeping that in mind, let's look inside Art's bag. You may be surprised to find less there than you might think.

Art shoots with full-frame DSLR cameras. Digital technology has far surpassed what film was capable of and has completely changed the game for what one can shoot in the field. In the past, ISO 50 was the norm for quality images with film, but now Art is shooting up to ISO 1600 without reservations, and in time that number will only rise.

In recent years, Art has shot the majority of his images with just two lenses: the 16-35mm F2.8 and the 70-200mm. They cover the major types of photography he does and allow him to travel light. He also includes extension tubes for macro work with the 70–200 and sometimes adds a 1.4x extender for additional reach when needed.

When he knows he is going to be shooting wildlife at a distance, he will add a long lens, which has changed over the years from an 800mm to a 600mm and now a 500mm. Why the change? Try packing around an 800mm prime lens that could double as a rocket booster on the space shuttle and then ask that question again!

Art sometimes brings a fish-eye lens, the 15mm F2.8, for special effects to mix things up a bit, but it's not a lens he relies on. He has started using a 24–105mm F4 as a walk-around lens, for shooting in crowded markets and capturing portraits and architecture. He had dismissed this "middle range" in the past, but now finds it perfect for those particular purposes.

A very important part of Art's kit is a lightweight, sturdy carbon fiber tripod. Art uses the Gitzo GT3541XLS carbon fiber tripod because it is both solid and light enough to travel easily. The head is a Kirk BH-1 ballhead mounted directly to the top of the legs of the tripod; he does not use a center column.

Finally, there are the miscellaneous bits and pieces: an intervalometer for shooting long exposures and stars; circular polarizers for all lenses; a couple of 2-stop, hard-edge graduated neutral-density filters; extra batteries for the camera and intervalometer; hex wrenches; and lens cleaning cloths. This all comes down to an equipment package that is simple, lightweight, and effective for Art as he travels the world.

PAGE 248: *Art on the Varanasi ghats, India*
Photo by John Greengo

WORKFLOW

Art is definitely not one to spend a lot of time thinking about workflow and its technology. He has never been a technical person and does many things intuitively. Still, we understand that digital photography can be challenging and it can be helpful to think about how to shoot an image from beginning to end, including postprocessing. (Rob has written a number of books on exactly these topics, so you might want to check some of them out. He also includes this type of information on his websites: robsheppardphoto.com and natureand photography.com.)

Workflow is basically about choice. The choices you make influence your photographs and how you photograph, which, in a way, is exactly what this book is about. So here is a workflow based on some choices that may help:

1. Find a potentially rich area for photography.
2. Consider the possibilities before getting out the camera.
3. Look beyond the subject to see both light and subject.
4. Look for color, shape, and form.
5. Think about what you want from the scene in front of you. What is it that most affects you?
6. Consider what is most important about the scene from your unique point of view and how to emphasize it with your photography.
 - What angle best shows off the subject?
 - Can you find a unique angle that will create something unusual and impactful for the subject?
 - How does angle affect background and light?
7. Get out your camera and consider what you need in order to get the shot done:
 - What focal length do you need? Is this a wide- or narrow-angle shot? What needs to be featured that focal length can affect?
 - Where do you need to focus and what amount of depth of field do you need?
 - Is a certain shutter speed needed to control motion?
 - What white balance will render colors best?
 - What exposure will keep bright areas bright without losing detail?
8. Work the subject by taking many photos from different angles and using different approaches to refine your approach to the image.
9. Don't be afraid to break the rules to see what happens.
10. Download your images into the computer. We both use Lightroom for this.
 - Set up a system that allows you to find your photos. Lightroom offers tools to help you organize your images, but it does not organize them for you.
 - Use a system that keeps your photos organized on your hard drive as well as in Lightroom. Lightroom recognizes whatever is on your hard drive and will show that in the Folders part of Library. If it is not organized on your hard drive, it will not be organized in Lightroom.
11. Edit your photos.
 - We are talking traditional photo editing, not Photoshop. This means sorting the good from the bad, finding the best images, and so forth.
 - Throw out your bad photos. Trash them and get them off your hard drive. A lot of photographers like to hang on to everything. If it isn't a good photo now, why will it be a good photo in the future? Keeping unneeded photographs just clutters up your hard drive and makes it harder to find the good ones.
12. Back up your photos.
 - This is critical. Back up your photos! Hard drives fail, and if your hard drive with your photographs fails, your photographs are gone.
13. Process as needed (see following pages).

LIGHTROOM WORKFLOW OUTLINE

Start in Library

1. Import photos with Import button or automatically when memory card is detected.
 - Choose to copy photos to a new location if from memory card.
 - Set location for photos.
 - Use a system that helps *you* organize and find your images.
 - Choose to leave photos in place if already on hard drive.
 - Set metadata if appropriate.
 - Include keywords (if keywords work for you).
2. Edit good from bad pictures.
3. Add specific metadata, such as keywords, copyright information, and captions as needed and if appropriate to the way you work. Do not make this a chore that keeps you from working in Lightroom.
4. Use Collections, Smart Collections, and Quick Collection like virtual storage bins.
5. Select images for processing.

Develop (image processing)

1. If cropping is needed:
 - Adjust cropping.
 - Straighten photo.
2. Start in Basic:
 - Set Blacks.
 - Use Alt/Option key as you move the Blacks slider to see blacks.
 - Find at least a minimum.
 - Beyond minimum is very subjective.
 - Tweak dark tones (Shadows).
 - Check whites (Whites).
 - Use Alt/Option key as you move the Whites slider to see whites.
 - Watch histogram to be sure you are not clipping detail.
 - Be cautious on your adjustment of whites.
 - Highlights may help bright areas.
 - Choose Clarity amount.
 - Watch out for a harsh look from too much Clarity.
 - Use the Shadows slider if the image starts looking too heavy in dark areas.
 - Choose a Vibrance amount.
 - Be cautious and do not overuse this tool.
 - Watch sky color and warm color casts.
3. Go to Tonal Curve:
 - Choose linear or moderate for most photos.
 - Work the parametric sliders to affect specific tones.
 - Dark is especially important for digital images because sensors often have trouble with dark areas.
 - Watch tonal and color changes.
4. Go to White Balance Eyedropper in Basic if needed for color correction.
 - Click on things in image that should be neutral.
 - Watch overall image color.
 - Tweak Temperature and Tint as needed.
5. Go to HSL to work specific colors.
 - Use Targeted Adjustment ("magic button" at upper left of panel to activate cursor).
 - Click on colors, drag cursor up or down.
 - Correct specific color Hue (color of color) where there are problems.
 - Optimize individual color Saturation (intensity of colors); one color may need more, another less to make image better visually balanced.
 - Adjust individual color brightness with Luminance.
6. Go to Effects and Post-Crop Vignette.
 - Darken edges for a traditional darkroom technique that Ansel Adams always used.

7. Go to Detail.
 - Set sharpening (numbers will vary on subject).
 - Use Alt/Option key as you adjust to see black-and-white version of photo to better evaluate effects.
 - Amount: for RAW files, 40–60 will usually work.
 - Radius: keep low, 1–1.3 most of the time.
 - Detail: try something in the range of 35–0.
 - Masking: blocks sharpening from large areas of one tone such as sky to minimize noise. You can see the mask by holding down the Alt or Option key as you use the slider. White allows the sharpening, black blocks it.
 - Set noise reduction.
8. Fix spot problems.
 - Clone.
 - Heal.
 - Revise by clicking and dragging.
 - Keyboard H to hide and reveal guide circles.
9. Look at photo for local adjustment needs.
 - Look to balance photo visually.
 - Darken large areas with Graduated Filter using Exposure and/or Shadows.
 - Lighten large areas with Graduated Filter using Exposure and/or Highlights.
 - Darken or lighten specific areas with Adjustment Brush using same controls.
 - Fix local color and other problems with Adjustment Brush.
10. Readjust Exposure in Basic if needed overall because of local area changes.

Export

1. Right-click photo (Mac users should acquire a right-click mouse).
2. Choose Export from menu that appears (or choose Edit in if you want to go to Photoshop).
3. Set a destination for your photo.
4. Name your photo.
5. Size your photo if needed.
6. Set output sharpening if needed.
7. Tell Lightroom what to do with the photo after Export, if needed.

STORING AND BACKING UP YOUR DIGITAL PHOTOS

Your photos should be saved to a hard drive that is not the main hard drive on your computer, and they should be backed up to a second hard drive that is also not inside your computer.

Many photographers put all of their pictures on the main hard drive of their computer. This can be a problem. The computer's main hard drive is the one that operates your computer with all of its programs and is used constantly. If you have photographs on it, you are going to increase the stress on that drive because you will be constantly accessing the pictures, too. That combination can be deadly and shorten your hard drive's life. Keep your main hard drive for programs and things that you are storing and don't access constantly.

Big accessory hard drives are not all that expensive, and are worth the price for protecting your images. You should have one big drive for your images and nothing else, and another big drive for backup of those images. This is a minimum. Some photographers will have additional drives for more backup. If you or somebody you know is fairly sophisticated with hard drives, you can look into Raid hard drives for this

Having separate drives means that you will have a specific folder on them for your pictures. Don't use the Pictures or My Pictures on your main hard drive if you shoot more than a few images. That will cause problems in organization, plus it will keep your pictures on the main hard drive, not where you want them to be.

ACKNOWLEDGMENTS

The Art of the Photograph has gone through many iterations. Years ago, it began as *The Curriculum* and ballooned as I fed it rich and extraneous imagery. From this I created my popular three-day workshop, Composing Effective Images, and my one-day seminar, The Art of Composition. Now with the extraordinary expertise of Rob Sheppard, my coauthor, and editor Julie Mazur, it has evolved into this cogent final product. There have been critical contributions made by many others, including my hard-working staff (Deirdre Skillman, Amanda Harryman, Bruce Decker, Libby Pfeiffer, Christine Eckhoff, and Brandon Fernandes); my photography assistants past and present who have worked on this since the Curriculum days (Gavriel Jecan, Jay Goodrich, Bill Edwards, and John Greengo); and my literary agent, Peter Beren.

—*Art Wolfe*

I have felt very privileged to be part of this book. I have loved Art Wolfe's work for a long time, and I always enjoyed working with his always evocative and inspirational images while editor of *Outdoor Photographer* magazine. Art has a similar worldview to mine: that the world is a beautiful place deserving of our attention, and this goes far beyond the most obvious locations. It was a pleasure working on this book because Art and I have such similar values and ideas about connecting with all photographers to help them make better and more effective images. I thank Art and Deirdre Skillman for working with me on this, and thanks to Julie Mazur for ensuring that the text is tight and clear. I also thank all of my students in workshops over the years who have helped me understand how to better communicate how they can photograph better. And I thank my wife, Vicky, for her steady presence and balancing personality that keeps me at my best.

—*Rob Sheppard*

INDEX

A

Adobe Photoshop, 114–118, 164–165, 167, 210, 212
Adobe Photoshop Elements, 114–118, 166, 167, 212, 214, 216
Adobe Photoshop Lightroom, 114, 118, 164, 167, 210, 223, 251, 252–253
Auto-rotation challenge, 61

B

Black-and-white
 in color, 156–157. *See also* Color
 conversions, 164–167
 history and importance, 139, 160–162
 JPEG + RAW for, 160
 key ways to work with, 163
 optimizing, 167
 sharpness, 163
 texture contrast, 163
 tone/brightness contrast, 163
 viewing on LCD, 160
Blur, avoiding, 105, 238–239
Book overview, 10–11

C

Cameras, 83–121. *See also* Exposure control; Lenses; Light
 in Art's bag, 250
 avoiding blur, 105, 238–239
 format options, 84
 optimizing, 110
 seeing lines on LCD, 124
 shutter speed, 104–105
 tripods for, 98, 250
Close-ups, 102–103
Color
 black-and-white in, 156. *See also* Black-and-white
 blue, 142
 complementary, 151–155
 evolution and importance, 139
 green, 144
 monochromatic, 158–159
 optimizing, 167

orange, 145
power of, 140
preplanning shots, 168–169
red, 141
RGB explained, 140
subjectivity of, 150
violet, 146–147
white balance and, 153
white, black, and gray, 148–149
yellow, 143
Color Efex, 118
Complexity, unity and, 75–77
Composition sins, 227–247. *See also* Images, constructing
 confusing subjects, 244–245
 distracting elements, 234–235
 focus and depth of field, 238–243
 horizon position, 230–233
 inappropriate light, 236–237
 missing emotion, 246–247
 subject in middle, 228–229
Creative solutions, 205–225. *See also* Exposure control
 concept to creation, 206–207
 finding essence of subject, 224–225
 illustration and photography, 210–211
 infrared photography, 213
 looking at subjects, 208–209
 optimizing, 223
 software for. *See Adobe references*

D

Depth of field. *See also* Focus
 deep, 108, 112–113
 defined, 108
 diffraction problem, 112
 inappropriate, 241–243
 preplanning shots, 168–169
 shallow, 108, 111
Design elements, 123–137
 diagonals, 130–131
 lines, 124–127. *See also* Horizon, position of; Leading lines
 questions to answer, 135

 shapes and patterns, 128–129, 136–137
 spirals, 132–133
 texture, 134–135
Diagonals, 130–131
Diffraction problem, 112
Distractions, avoiding, 78–79, 234–235

E

Elements. *See* Adobe Photoshop Elements; Design elements
Emotional impact, 140, 142, 246–247
Equipment, 249–250. *See also* Cameras; Filters; Lenses
Everest expedition, 19–21
Exposure control, 114–119
 combining two photos, 216–217
 graduated filters, 218–219
 HDR, 114, 150, 184, 186, 214–215
 long exposures, 106–107
 polarizers, 220–223
 software for. *See Adobe references*
Extension tubes, 103

F

Filters
 in Art's bag, 250
 graduated, 218–219
 neutral density, 51
 polarizers, 220–223
Focus. *See also* Depth of field
 avoiding blur, 105, 238–239
 distance to subject and, 108
 focal length and, 108
 f-stop and, 108
 inappropriate, 240
 selective, 108–113
F-stop, 108

G

Gardens, inspiration from, 23

H

HDR, 114, 150, 184, 186, 214–215
Horizon, position of, 62, 64, 196, 230–233

I

Images, constructing, 55–81. *See also*
 Composition sins
 auto-rotation challenge, 61
 avoiding distractions, 78–79, 234–235
 complexity, unity and, 75–77
 conveying scale, 67–69
 listening to subjects, 80–81
 making order from chaos, 70–71
 orientation and, 60
 point of view and, 56–58
 practicing, 59
 questions to answer, 79
 rule of thirds, 64–65
 simplicity in, 73
 subject needs and, 66
 subject placement, 62–63
 zoom lens challenge, 72
Infrared photography, 213
Inspiration, Art's story, 13–33
 art influence, 27–29
 becoming photographer, 17–18
 Everest expedition, 19–21
 gardens and nature, 23
 growing up, 14–16
 at home, 22–25
 influence of others, 31
 integrating life, 26
 special moments, 32–33
Inspiration, identifying yours, 31

L

Leading lines, 90–93, 102, 112
Lenses
 in Art's bag, 250
 bold foregrounds and, 86–87
 choices, 85
 close-up/macro, 102–103
 compressing distance, 96–97
 extension tubes, 103
 framing simple compositions, 94–96
 leading lines and, 90–93
 perspective and, 88–89
 tele-extender option, 99, 103
 telephoto, 94–97, 99–101
 wide-angle, 86–93
 zoom, challenge, 73
Light
 artificial, 198–201
 backlight, 180–181
 chiaroscuro, 186
 composition and, overview, 171
 diffused, 190–193
 front, 176–177
 how camera sees, 172–173
 inappropriate, 236–237
 looking at, 174–175
 optimizing, 201
 reflective, 194–195
 shadow and, 184–185
 side, 178–179
 silhouettes, 182–183
 spotlight, 187–189
 twilight, 196–197
 working with, example, 202–203
Lightroom. *See* Adobe Photoshop Lightroom
Lines, 124–127. *See also* Horizon, position of;
 Leading lines
Live View, 98, 172, 213
The Living Wild (Wolfe), 14, 31
Long exposures, 106–107

M

Macro shots, 102–103
Megapixels, perspective on, 75
Migrations (Wolfe), 28, 128–129, 210
Monochromatic color, 158–159. *See also*
 Black-and-white

O

Order, from chaos, 70–71
Orientation, 60

P

Painterly software, 212
Patterns and shapes, 128–129, 136–137
Perspective, 88–89
Photoshop. *See* Adobe Photoshop
Point of view, 56–58
Polarizers, 220–223
Practicing, 36, 59
Preplanning shots, 168–169

R

Rule of thirds, 64–65

S

Scale, conveying, 67–69
Shadow, 184–185
Shapes and patterns, 128–129, 136–137
Shutter speed, 104–105
Signs, in images, 78–79
Silhouettes, 182–183
Spirals, 132–133
Spotlight, 187–189
Subject, discovering, 35–53
 constructing images. *See* Images,
 constructing
 finding better images, 46–47
 framing process and, 44–45
 freeing yourself to see, 40–41
 importance of practice, 36
 mechanics of seeing and, 44–45
 moving beyond the visible, 50
 as photograph, 38–39
 questions to answer, 51
 staying with subject, 48–49
 unique subjects, 51
 visualization and, 42–43
 when subject changes, 52–53
 without prejudice, 36
Subject(s)
 confusing, 244–245
 finding essence of, 224–225
 listening to, 80–81
 looking at, 208–209
 in middle, avoiding, 228–229
 needs, 66
 working, 46–47, 120–121, 202–203

T

Texture, 134–135
Thirds, rule of, 64–65
Travels to the Edge (TV series), 32, 52
Tripods, 98, 250

U

Unity, complexity and, 75–77

V

Visualization, 42–43

W

White balance, 153
Workflow, 251–253